ABSOLUT BOOK.

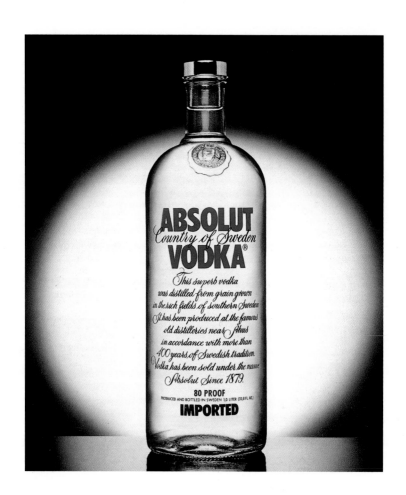

ABSOLUT BOOK.

The Absolut Vodka Advertising Story.

Richard W. Lewis

JOURNEY EDITIONS
BOSTON • TOKYO

Published in 1996 by

JOURNEY EDITIONS

an imprint of Charles E. Tuttle Co., Inc.

153 Milk Street, fifth floor

Boston, Massachusetts 02109

Absolut country of Sweden vodka & logo, Absolut, Absolut bottle design, Absolut
calligraphy and Absolutvodka.com are trademarks owned by V&S Vin & Sprit AB.

Library of Congress Cataloging-in-Publication Data

Lewis, Richard W.
 Absolut book : the Absolut Vodka advertising story / Richard W. Lewis. —
1st ed.
 p. cm.
 Includes index.
 hardcover ISBN 1-885203-32-2 paperback ISBN 1-885203-29-2
 1. Advertising—Alcoholic beverages. 2. Vodka industry—Sweden—History.
3. Absolut Company. I. Title.
HF6161.L46L48 1996
659.1'96635—dc20 95-53040
 CIP

Wherever possible, the illustrations in this book were reproduced from original artwork,
but some variation may occur when such artwork was no longer available.

Some of the materials in this book are reprinted by special permission,
and the names of all those granting such permission are included in
ABSOLUT CREDITS AND PERMISSIONS. on page 270.

JACKET DESIGN BY ALIX BOTWIN, DAN BRAUN, BART SLOMKOWSKI
BOOK DESIGN BY SHERRY FATLA

7 9 10 8 6

Printed and bound in Hong Kong

Dedicated to Isabel, Ariane, Amanda, and Sam:
my ABSOLUT FOUNDATION.

"There are no absolutes in life, only in vodka."
—Detective Mike Kellerman, HOMICIDE: Life on the Street

CONTENTS

ACKNOWLEDGMENTS ix

ABSOLUT INTRODUCTION. xi

CHAPTER 1 ABSOLUT BEGINNING. 3

CHAPTER 2 ABSOLUT PRODUCT. 11

CHAPTER 3 ABSOLUT OBJECTS. 31

CHAPTER 4 ABSOLUT CITIES. 47

CHAPTER 5 ABSOLUT ART. 65

CHAPTER 6 ABSOLUT HOLIDAYS. 89

CHAPTER 7 ABSOLUT FASHION. 105

CHAPTER 8 ABSOLUT THEMED ART. 137

CHAPTER 9 ABSOLUT FLAVORS. 189

CHAPTER 10 ABSOLUT SPECTACULARS. 203

CHAPTER 11 ABSOLUT EUROCITIES. 219

CHAPTER 12 ABSOLUT FILM & LITERATURE. 231

CHAPTER 13 ABSOLUT TAILOR-MADE. 241

CHAPTER 14 ABSOLUT TOPICALITY. 253

CHAPTER 15 ABSOLUT REJECTS. 263

ABSOLUT CREDITS AND PERMISSIONS. 270

INDEX 271

ACKNOWLEDGMENTS

Fifteen years plus a few hundred ads equal a long list of thank you's. The following list is (I hope) every "creative" person who contributed to the campaign from The Absolut Company (Vin & Sprit of Sweden), Carillon Importers, The House of Seagram, and the many TBWA offices that have dreamed up ideas, created headlines, imagined visuals, and even sometimes wrote copy—or made any of these elements better—in the campaign.

Geoff Hayes, the father of Absolut advertising, without whom there would be no story to tell.

Frank Anton	Steve Feldman	Lisa Lipkin	Michel Roux
Arnie Arlow	Carol Ann Fine	Peter Lubalin	Arthur Shapiro
Olga Arseniev	Pascale Gayraud	Phil Martin	Bart Slomkowski
Frederic Beigbeder	Paul Goldman	Cara McEvoy	Karen Sultz
Marianne Besch	Sophie Guyon	Tom McManus	Tessa Super
Alan Blum	Pat Hanlon	Ray Mendez	Graham Turner
Alix Botwin	Pete Harle	Elizabeth Morse	Delphine Valette
Dan Braun	Charlie Herbstreith	Page Murray	Simon Walker
Peter Callaro	Leslie Hohnstreiter	Curt Nycander	David Warren
Ernie Capria	Andy Judson	Dave Oakley	Sue Wiedorn
Evert Cilliers	Richard Kaufman	Graeme Parsons	Lloyd Wolfe
Brennan Dailey	Lisa Kay	Jim Peck	Dave Woods
Tony DeGregorio	Maria Kostyk-Petro	Lisa Rettig-Falcone	Harry Woods
Joan Ellis	Allan Levine	Bruno Richard	Phil Wyatt
Michael Feinberg	Lisa Levy	Nigel Rose	Zach Zych

Thank you to my friends at Absolut who trusted me with such an important project: Egon Jacobsson, Goran Lundqvist, Lars Nellmer, Claes Fick, Peter Bunge-Meyer, and Claes Andreasson.

There is also a group of people at TBWA/Chiat Day New York who have been indispensable in helping me compile this book. On the production side, Ira Lager and Sandie Torres crawled through the archives, supplying and preparing material for publication. My assistant, Kimberly Hines, who trafficked and logged the various permissions this book required and put up with my bad puns and general crankiness. And Elizabeth Morse, who was a crackerjack at wheedling and securing the approvals from the photographers, artists, and models whose work appears here.

Peter Ackroyd is the publisher at Journey Editions. We first discussed doing the Absolut Book in 1992. Thanks for your patience, mate.

Finally, thanks to Sherry (Fatla) and Terry (Hackford), the book's designer and editor, respectively. Sherry demonstrated an immediate respect for the advertising, created a design scheme that transformed it into a book (without imposing too many rules on me), and, I think, even had some fun in the process. And Terry, because she didn't force me to use semi-colons when I didn't want to; and was so gentle, she had me believing that I was actually the editor.

ABSOLUT INTRODUCTION.

(Don't skip this part.)

The Absolut Vodka advertising campaign has been running nonstop for 15 years, since 1981. This is remarkable because in the advertising business, campaigns can change as often as every year, as marketers attempt to keep their brands' personalities fresh.

Still, Absolut advertising is celebrated not just for its longevity but also for its ingenuity. Readers tear out the ads and hang them on their walls. Librarians have to guard their magazines from being de-Absoluted. College students actually collect and trade ads. A SoHo antique shop hawks copies of ABSOLUT WONDERLAND, while a Madison Avenue newsstand carefully razors the Absolut pages from its stock and sells them for a few dollars apiece (naturally, selling the magazines as well). What's going on here?

Readers enjoy a relationship with this advertising that they have with few other advertising campaigns, especially in the print media. They are challenged, entertained, tickled, inspired, and maybe even befuddled as they try to figure out what's happening inside an Absolut ad.

The advertising has won hundreds of awards, including charter membership in the American Marketing Association's Marketing Hall of Fame. Absolut was inducted into the Hall in 1992 along with just two other brands: Coca Cola and Nike. Of the three, only Absolut accomplished this feat without the benefit of another, much more powerful advertising medium: television.

As rewarding as the recognition within the advertising and marketing fields has been, however, it takes a backseat to the simple but real purpose of the campaign: to build a healthy and enduring brand for Absolut. The campaign was conceived by TBWA Advertising (now called TBWA/Chiat Day after our merger in 1995). As this is our signature account at the agency, naturally, we're very proud that the advertising has played a role in the Absolut success story. When the campaign began, in 1981, Absolut was selling about 20,000 cases annually in the U.S.A.; last year, sales were over 3 million cases—an increase of 14,900%!

Some people say we've had an easy job, and maybe they're right. After all, the Swedish producer, The Absolut Company, handed us the world's finest vodka, in a beautiful, even arty bottle, with a catchy brand name. Michel Roux, President of Carillon Importers, the U.S. distributor, was a made-in-heaven client who believed that advertising could change a brand's destiny and continuously supported that belief. It was up to us not to screw it up. And I guess we didn't.

In this book, you'll learn who *we* are. There are a lot of names because many talented people have contributed to the advertising. I've tried to help you keep them all straight because they're worth getting to know, and they're even nice people. My position at the ad agency earned me the opportunity to tell the story.

I joined TBWA Advertising in 1987 as a midlevel account manager in charge of running the day-to-day business of the Absolut account. I was hired by two account management supervisors, Brian Barry and John Doman, who preceded me on the Carillon business. Doman, incidentally, later went on to become a professional actor. Two generations ago, actors—and artists, pilots, circus performers, you name it—became admen. Today, in a career twist, the path is reversed. Prior to joining TBWA, I had managed corporate-, entertainment-, computer-, and automotive-related advertising accounts, but I had virtually no experience in marketing liquor. (I mention this only because advertising, like many other fields, can often have a catch-22 attitude toward experience.) But the enlightened management at TBWA seems to have considered my lack of direct experience to be a benefit, thinking I could provide a fresh perspective, and the client either didn't care or figured I couldn't do too much harm. By then Absolut was already a successful brand, though it wasn't yet a famous success.

As Account Director, I was responsible for pulling together the agency's creative, media, and research resources and for building an agenda for our weekly meetings around the conference table at Carillon's

offices in Teaneck, New Jersey. Move the projects forward, move the brand forward, and, I hoped, move Richard Lewis forward. These meetings were fun because like the product, Absolut Vodka, we didn't take ourselves too seriously. And to be honest, things were going very well.

Today I'm in charge of Absolut's advertising worldwide. And with nearly a decade's experience, I can remind my colleagues that I'm one of the Absolut dinosaurs whenever someone wants to change everything. Still, it's this change that has kept the campaign constantly fresh, even as it embraces a single, simple idea: the Absolut bottle is the hero.

We learned early on that great ideas could come from surprising sources. As the campaign became infectious, it began to seem that nearly everyone had an idea for an ad. We've never been too jealous of protecting our turf or too proud to seek out the best thinking, whatever the origin—whether it's the magazines that carry the advertising, family, friends, or the public. Even the client.

More about the client. Michel Roux, President of Carillon, Absolut's U.S. importer until 1994, was one in a million. He understood—and helped us understand—how to market premium products. He lived the brand, day and night, leading us to do the same. If one week we showed him a crazy idea that he thought was all wrong, when we returned the following week with something equally outrageous, he'd never begin the meeting with, "I hope you haven't brought me another ad with insects in it," or whatever. He'd forgive and forget.

And while we undertook considerable research into the market, the competition, and our customers, we never had to "test" the ads to determine whether they were *good*. Rather, we knew it was our job as the ad agency to figure out, along with Michel's team, what exactly constituted *good* advertising. (In some respects, this was a throwback to the creative freedom of the 1960s and the great advertising campaigns for Volkswagen, Chivas Regal, and Alka-Seltzer.) Therefore,

we didn't have to pluck consumers off the street and ask them questions like "What is Absolut trying to communicate in this ad?" If we had done that, some of the more daring ideas would surely have been left on the focus-group floors.

Thank you, Michel. And thanks also to our Swedish client, The Absolut Company, and its American distribution partner, The House of Seagram, which has continued to endorse the philosophy against testing the ads.

The Absolut campaign is about five hundred ads deep. (And most of them are actually pretty good.) I don't think anyone knows exactly how many have been produced, but this book will reproduce a great many, if not all, of them.

Over the course of the book, I'll explain what we had in mind as we opened new and different doors for the advertising. Because the campaign has encompassed many different kinds of ads—art, fashion, cities, spectaculars, Hollywood, etc.—that's how I've organized the book.

I'll point out where we were smart and where we were lucky. And where we were both.

However, I've tried not to be a slave to chronology, especially since many of the various advertising paths have been explored simultaneously. And because it isn't a matter of opening one ad door, pushing through to a conclusion, and then selecting another door, we haven't really exhausted any of the paths. That's why, though the bottle has assumed the identity of dozens of different objects over the years, we can still create Absolut ads in which the bottle is even made of glass. I like to characterize this evolution as a circular one, in which each path can return to its beginnings, as opposed to a more traditional, linear evolution lacking such flexibility. The result is a campaign that can go on, well, for a long, long time.

RICHARD W. LEWIS

ABSOLUT

ABSOLUT

ABSOLUT

ABSOLUT

ABSOLUT

ABSOLUT
BEGINNING

ABSOLUT BEGINNING.

Like so many other stories, the Absolut story begins in the fifteenth century. By that time, Sweden already had a bustling industry of vodka distillers, with hundreds of entrepreneurs preparing their own secret recipes for vodka and sharing them with their family and friends to help them get through the long, tough Swedish winters.

Although Swedish vodka was an unrefined product, it nonetheless contained some of the world's finest raw ingredients: pure Swedish water and rich Swedish wheat. Its creation was a most imprecise science, however, and the home distillers lacked the equipment and the know-how to remove the impurities that are a natural result of the distillation process.

Push the clock ahead some four hundred years. In 1879, the Swedish inventor and industrialist Lars Olsson Smith changed everything with his creation of a new distillation method called rectification, which is still in use today. In this method, a series of distillation columns separate different sets of impurities, allowing the removal of nearly all the congeners, or impurities, produced during the vodka-making process. He called his product *Absolut rent bränvin*, Swedish for "Absolute pure vodka." And for these accomplishments he earned the sobriquet King of Vodka.

Over the next hundred years, Absolut Vodka was steadily refined and improved, even as every single bottle continued to be distilled in the little village of Åhus, in southern Sweden. Åhus (pronounced OR-hoos) is a picturesque port town on the Baltic Sea, with a population of only ten thousand. By the late 1970s, however, it was clear that if the distillery was to survive, Absolut would have to become an export product with enough sales volume to justify keeping it open and running.

Earlier in this century, the Swedish government had taken control of the production and distribution of the beverage alcohol industry, including Absolut. The brandowners in Stockholm, Vin & Sprit, knew what market they had to tap to keep Absolut alive: America.

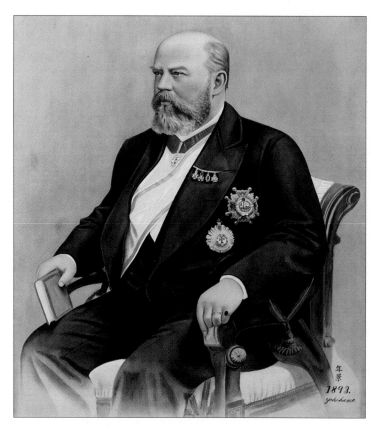

Lars Olsson Smith.

In the 1970s, the United States accounted for 60 percent of the vodka consumed in the free world—about forty million cases. (Each case consists of twelve 750-milliliter bottles, or nine liters.) However, about 99 percent of the vodka consumed in America was produced in America, and most of it was very inexpensive. Conventional wisdom held that "all vodkas are alike," due to the relative ease of production, the few ingredients necessary, and the fact that no aging is required, as with Scotch and other whiskeys. Also, because most consumers combined their vodka with orange juice, tomato juice, tonic, or any number of other mixers, they didn't much care about the underlying quality of the vodka itself: the cheaper, the better.

The remaining 1 percent—the imported-vodka market in America—was interesting. It was dominated by Stolichnaya, the Russian vodka. Stolichnaya had been imported since 1968 by a subsidiary of the Pepsi-Cola Company as payment, in lieu of hard currency, for the Pepsi sold in the Soviet Union. Created specifically for export, it was good vodka, some of Russia's finest, and the only Russian vodka "officially" exported to

America. The U.S. consumer paid about ten dollars a bottle for it, or up to twice as much as for domestic brands. Being Russian, Stoli possessed a seamless authenticity for many Americans: from the czars to the revolution to the summit meetings, vodka and Russia have long been synonymous in consumers' minds. (Most of the vodkas made in America even have Russian-sounding names: Smirnoff, Romanoff, Georgi, and so on.)

A much smaller segment of the imported market was controlled by Finlandia, the vodka from Finland. It arrived in this country a few years after Stoli, but its modest success proved that a Scandinavian vodka could be compelling, too, possibly because Finland is physically—and maybe psychologically—near Russia. Its sales amounted to nearly fifty thousand cases. Several other brands were also just getting their feet wet, including Wyborowa from Poland and vodkas from other Eastern European countries.

By 1978, Vin & Sprit was ready to test the waters. It sent a delegation to the United States, led by Lars Lindmark, its energetic President, and Curt Nycander, its Director of Export. Carrying different prototypes and concepts for the "American" Swedish vodka, they arrived with 80 proof optimism. In all, they had six Swedish vodka ideas, Absolut being just one of them.

Arrangements had been made through various Swedish and American intermediaries for the delegation to visit the leading U.S. distillers and importers, and in short order, they met with representatives from Hiram Walker, Seagram, Brown-Forman, and Austin Nichols. In equally short order, Lindmark and Nycander were rejected by all of them. Each found fault with the bottle designs, the product names, the Swedish origin, or just the notion of a new vodka. There weren't many options left, though there was the proverbial last chance.

Carillon Importers was a small New York liquor-import company headed by the charismatic Al Singer. Carillon's leading product was Grand Marnier, the prestigious French liqueur, but the company also imported England's Bombay Gin, Achaia Clauss wines from Greece, Bertani wines from Italy, and other specialty items. Singer himself was something of a character: a gambler, a high liver, and a sharp businessman.

"I don't want a vodka," he initially said, according to Martin Landey, his advertising-agency head at the firm of Martin Landey Arlow, and a man who deserves some credit for introducing the Swedes to Carillon. But in fact, Al Singer was open to practically anything, and this meeting would be merely the first in the courtship. Over the next several months, Singer and Landey visited Sweden frequently, and ultimately, the Swedish-American team finalized the product and the packaging.

Developing the now-classic Absolut bottle was no small challenge. The Swedish design team led by Gunnar Broman and Lars Borje Carlsson developed a fleet of different bottles but was most satisfied with a version inspired by Swedish medicine bottles. Various typographical and label treatments were considered and discarded, among them silver type, proposed for its prestige value but rejected for its expense and showiness. A small medallion was added that included the likeness of L. O. Smith, the inventor of the rectification process. Everyone had an opinion, which didn't hasten a solution. Nonetheless, the collaboration must have worked, as the bottle is surely the original piece of Absolut Art.

Unlike most liquor bottles, which have long necks and square shoulders, Absolut bottles have short necks and round shoulders. Before Absolut appeared, every liquor bottle featured a paper label. It was the Swedish team's brilliant innovation to print all the label information directly onto the bottle in bold, colorful type. Absolut's features added up to a unique and distinctive presentation. However, these same features almost killed the deal. Carillon commissioned some research to gauge the product's viability in the trade. Bartenders declared that because of its clear bottle, Absolut would disappear on the back bar, as consumers would not *see* it but see *through* it. Then, too, the short neck made it difficult to grab. And "Absolut" didn't sound like a brand name so much as a request for the best, with bartenders visualizing a lowercase *a* at the beginning and an *e* at the end: the bartenders said they'd give the customer Smirnoff. Happily, Al Singer said, "Who needs research?" and kept the momentum going.

The Swedes still had to find a manufacturer to make the bottle. When they presented a finished Plexiglas prototype to PLM + Hammar's Glassworks in

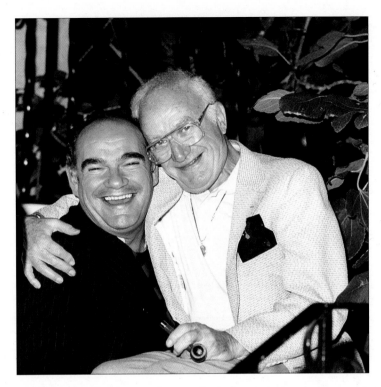

Michel Roux and Al Singer photographed after Singer's retirement.

the little village of Hammar, Sweden, they were told it would be technically impossible to produce. (By now the group was accustomed to instant rejection, but forged ahead anyway.) With the help of a French perfumery, St. Gobain of Brittany, they proved it *could* be produced, and Hammar tried again, this time successfully.

Back in America, Al Singer and his head of sales, Michel Roux, were plotting the launch. Michel Roux had joined Carillon in 1970 as the company's first salesman (prior to that, Carillon's products had been sold exclusively through brokers). He had emigrated from France in 1964 and settled in Houston, Texas, where he had washed dishes at the Rice Hotel—and probably was a damn good dishwasher—before opening a French restaurant of his own. Soon after meeting the sophisticated and apparently well-off liquor salesmen who called on him, Michel gave up the restaurant to peddle Grand Marnier across Texas.

Boston was selected as Absolut's launch market in 1980. However, just as plans were being finalized and a not particularly memorable advertising campaign was being developed, fate intervened: Carillon's ad agency, Martin Landey Arlow, was acquired by the British agency Geers Gross.

5

Lars Lindmark

Curt Nycander

This new ownership was significant not in itself but because Geers Gross had another liquor client, Brown Forman, with such brands as Cella and Bolla wines (two big spenders) and Martell Cognac. In the advertising business, it's the rare client that permits its agency to create advertising for one of its competitors, and it's the clients themselves that decide which companies constitute their competition. Although Landey insists he fought Bob Gross about resigning the smaller Carillon business, he had no choice. Al Singer wasn't happy either, as he let it be known that Carillon's account was up for grabs.

Even before Carillon could invite other ad agencies to pitch their prospective business, at the official start of a competition that would eventually include ninety-four advertising agencies (an incredibly large field even for the masochistic advertising industry), Bill Tragos was hot on the scent.

Tragos was the chief executive of TBWA, an agency he had cofounded in 1970 with three colleagues from Young and Rubicam, where he had been in charge of Y&R's Paris office. A proud Greek-American from St. Louis, Missouri (a fact he will reveal within thirty seconds of meeting anyone), Tragos went to Europe in 1961, at a time when Y&R was rapidly expanding its overseas agencies. There he met Claude Bonnange, a French strategist; Uli Wiesendanger, a Swiss copywriter;

and Paolo Ajroldi, an Italian account manager. Together the four men created an advertising agency that was international by design from its very birth, comprising four different passports, four different advertising disciplines, and a desire to build a sterling creative reputation in every market where it would plant a flag.

By 1977, there were eight TBWA offices in leading European cities, and Tragos was ready to build an agency back in New York and raise his family in America. He bought a creative New York agency named Baron Costello & Fine, and within three years, it had a roster of small quality accounts, many with a European origin or flavor, including Evian water, Eminence underwear, and Ovaltine beverage. Tragos was always on the prowl for more European clients, and at one time or another probably contacted every European company doing business in the States. By 1980, when Carillon needed a new agency, Tragos had already met Michel Roux.

After a friend told him about Carillon and its French salesman, Tragos had phoned to introduce himself. There was a quick rapport between the two men, but no business—at least not yet. Roux made no pretense of his ability to move the account to TBWA, but when Landey resigned the business, before it became "public" in the trade publication *Advertising Age*, he tipped off Tragos that the account was in play.

Bill Tragos and Michel Roux wearing identical shirts and smiles.

Tragos also had Claude Fromm on the case. Claude had been Media Director of Martin Landey Arlow, where he had impressed Carillon's Al Singer with his negotiating prowess and overall media smarts. He had joined TBWA in the same capacity in 1978 and had kept in touch with Singer.

So Bill and Claude visited Al and Michel in October to begin the "official" mating dance. The grand prize was Grand Marnier, a $3 million brand assignment; Absolut, at $800 thousand, was the dessert. "Sure, you guys can take a whack at this, too!" Al generously declared.

TBWA took nothing for granted. Tragos asked Landey out to lunch to scope out the client. He flew to Los Angeles, where Singer had an office and spent most of his time, and sent Fromm to Paris to surprise Singer at the airport, on his way to a Grand Marnier meeting. Beyond serving as a greeter at Orly, Fromm was to help present TBWA's Paris office and, more important, impress Singer with the agency's determination and enthusiasm. Tragos also sought out the best and most experienced people in liquor sales promotion, an acknowledged weakness at Carillon. He sent Carillon highlights of the agency's merchandising ideas for

Würzburger beer, another TBWA client. Tragos did his homework. He was relentless. And he kept in touch with Michel.

TBWA made it through the first round, the credentials. This is the meeting in which the agency describes its capabilities in the prospective client's business, presents successful case histories of clients with similar marketing or advertising problems, and generally tries to establish good chemistry and show that it's staffed by likable, talented, and motivated people. The long list of ninety-four agencies was now trimmed down to a very manageable shortlist of six.

Next would come the presentation of the "creative"—the actual ad campaigns. The Grand Marnier creative was set: TBWA would recommend continuing the "Time for Grand Marnier" campaign but would show additional ad executions to position the romantic liqueur as suitable for drinking at times other than the customary after-dinner/into-the-evening period.

Absolut was a different situation. Here, the agency needed a brand new campaign.

ABSOLUT

ABSOLUT

ABSOLUT

ABSOLUT

ABSOLUT

ABSOLUT PRODUCT

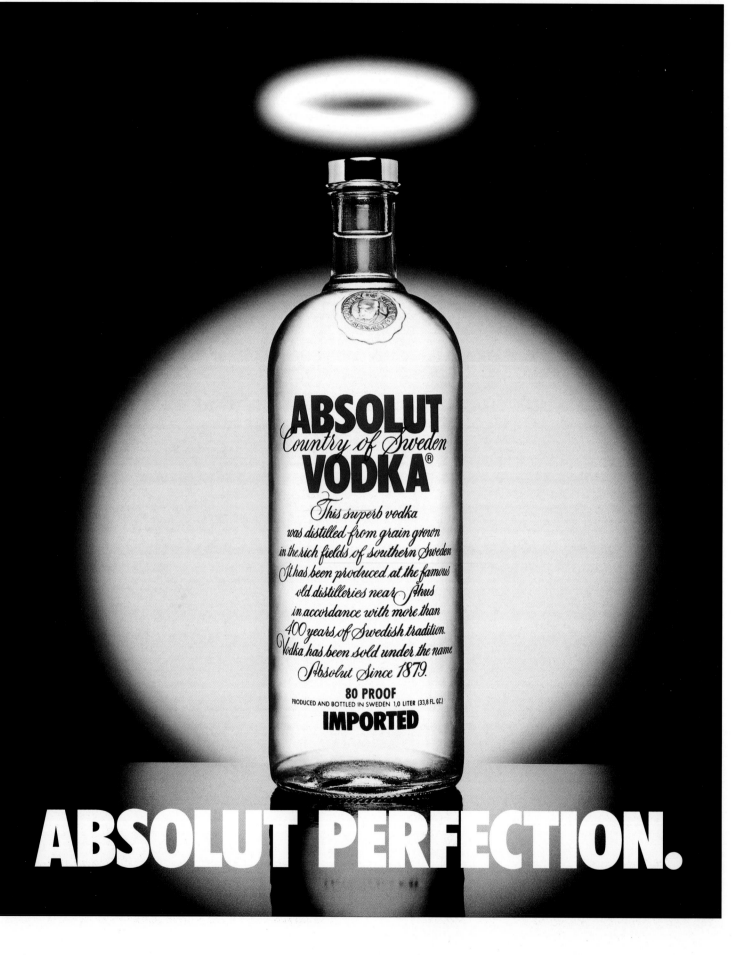

ABSOLUT PRODUCT.

Faced with the challenge of creating a great campaign for Absolut, Bill Tragos and TBWA's president, Dick Costello, encouraged the creative director, Carol Ann Fine, to give all the agency's creative teams the assignment. (It isn't unusual, particularly in a small agency, to call "All hands on deck!" when a juicy account beckons.) One such team seemed especially well suited to the task: they were talented, they were eager, and they had some free time. Geoff Hayes, a South African, and Graham Turner, from Yorkshire, England, had arrived at TBWA New York as an art director/writer team in spring 1980. They had worked together in London, at Euro, a small but hot agency. Who better to entrust with a vodka from Sweden?

Hayes and Turner examined the two Absolut ads produced by Martin Landey Arlow (which had had a blessedly short and local run). Hayes knew immediately what he wanted to do: go head-to-head against Stolichnaya. Even though Absolut lacked the Russian credentials, it could be positioned, he thought, as being equally prestigious. Hayes and Turner understood that the concept of "Sweden" often draws a blank. When there *is* some recognition, it's usually dominated by tall blondes, fields of snow, and maybe a Volvo. Otherwise, it's simply confused with the other "Sw" country, Switzerland. Neither Hayes nor Turner wanted to take the "Swedish heritage" route, but both felt it would probably be a necessary part of the mix at the final presentation.

Somehow they had to establish that Absolut was the best vodka on the market, without actually saying that in an ad. That kind of advertising claim—"This is the best [whatever] that money can buy"—is both boring and unpersuasive. (In fact, you stand a better chance of convincing consumers that you really have a great product if you display a little modesty and let them discover it for themselves. Consumers are continually assaulted by advertisers' superiority claims, and are thus not unreasonably skeptical.) Although Absolut was a superior product and among the most expensive vodkas, in an undistinguished category that wasn't in itself necessarily interesting.

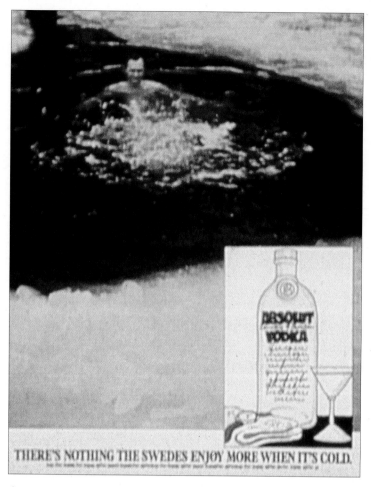

The "Swedish heritage" backup campaign.

The following morning, Hayes showed the sketch to his partner. Turner liked it, but he looked at the long headline and asked, "Why not just say 'Absolut Perfection'?" Together they turned out a few more ads, and soon a format emerged: in just two words (the first one always being *Absolut*), the ad would say something complimentary or flattering about either the product itself or the person drinking it, and, importantly, add a dollop of humor so the "We're the best" claim wouldn't be quite so boring or pretentious. Absolut would be a product that didn't take itself too seriously. Absolut would be a product that could laugh at itself.

They showed their work to Carol Ann Fine and then to Bill Tragos. In his typical less-is-more fashion, Tragos said, "Great. Do fifty of them!" Instantly, he understood this was a campaign that he could demonstrate to the client had "legs," a campaign that could be fed by a limitless number of ideas for years to come.

Prior to the official presentation the following week to Al Singer, Bill Tragos presented and presold the campaign, privately, to Michel Roux. It was a hit both in private and in public: TBWA was awarded the account the next day. Still, a chuckling Michel recalled, "Tragos sent me caviar only *after* he won the business."

Hayes and Turner's first concrete idea was to poke fun at the Swedish heritage and landscape. They created an ad to run over the headline "There's Nothing the Swedes Enjoy More When It's Cold," showing a typical Scandinavian ice bather as well as a small photo of the Absolut bottle. Though mildly amusing, it was at best a backup campaign, and they both knew it. While it might even be shown at the final presentation, there was much more work to be done.

Geoff Hayes frequently brought his work home with him and would scribble on his layout pad while watching television. He lived (and lives) quite simply; his home, says Turner, is "an apartment with a bed and a mug." One November evening in 1980, Hayes was doodling huge Absolut bottles on a pad as he watched "The Honeymooners." Atop one bottle, he drew a halo much like an angel's. Then he jotted down a headline: "Absolut. It's the perfect vodka." Hayes liked it, especially the little joke. He knew the halo would reduce some of the pompousness of the headline.

The campaign's origin took a left turn when *Art Direction* magazine interviewed Geoff Hayes. Although Hayes explained that he had been watching "The Honeymooners" when the concept came to him, they re-created his brainstorm in the shower. Ah, advertising.

Producing the first few ads proved to be a big headache. A well-known studio photographer (whose identity we shall spare) was hired to shoot the first three ads. But when Hayes arrived at the studio to discuss how he wanted the first shot to look, he was amazed to find that the photographer was already finished. Being new to the U.S., and directing his first shoot, Hayes thought, well, maybe this is how it's done here. The bottles were shot like a cartoon. They lacked the now-familiar light, or halo, shining behind the bottle. They were flat. And they were so white that they appeared to be filled with milk.

Returning to the office with the Polaroid test shots, Hayes knew he had a big problem. Bill Tragos took one look and went apoplectic. "This is all wrong. It stinks. Fix it!" Not an auspicious start.

Since the photographer declined to reshoot, Hayes had to find someone new. Combing through an advertising-photography directory, he came across the work of an unknown named Steve Bronstein. To Hayes, every piece of Bronstein's sample portfolio looked right.

Bronstein had heard of Absolut's reputation as a tough bottle to light properly. "The bottle is like a big lens," he explains. "Anything put behind it is distorted and reversed." Rather than shoot the bottle in front of a black background, he chose to place a sheet of matte Plexiglas behind it, and illuminate it with a soft glow. This solution worked to everyone's satisfaction: the bottle was now perfectly round and clear. Bronstein would become an integral part of the creative team for every studio shot (as he still is today, fifteen years later).

The first two years weren't easy. Al Singer found the campaign too cartoony, too cutesy; though sales were increasing, some of that increase was simply filling the pipeline. Michel Roux helped us buy time with Singer until the campaign started to get some good industry word-of-mouth, but according to Tragos, the client was still expressing doubts as late as 1983.

A few years ago, we started to call this whole group of ads "Product ads" simply because they still feature Absolut Vodka inside the actual glass bottle. Not only do we continue to run these early ads in our magazine schedule (they're still relevant to new and current Absolut consumers), but we also produce new variations that look like "old" ads.

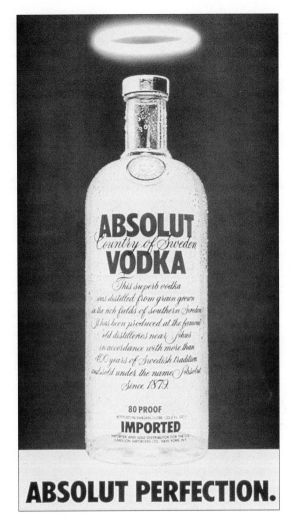

The "milk bottle" shot.

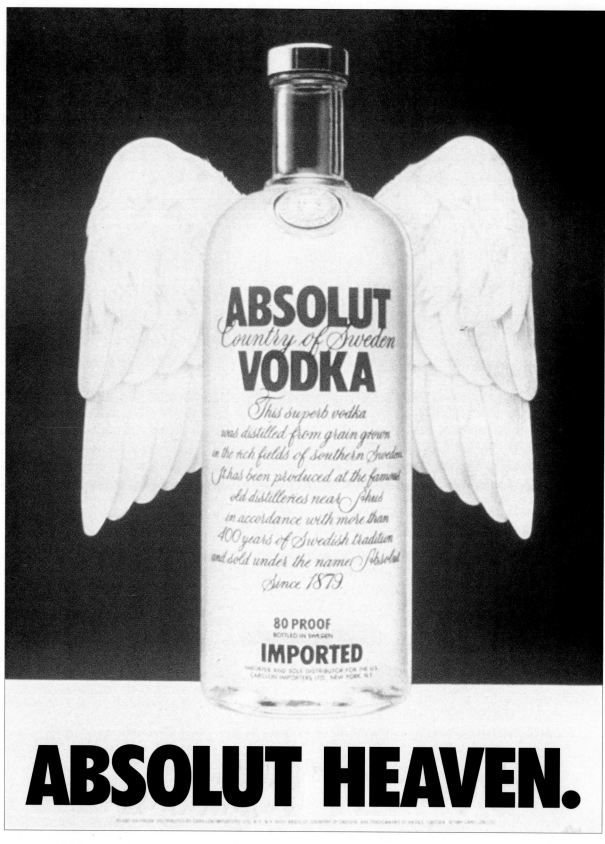

ABSOLUT HEAVEN.

ABSOLUT HEAVEN. This may actually have been the first ad to run; no one is quite certain anymore. What everyone does remember is that in order to accommodate the small budget, space was purchased in the *New York Times* on a standby basis, meaning that the ad could run anytime, anywhere. The staff of the *Times*, thinking they were doing the client a favor, ran the ad opposite the obituaries. The next day, Al Singer voiced his suspicion to Tragos that TBWA didn't know what it was doing.

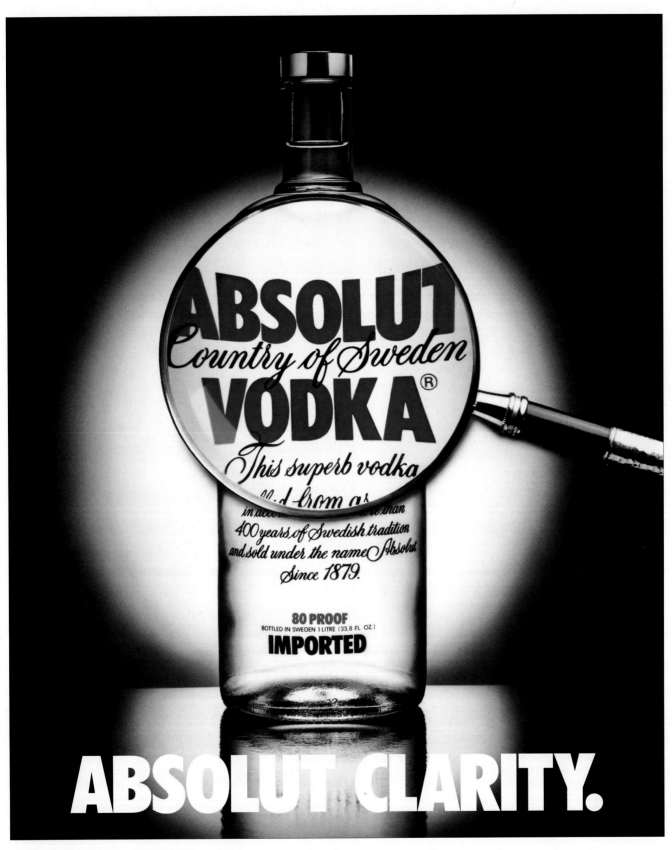

ABSOLUT CLARITY. At a time when the Soviet Union was particularly unpopular in the United States due to its invasion of Afghanistan and, later, the downing of a Korean jetliner, this ad subtly emphasized the fact that Absolut was made in Sweden, not in Russia.

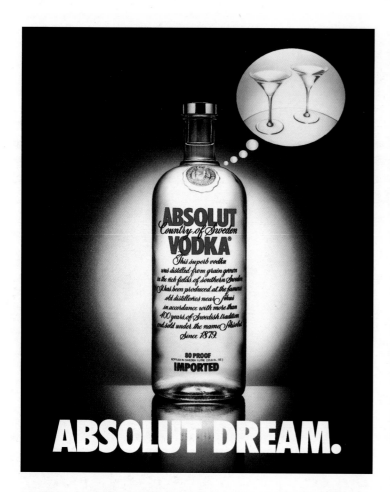

ABSOLUT DREAM.

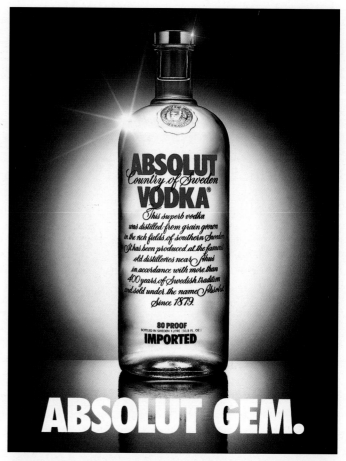

ABSOLUT GEM.

ABSOLUT DREAM. Early on, we understood that we shouldn't dictate to consumers how to drink Absolut. We wouldn't be preachy: there is no right or wrong way to enjoy the brand. But this ad gave the Absolut bottle an imagination, and we knew a screwdriver wouldn't have the same effect as a martini.

ABSOLUT GEM. Although not the most exciting ad from the early days, this one helped establish Absolut's best-of-category position.

ABSOLUTLY. It didn't take Hayes and Turner long to break one of the campaign's basic rules: the two-word headline. Looking back, neither thinks ABSOLUTLY merited the exception. The ad was so corny you could smell the livestock in the studio.

ABSOLUT ATTRACTION. The first great Absolut ad in both concept and execution. The bending martini glass was actually several glasses; back in 1983, this was considered high-tech. This is one of Geoff Hayes's favorites because it doesn't employ any stuffy status symbols.

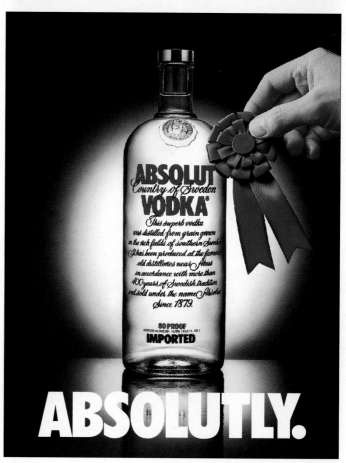

ABSOLUTLY.

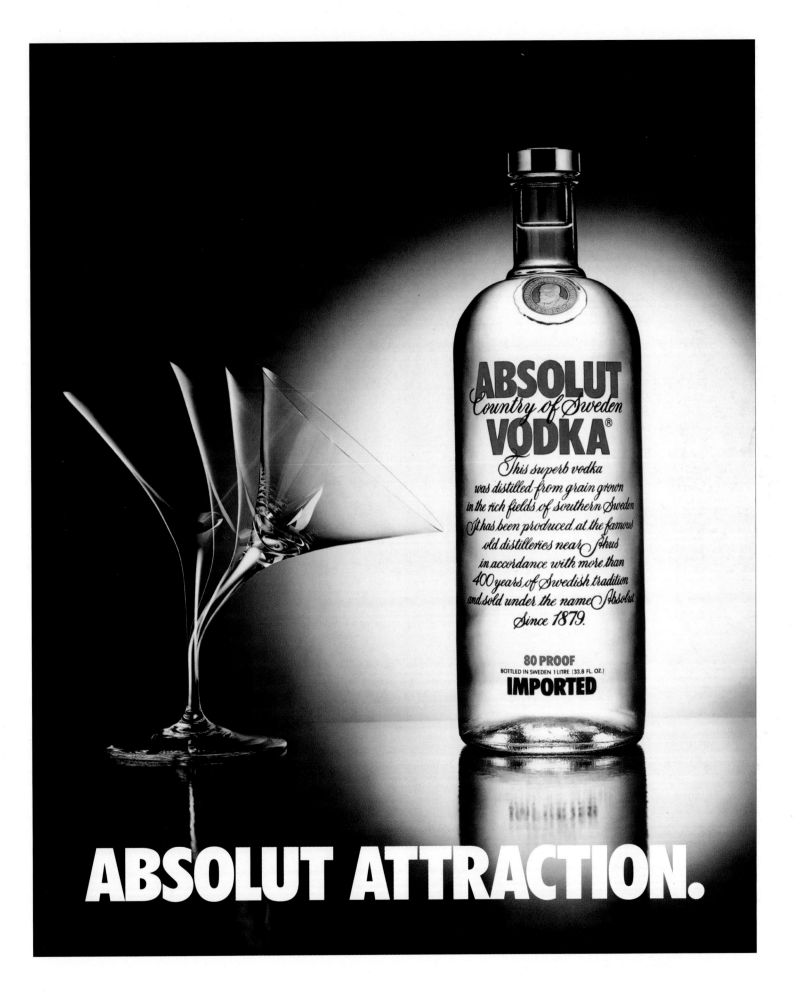

ABSOLUT ATTRACTION.

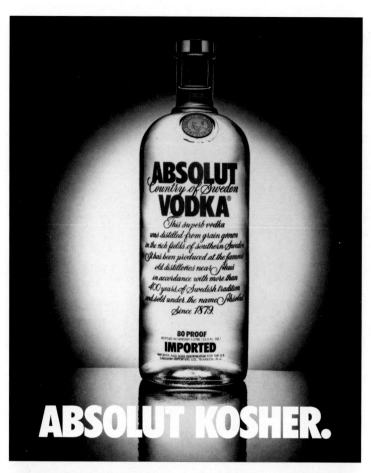

ABSOLUT KOSHER.

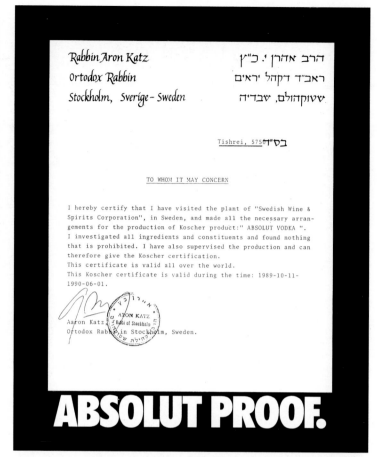

ABSOLUT PROOF.

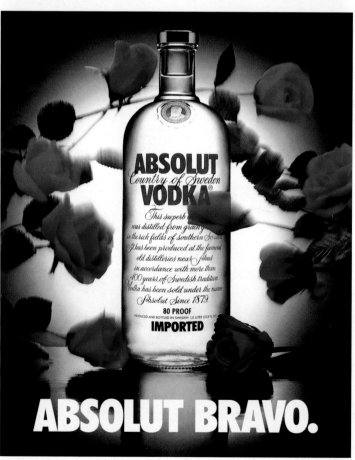

ABSOLUT BRAVO.

ABSOLUT KOSHER/ABSOLUT PROOF. Not surprisingly, Absolut is a favorite bar offering at weddings, bar mitzvahs, and other parties. A few years ago, some caterers asked if Absolut Vodka was kosher, a requirement at some affairs. Having ascertained that there were no unkosher ingredients in Absolut, and that the production process conformed to kosher standards, we sought the help of Rabbi Aron Katz of Stockholm to reassure the caterers.

ABSOLUT BRAVO. This was the first ad designed for a particular magazine: the theater program, *Playbill*. (We wanted to get into the reader's head, wherever he or she was at that very moment.) It served as a salute not just to Absolut Vodka but to the actual performance taking place. Geoff Hayes remembers that someone wrote in to complain of "finding" a penis in one of the roses (there must be one reader out there whose mission in life is to find the penis in every advertising campaign).

ABSOLUT TREASURE. The campaign took a subtle but definite turn with this ad. Although all of the prior ads had used four-color process printing, they were predominantly black, blue, and white. The introduction of "Treasure" was like the advent of color TV. This ad also demonstrated great attention to detail—so much so that the fish really look alive. However, one sharp reader pointed out that this aquarium comprised an impossible ensemble, as these particular fish would kill each other given the chance.

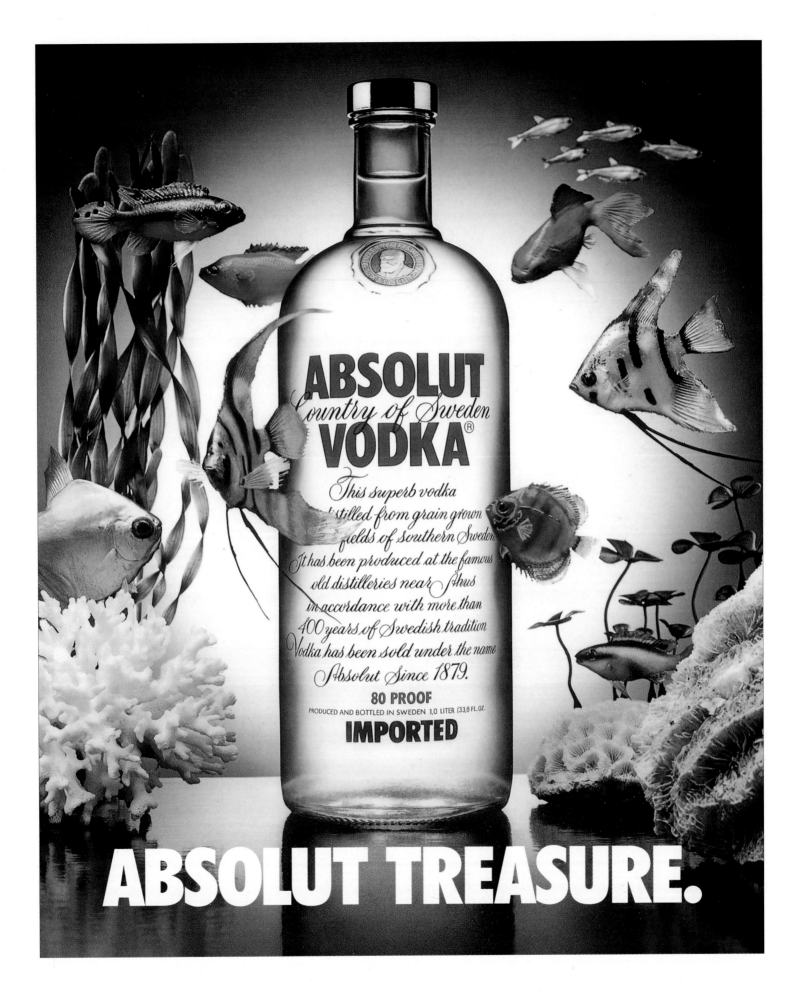

ABSOLUT TREASURE.

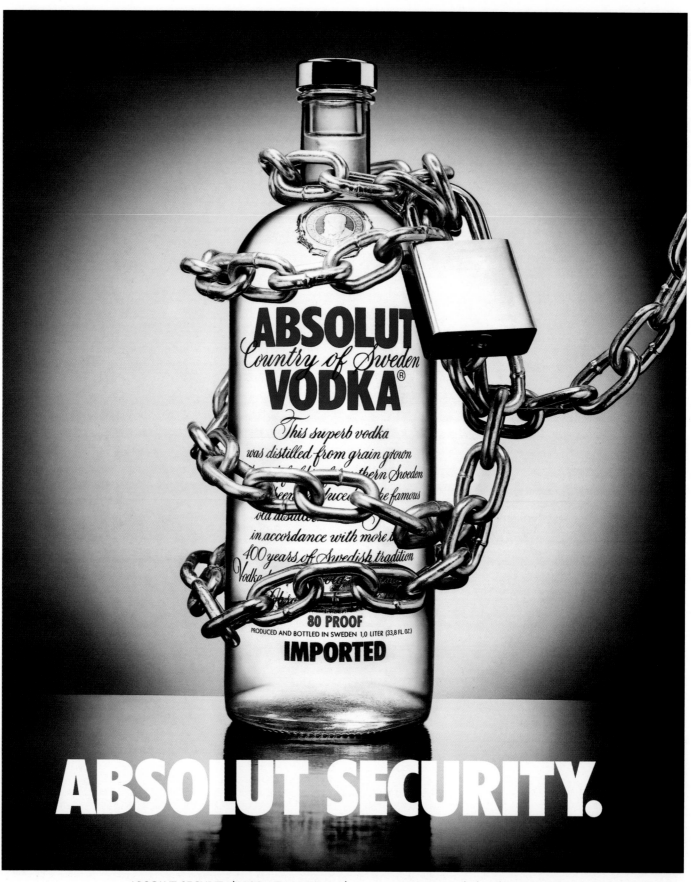

ABSOLUT SECURITY/ABSOLUT LARCENY. These two consecutive right-hand pages made it abundantly clear that your neighbor coveted your bottle of Absolut so much that you could never fully protect it.

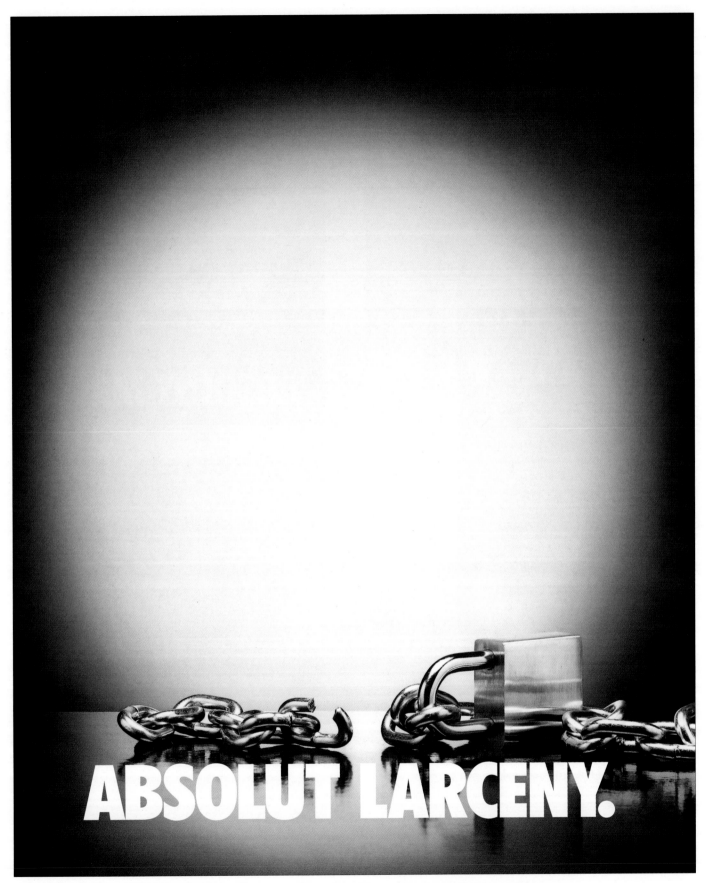

In time, Michel Roux would agree that the product was sufficiently well known that the ABSOLUT LARCENY page could appear on its own. We convinced him—and we believed it, too—that the reader would visualize the absent bottle anyway.

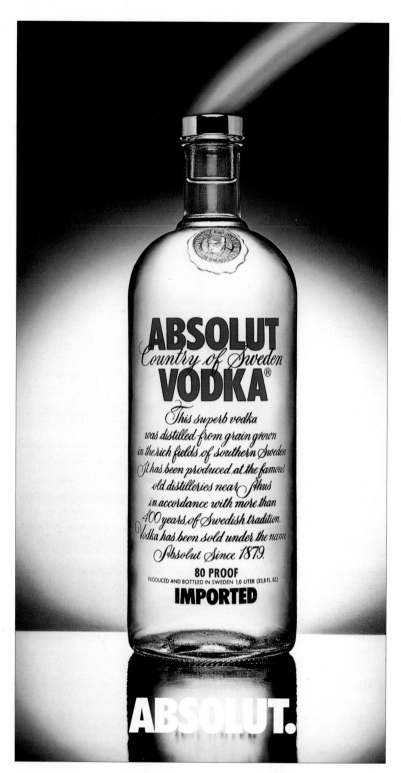

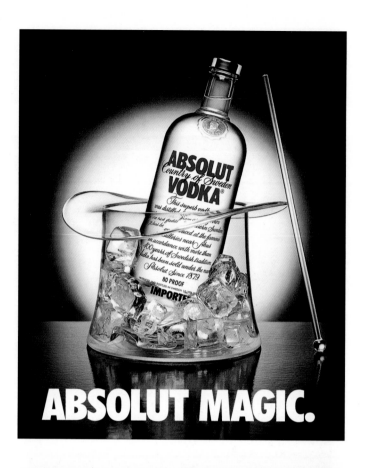

ABSOLUT MAGIC.

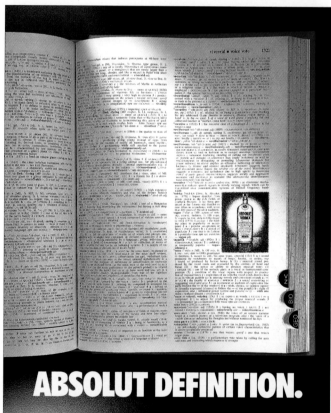

ABSOLUT DEFINITION.

ABSOLUT PHENOMENON. This is the campaign's first ad that creatively played with the placement within a magazine. PHENOMENON runs on the outer two-thirds of two facing pages; the effect is that the rainbow "leaps" from one page to the next.

ABSOLUT MAGIC. This ad is noteworthy as an early example of the participatory nature of the campaign, ideas for which have come from everywhere. It was created by Cara McEvoy, the twelve-year-old daughter of Dick McEvoy, Carillon's head of sales and marketing.

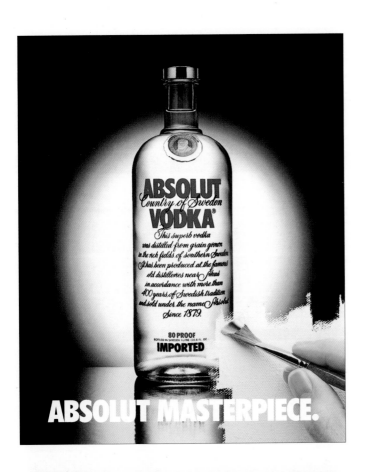

ABSOLUT MASTERPIECE.

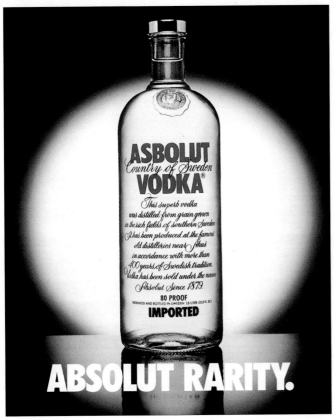

ABSOLUT RARITY.

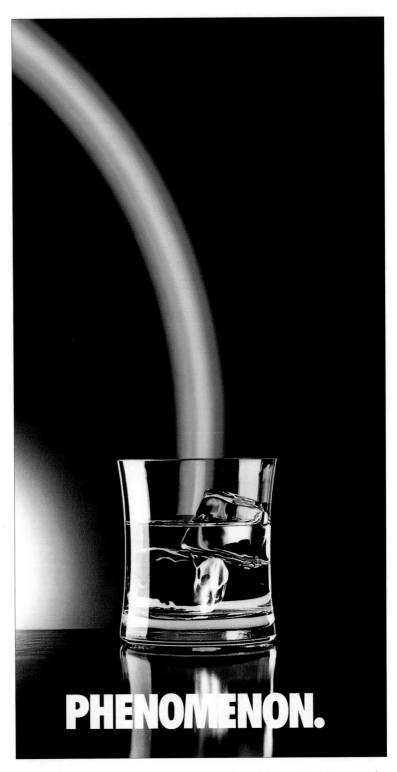

PHENOMENON.

ABSOLUT DEFINITION. Several years ago, the spirits world woke up to discover that Absolut was a big business and imported vodka a hot category. In the space of eighteen months, roughly a dozen new "imported" vodkas were introduced. (One of these, "Icy from Iceland," turned out actually to be Icy from Kansas.) To confirm Absolut's roots, TBWA created ABSOLUT DEFINITION.

ABSOLUT RARITY. The ads often require the reader to take a few seconds to figure out what's happening. ABSOLUT RARITY features a significant typo, but people couldn't find it and so didn't get it. The ad survived neither the secretary test nor the mother-in-law test, so we pulled it from the rotation.

ELLEN COLTON'S DINNER PARTY WAS THE opening of the season. Her first dinner this particular year was to officially introduce Maggie, though she was already known to many of the ladies who were wearing her Miss MerMaid fashions. Among the guests was Mortimer Sheldon, a leather manufacturer from Massachusetts. He was a childless widower, his wife having died five years earlier. When his eyes first lit on Maggie, his heart beat wildly; he had found the perfect mate. Her diminutive stature, rose-gold hair and delicate features represented the child he never had; her petite, shapely body–a pocket-Venus, he called her–made her a desirable second wife.

Mortimer had little opportunity to get close to her on that first occasion as she was surrounded most of the evening by others equally eager to welcome her. He left early, his mind a whirl with plans to make her his very own.

THE FOLLOWING MORNING.
Maggie received a huge bouquet of roses tied with a green satin ribbon. A card was pinned to the ribbon with a diamond brooch: "Please accept this as a token of my deepest admiration," she read, astonished. The card was signed "Mortimer Sheldon" and as hard as she tried she could not remember him.

Four o clock was the accepted time for callers and Ellen's home became the only place to be at teatime(although there were stronger libations for those who wanted them). Mortimer was the first to call that day, carrying a tremendous bouquet. When he was announced, Maggie came forward to meet him, took the flowers and asked the maid to put them in water. As she extended her hand he held it too long and kissed it greedily. Inwardly she recoiled from this unprepossessing old man. He was approaching fifty and the passing years and his unstinting devotion to business had not been kind to him. His eyes had puffy, dark bags under them, his whole being had sagged and his mouth on her hand felt loose-lipped and wet. Although he did not resemble the man in the least, a picture of Dr. Henderson flashed in Maggie's mind's eye. A few years ago, Maggie would have run from him; but now she called on her newly acquired sophistication to handle the situation.

"Mr. Sheldon,"(she withdrew her hand wishing she could wipe it off) "thank you for the flowers, but I cannot accept the gift you attached to them. She reached into a pocket of her dress and held out the diamond pin.

He pushed her hand away. "My dear, this is just a token of my affection. There is much more I will give you when we get to know each other better."

"Again I thank you," Maggie said

firmly, "but believe me when I say I will not accept gifts of money or anything of value. Flowers if you insist, but without I prefer not to recieve anything."

Mortimer, delighted by her maidenly reserve, said, "I am very wealthy my dear, and it gives me pleasure to lay my treasures at your feet."

Exasperated, Maggie was about to answer when another caller was announced. She thrust the brooch into his hand and with relief moved away to greet the newcomer. She managed to dodge Mortimer's attentions for the rest of the afternoon and was satisfied she had discouraged his insistence.

She had not. Mortimer was obsessed with her extreme youth and enchanting prettiness and came every after noon, always with flowers, and a card he had decreed. But as long as it took to bring her to accept his name, later he caught her as she took to greet him to receive a kiss, and a young law student who was also in attendance. Maggie but secretly by her. Then her Maggie! Mortimre had madly really jerked to take her on the terrace. "I love you, Maggie. I want you for my wife." May had his hands on her shoulder to draw her close. "Stop it"! He reached to draw her close. She slobbering wet kiss on her face. With a free right hand she wrenched out of his grasp and hand back and slapped him with as much force as she could muster. John who had witnessed the whole thing called for John and came running ostensibly to Maggie's aid but it wasn't necessary. Mortimer was rubbing his cheek, stunned at her unexpected rebuff. John first guiding Mortimer to the door was angry, but he also felt sorry for the older man. What are you to do with you, Morty old man. What is wrong Maggie alone!" he said. "I would rather leave with her than with him."

I LOVE HER
Mortimer whined "I can do so much for her" "can you understand that's " "doesn't want this? She has worked to become we think crowned to be someone we think crowned

"She's only a child! She doesn't know what she want. I can show her the world," Mortimer protested as a

John took a deep breath along time "We've been friends for a long time but Morty and I'm sorry to say Morty busy must ask you not to come here again.

You're being cruel but I must be patient. You will see she'll come to me one day Mortimer baby old

And no more gifts. Not even flowers? " so this

John had him out of the huge back door time and said he had done him a favor. Not even flowers stay away f

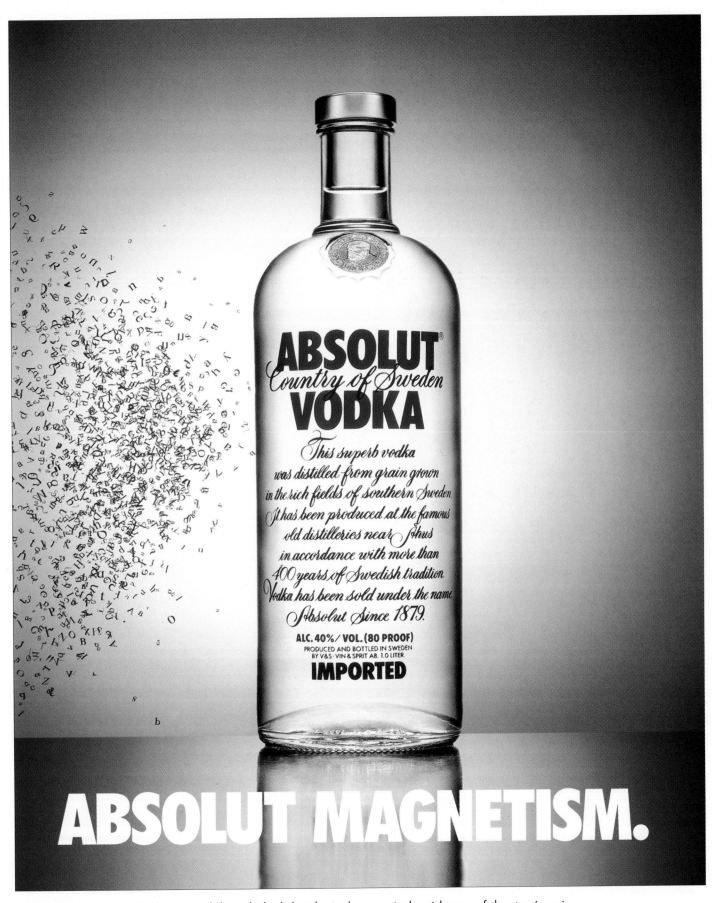

Alix Botwin and David Oakley created this ad; the little joke in the copy is the nickname of the story's main character: Maggie (sorry).

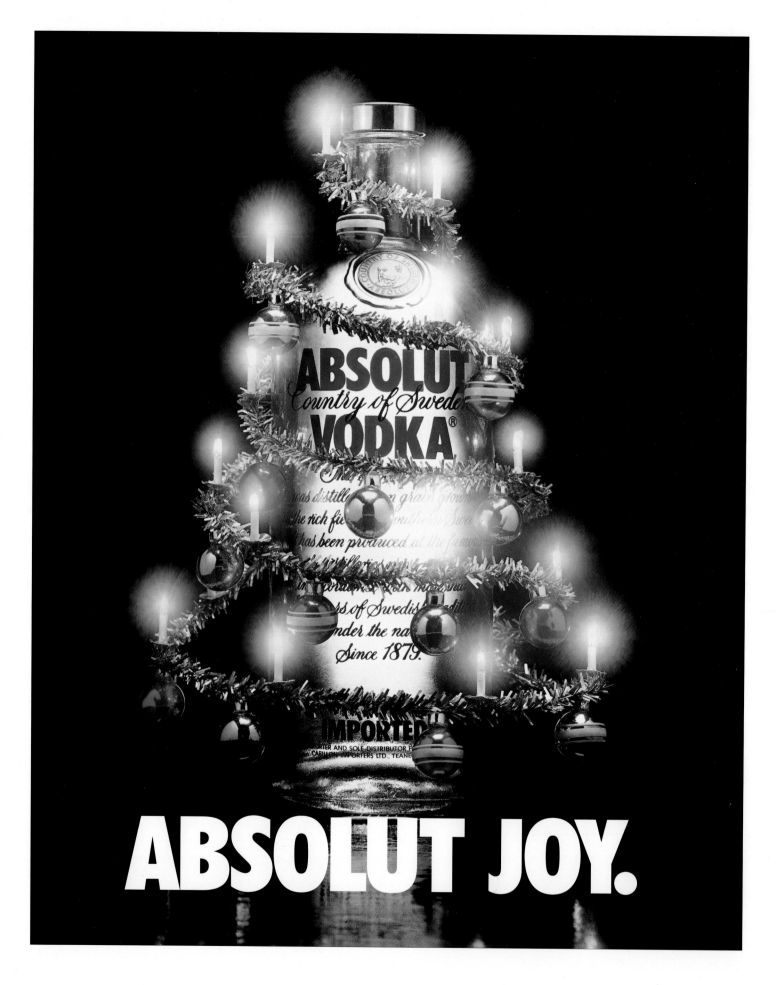

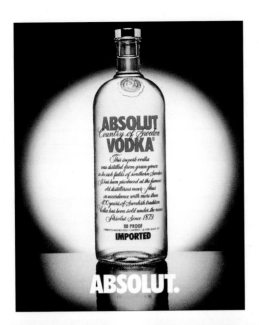

ABSOLUT.

ABSOLUT DÉJÀ VU.

ABSOLUT OPTIMIST.

ABSOLUT PESSIMIST.

ABSOLUT GENEROSITY.

ABSOLUT ANTICIPATION.

ABSOLUT PROFILE.

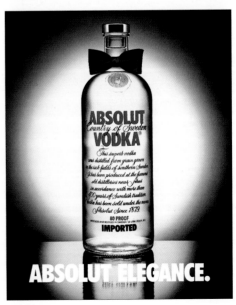

ABSOLUT ELEGANCE.

ABSOLUT

ABSOLUT

ABSOLUT

ABSOLUT

ABSOLUT

ABSOLUT
OBJECTS

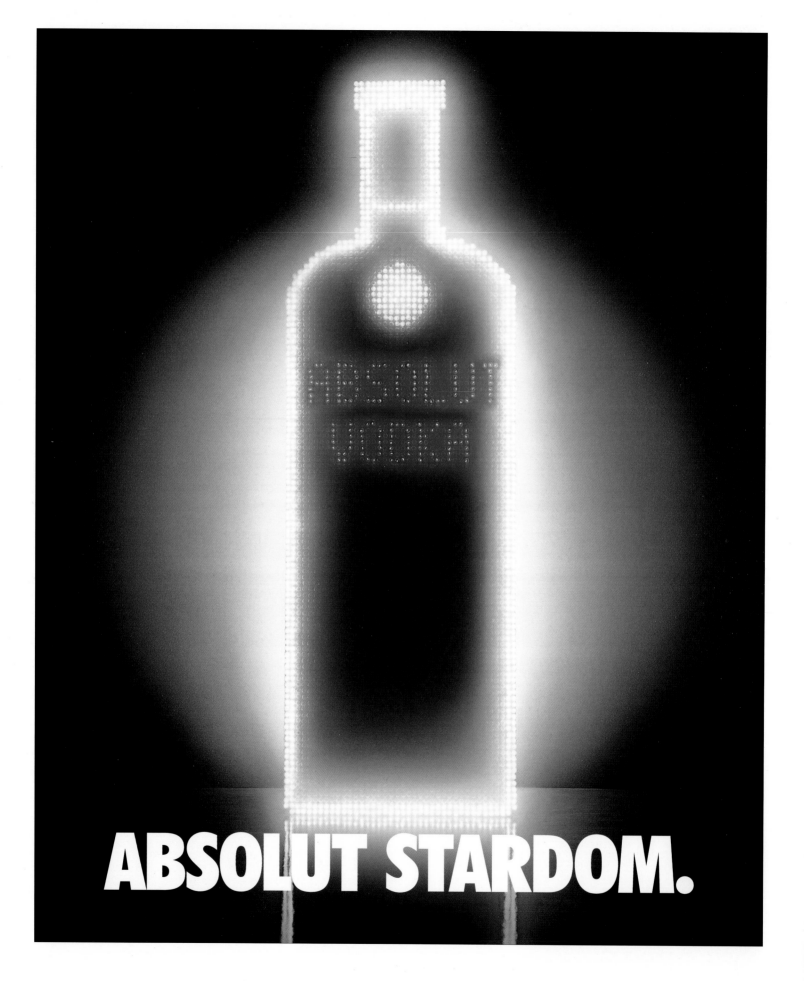

ABSOLUT STARDOM.

ABSOLUT OBJECTS.

Over the first four years of the Absolut Vodka campaign, Geoff Hayes and Graham Turner created nearly every ad that ran. The campaign had earned a moderate amount of acclaim within the ad industry for its stylishness, and by the end of 1984, the brand was also enjoying considerable success in the liquor industry: it sold 444,000 cases in the United States that year and was closing in on Stolichnaya's lead in the imported-vodka market.

But Hayes and Turner were by now going a little stir-crazy. They wanted to open up the campaign some, give it more edge, more bite, more . . . whatever. Turner was also concerned that the campaign would soon run out of "good words"—that is, all those superpositive adjectives and nouns (*perfection, clarity, magic, treasure*) that modified ABSOLUT, or were modified by it. Although he agreed with Hayes that this was an "art director's campaign" (meaning that headlines and copy played a secondary role to the visual, or picture, typically created by the art director), he felt that the words were still important, too, even if nine out of ten times the headline was written to a predetermined visual, not vice versa. In their wish to explore new avenues, however, Turner and Hayes were reined in by Carillon, which was (now) understandably quite pleased at the way things were going.

Ready for other challenges, Hayes and Turner moved back to London to continue as a team at J. Walter Thompson. (Hayes ended up returning to New York within a year.) But before they left, they developed an ad that would open the campaign door a crack—just wide enough to change everything.

ABSOLUT STARDOM is a little-known and underappreciated ad. In depicting an Absolut bottle as a Broadway marquee, it became the first Absolut ad where the Absolut bottle is not made from glass but is actually represented by something else, another object. Because the size and shape of the object resemble the size and shape of the bottle, the object itself becomes an Absolut bottle. And that is the whole trick.

People understood the concept right away (or else, in the case of STARDOM, they simply didn't notice the subtle substitution).

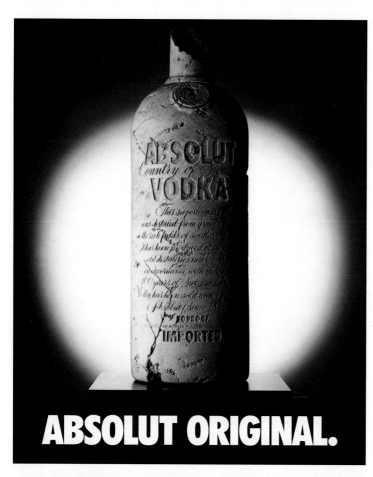

ABSOLUT ORIGINAL. In 1987, I took my family to Iraq to participate in an archeological dig, an interest of mine. What should we have found there but a marble relic from 2500 B.C.? It became the inspiration for Tom McManus and Dave Warren's ABSOLUT ORIGINAL.

Because they had consumed several years' worth of glass bottles as a lengthy appetizer, the Absolut bottle image was firmly established in their minds before we took it away.

Despite being a door-opener, this ad was a production nightmare. The nearly five thousand tiny lightbulbs used to create the marquee were especially ornery, and so much power was required to light them all at once that the current in the entire building was affected. Photographer Steve Bronstein couldn't shoot this ad fast enough before his neighbors began to complain.

We also tried to be very careful and conscientious about what sort of entities could become Absolut bottles: they had to possess or reflect either a high value, such as gold, or an upscale activity, such as skiing or golf. It may not have been obvious to the reader, but we perennially strove to build upon Absolut's premium image.

This new freedom to transform the Absolut bottle into virtually any object could all too easily have sent us hurtling down a path leading to a version of that old childhood game "Animal, Vegetable, or Mineral." That we controlled some of our worst impulses in bottle transformation was thanks largely to Arnie Arlow, who arrived at TBWA in late 1983 as Co–Creative Director. Arnie had just taken a year off—or enjoyed a slice of chocolate cake, as he put it—following an acrimonious split from his partner Martin Landey. One slice of cake was enough for him, though, and he was eager to return to the ad business.

Although Arnie would personally create only a few Absolut ads in his ten-plus years at TBWA, he would have a considerable influence on the campaign. He was the gatekeeper, creating a fertile environment where good work could grow into great work, where writers and art directors could be egged on to improve their ideas. This is exactly what a creative director is supposed to do. I saw, on numerous occasions, Arnie's positive impact on the creative teams' ideas; above all, he was a tastemaker with good taste. And he became a fast and enduring friend to Michel Roux.

For some reason, as hard as I tried, I could never convince Arnie, Michel, or Vin & Sprit's Curt Nycander to use a salami-shaped Absolut bottle for ABSOLUT NAPLES (Italy, that is). Good taste prevailed.

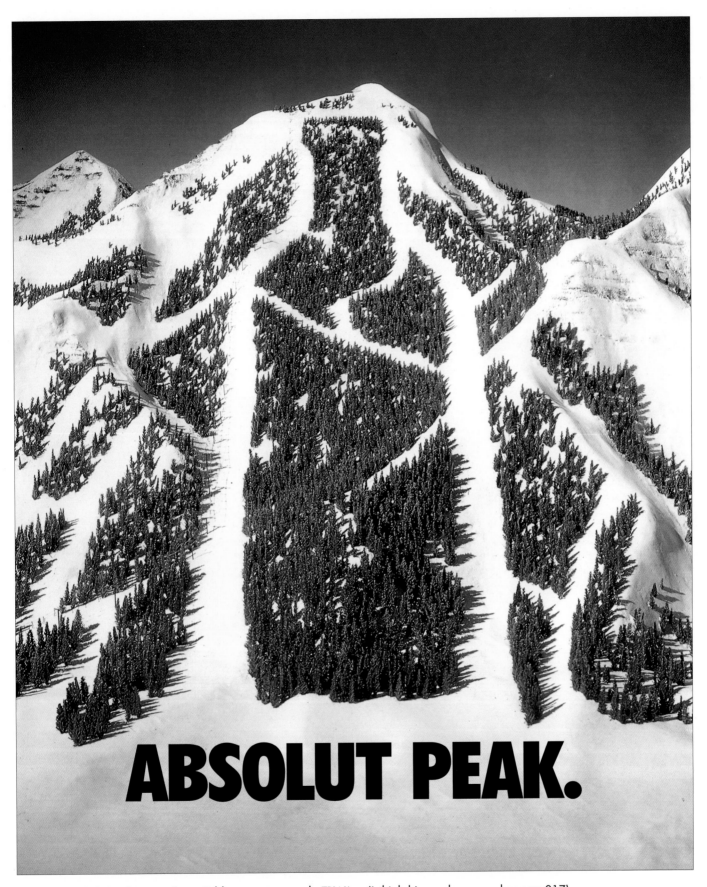

ABSOLUT PEAK. Art Director Steve Feldman, a very early TBWAer (I think his employee number was 017), created something like a dozen ads over the years. Plus, he's savvy: knowing that Michel Roux was an accomplished skier made this a relatively easy sale.

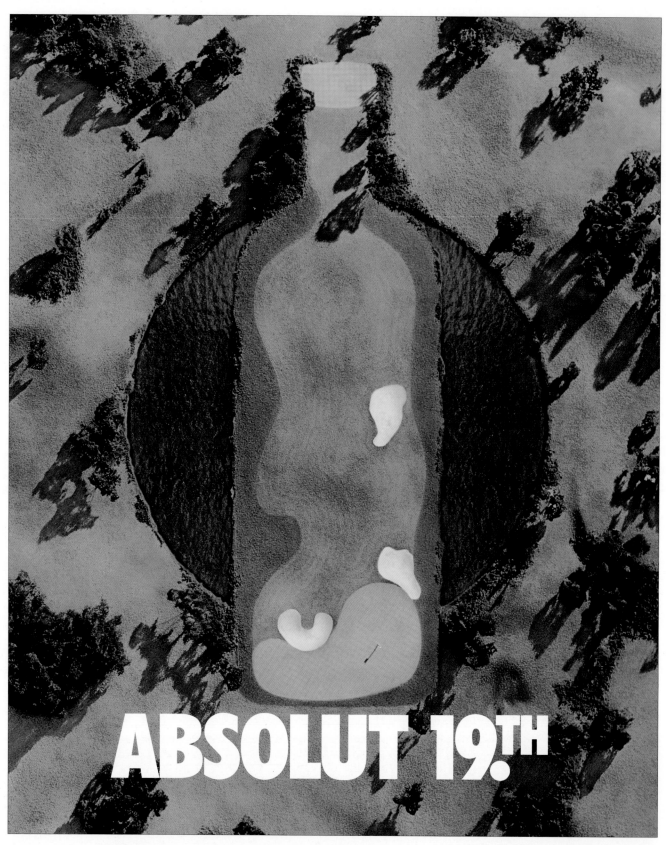

ABSOLUT 19TH

ABSOLUT 19TH. Michel Roux would be the first to tell you that he isn't a sports fan. (I once took him and his son Max to a New York Mets baseball game, and he spent nearly the entire time reading *Les Miserables*—in French, of course. Still, he must have *some* kind of baseball soul: he ate six hot dogs.) But we convinced him, rightly, that golf was very upscale, that our customers were playing it, and that ABSOLUT 19TH was exactly the place to wind down after a day on the links.

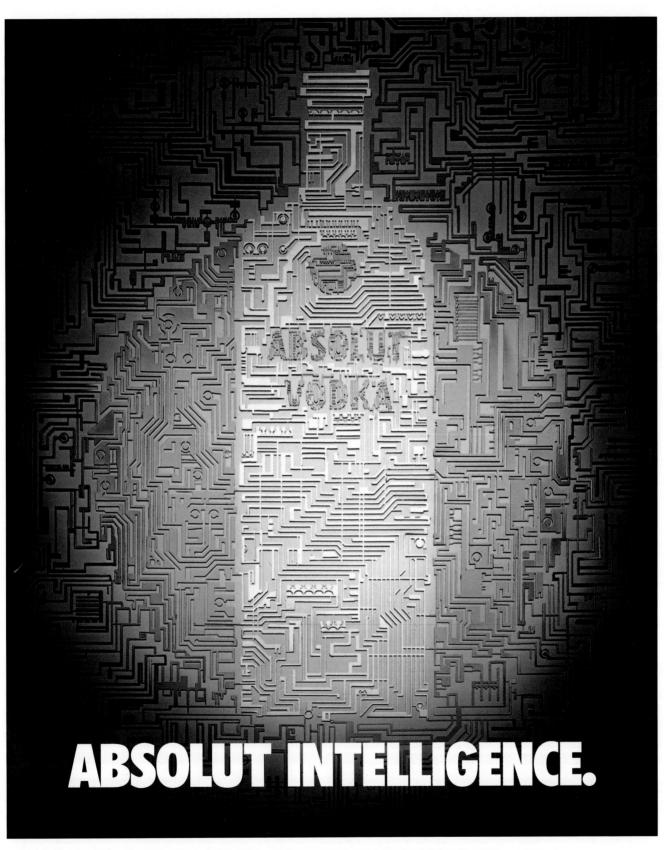

ABSOLUT INTELLIGENCE.

ABSOLUT INTELLIGENCE. Absolut's first visit to Silicon Valley seems almost quaint today, but in 1989, seven computer generations ago, being an integral part of a computer chip was, well, leading-edge.

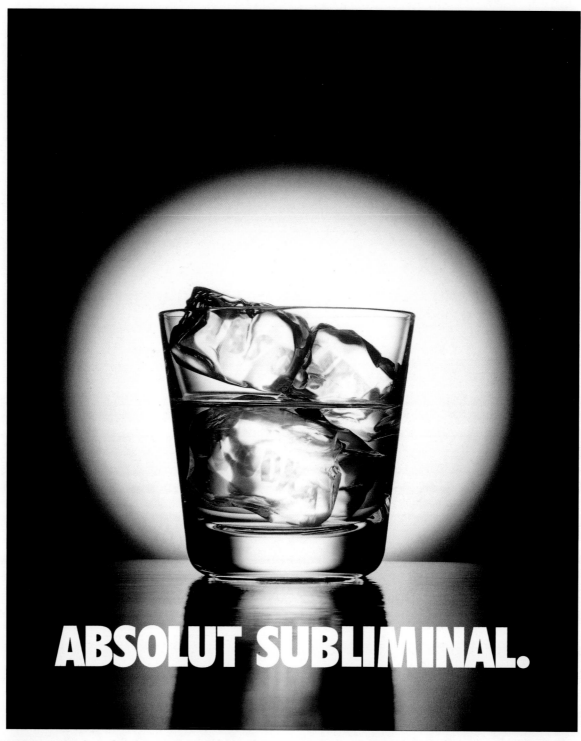

ABSOLUT SUBLIMINAL.

ABSOLUT SUBLIMINAL. A number of authors and psychologists have perpetuated a popular myth about American advertising, claiming certain ads contain hidden or secret images, usually sexual, that except under very close scrutiny are revealed only to the unconscious self. They call this subliminal advertising. (Personally, I find the idea ridiculous, since advertisers must devote all their energy to getting the *conscious* elements just right.) The team of Tom McManus and Dave Warren created ABSOLUT SUBLIMINAL to poke fun at this myth: if you examine the ice cubes carefully, you'll see ABSOLUT VODKA spelled out.

ABSOLUT TRUTH. At one time, we actually considered doing a law-and-order series. When it debuted in 1995, during the O. J. Simpson trial, the ad received some buzz. (And to think, Graham Turner thought we were running out of "big" words ten years ago!)

ABSOLUT EVIDENCE. When we first presented the "thumbprint" ad, the bottle and the print were a lot larger. Once in production, we shrunk it, in order to increase the challenge for the reader. Michel, a big believer in man-in-the-street research, asked his barber if he understood the ad. He didn't. So, Michel was ticked off at us. I learned a lesson: the next time I got to the barber first.

ABSOLUT PASSION.

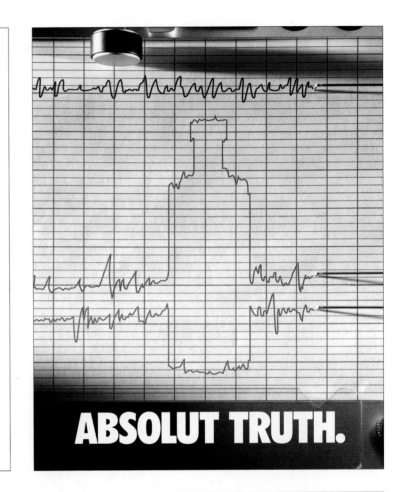

ABSOLUT TRUTH.

ABSOLUTTUJOƧ8A.

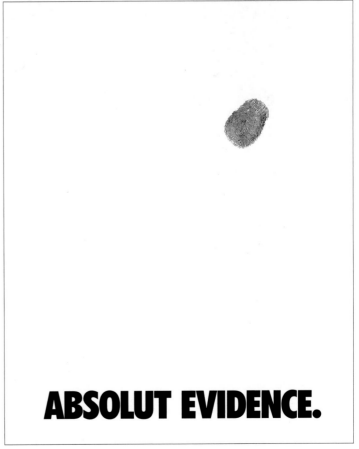

ABSOLUT EVIDENCE.

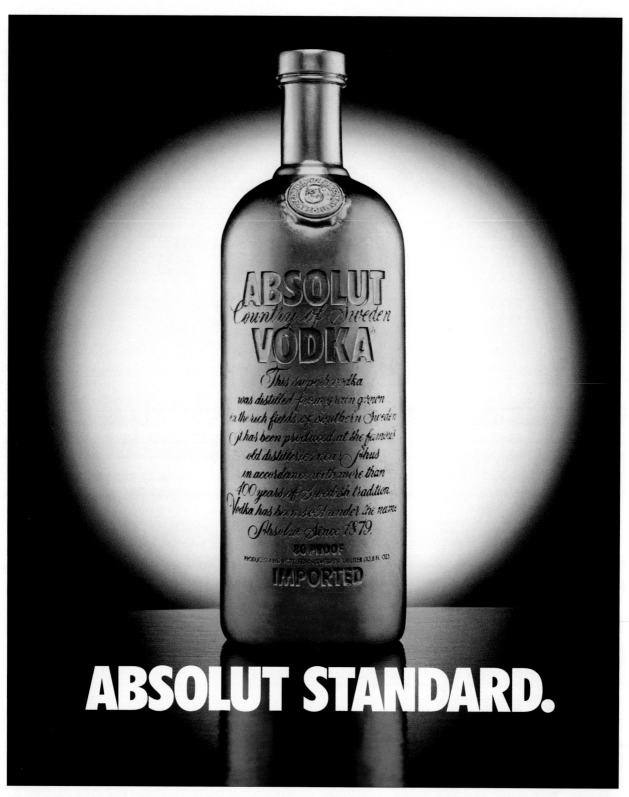

ABSOLUT STANDARD.

ABSOLUT STANDARD. This escapee from Fort Knox makes regular appearances in the business and financial publications we advertise in. I think we've shown considerable restraint by not producing platinum and silver companion pieces. While there was some discussion about the word standard—it isn't exactly a superlative—we were counting on people to figure out that we were referring to the gold standard, of course.

ABSOLUT LANDMARK. Earth artist Stan Herd planted this Absolut ad on a thirty-acre field outside Lawrence, Kansas. The use of real crops—corn, hops, maize, and other grains—ensured that the ad would evolve with the seasons. It became quite a conversation piece among commercial pilots flying across Kansas, with some of them even alerting passengers to the sight. Our proficiency in producing magic in the studio led many readers to suspect that this field wasn't "real," but those are real farmhouses and that's a real bus rolling down Douglas County Road.

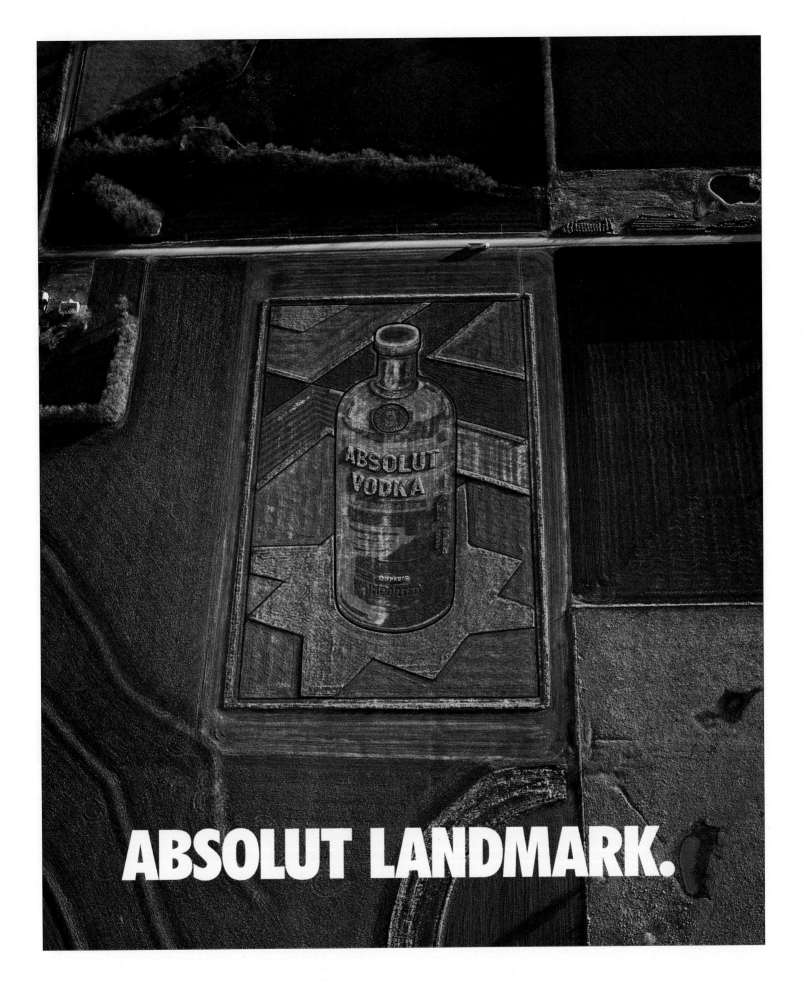

ABSOLUT LANDMARK.

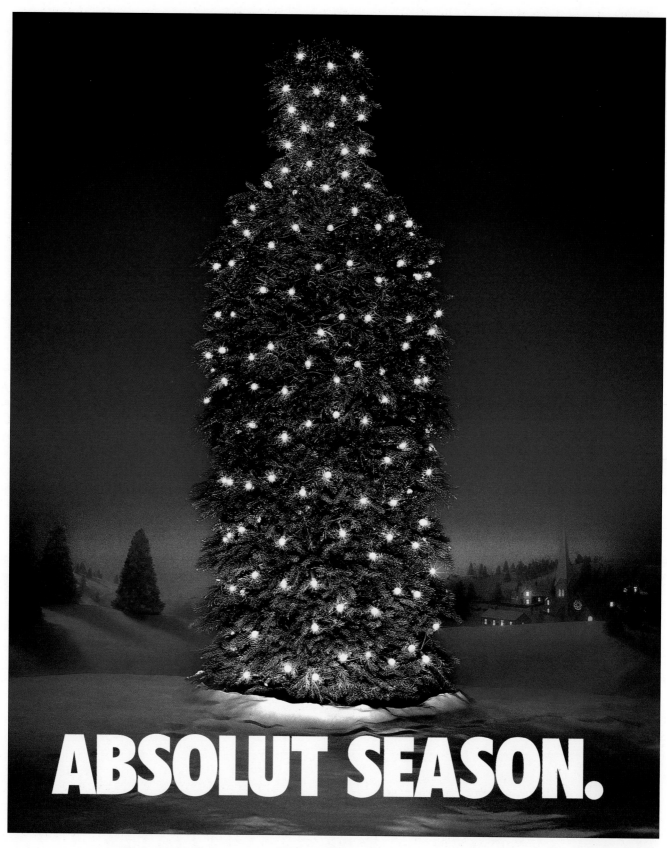

ABSOLUT SEASON.

ABSOLUT SEASON. This was probably the first Absolut Christmas ad to take liberties with the bottle. As the Christmas ads appear in a very diverse list of more than 125 magazines, they tend to be somewhat conservative, even serious by Absolut standards, in order to appeal to a broad range of tastes. ABSOLUT SEASON, Steve Feldman's creation, broke the pattern with its evergreen bottle.

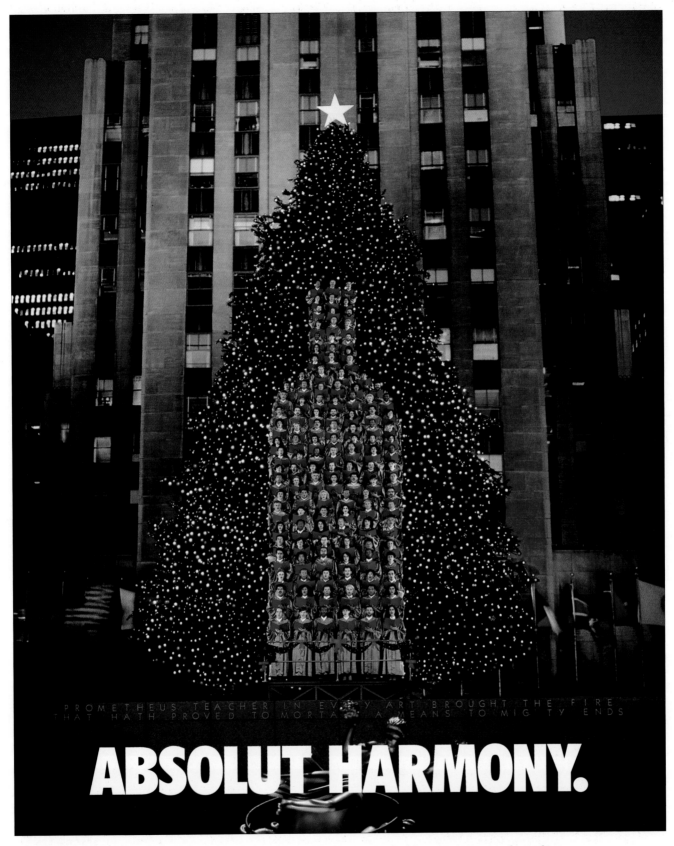

ABSOLUT HARMONY. For this ad, we enlisted the 102-member New York Choral Society to pose in front of New York's Rockefeller Center Christmas tree: every one of these tiny heads belongs to a real person who endured a long, long shoot. This ad is notable for being the first and only time in the campaign that we used actual people to create the bottle shape. (To complement the ad's run, we created posters for a dozen singing bus-stop shelters in New York City. They played holiday carols for twelve hours a day, and incredibly, nobody complained!)

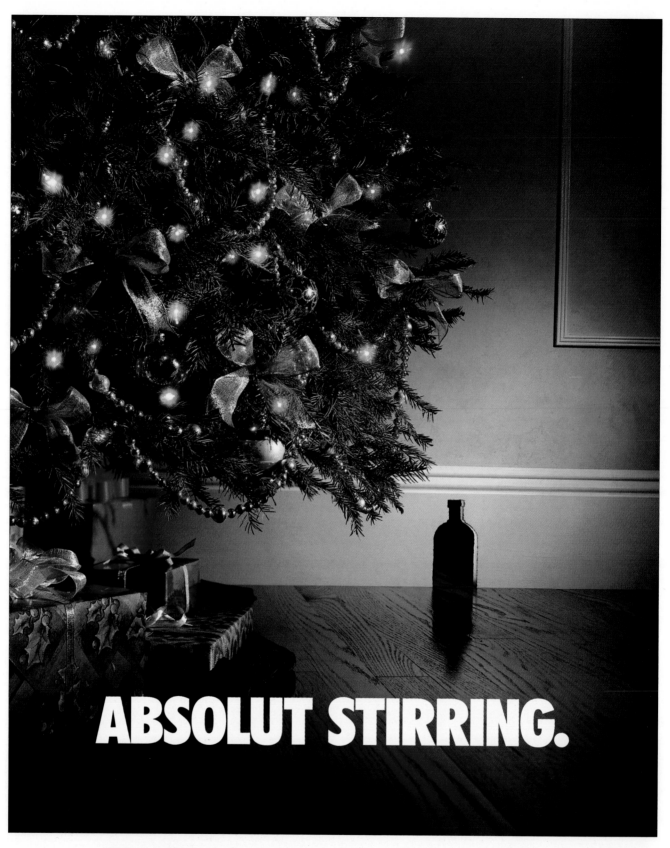

ABSOLUT STIRRING.

ABSOLUT STIRRING. Absolut's '94 Christmas ad made us all a little nervous. We honestly weren't sure if readers would understand, even after pondering it for a few moments, that ABSOLUT STIRRING referred to the famous opening lines of Clement Clarke Moore's poem "A Visit from St. Nicholas": "'Twas the night before Christmas, when all through the house, /Not a creature was stirring—not even a mouse." With the ad set to appear across the entire Absolut schedule, the client showed particular courage in giving it the go-ahead.

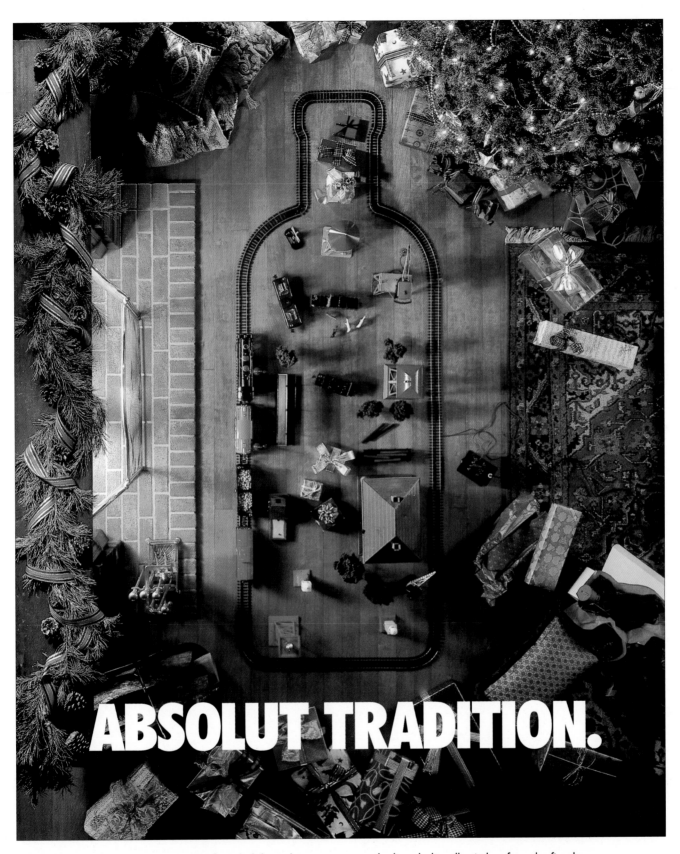

ABSOLUT TRADITION.

ABSOLUT TRADITION. Nineteen ninety-five's holiday ad was a return to the hearth, literally. Aglow from the fireplace on Christmas morning is every dad's dream: a set of Absolut electric trains. Be sure to slow down on those tough curves at the top.

ABSOLUT

ABSOLUT

ABSOLUT

ABSOLUT

ABSOLUT

ABSOLUT
CITIES

ABSOLUT
ABSOLUT
ABSOLUT
ABSOLUT
ABSOLUT
ABSOLUT

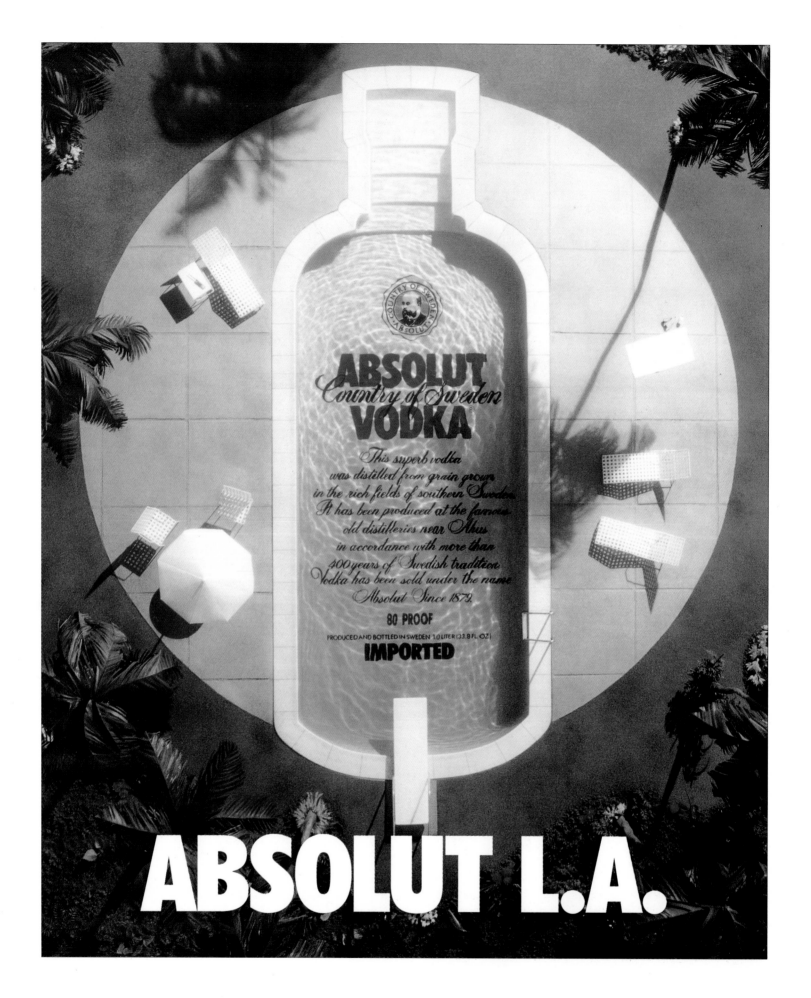

ABSOLUT CITIES.

Among the most popular ads in the Absolut campaign are the cities series, the brainchild of the art director/writer team of Tom McManus and Dave Warren (with a push from Carillon's head of marketing, Dick McEvoy).

One day in early 1987, Page Murray, an account executive with an imaginative streak, strolled into Tom McManus and Dave Warren's office with an assignment. "Dick McEvoy says Absolut sales are heating up in California," he reported, "so we need to do some kind of ad for Los Angeles."

McEvoy, a liquor-industry veteran, had joined Carillon a few years prior from Seagram, bringing to bear significant business sense and marketing skills that counterbalanced Michel Roux's vision and creativity. McEvoy wasn't "Mr. Warmth," but he commanded considerable respect for his savvy and intelligence. He knew California had long been a Stoli stronghold, but he was beginning to see signs of Absolut's penetration.

Tom and Dave had arrived at TBWA separately but within less than a year of each other, Dave first, in May '86, and Tom in January '87. This was a bit unusual because they had previously been partners at Campbell-Ewald in New York, where Tom had "rescued" Dave from the business side of broadcast production and given him an opportunity to be his writing partner by challenging him to help out on a National Rent-a-Car project.

A few weeks before Page came into their office, Tom had seen a photo of a swimming pool in the *Creative Blackbook* (a sourcebook for illustrators, photographers, retouchers, and other ad-agency suppliers). Enthralled, he had been trying ever since to figure out what current assignment he could squeeze a swimming pool into. "We didn't know what the rules were," Tom says today, donning a mask of innocence.

"Yeah," adds Dave, "that's right. Sure, 'STARDOM' had already appeared, but no one really noticed it wasn't an actual bottle. And Warhol had taken liberties with the bottle, so why couldn't we try?"

Tom did a quick magic-marker scribble on a layout pad under the headline ABSOLUT L.A. and showed it to the creative directors, Arnie Arlow and Peter Lubalin. Both men were skeptical. Arnie was troubled by the lack of a bottle, despite the STARDOM precedent, while Peter voiced a bigger problem: "This doesn't work. L.A. is just a place. It doesn't say anything positive about the product or the person drinking it."

"And Warhol was *just* a painter," countered Warren. Lubalin, not satisfied, replied, "Well, they're gonna hate this in L.A." The meeting ended without a clear resolution. What *was* clear was that the rules were evolving, and no one knew exactly where the campaign was going. Today Dave Warren understands and articulates the change: "L.A. became the Absolut 'version' of something—how Absolut sees and perceives L.A. We got out of the land of descriptions."

When ABSOLUT L.A. was presented to Carillon the following week, neither Roux nor McEvoy obsessed about the rules. They both loved it. Now the agency just had to produce it.

Tom McManus met with photographer Steve Bronstein, and Bronstein brought in Mark Borow of McConnell & Borow, a model maker who did great miniatures. Although this was to be Borow's first Absolut job, his immediate reaction was a forthright one. "Do you realize," he asked Tom, "that this will cost as much as a real pool?" Tom, like many creatives, was always cost-conscious, but he responded, "No problem, the account guys will sell the estimate." Meaning that it was not his problem, but Page Murray's.

After the shoot, Tom presented his selected chromes to Arnie for approval before proceeding. "It looks fake, Tom," Arnie said. "It doesn't work. Look at the palm trees. It has to be as real as possible."

Tom was desolate. This was his first ad at TBWA, it was a disaster, and he figured he was going to be fired. Desperate, he convinced Arnie to let him spend eight hundred dollars on some color blow-ups. Tom was sure the ad would look better, look "real," as an 8x10.

He was right: it looked terrific. Right down to the little cellular phone he no longer needed to call for help.

After the success of ABSOLUT L.A., Tom and Dave were urged to come up with a counterpart for New York City. Peter Lubalin cornered McManus and told him, "OK, Tom, do a New York ad, and do it today!" Since Carillon never rushed the agency for an ad, except in extreme circumstances (and this wasn't one of them), I believe this was simply a personal challenge from Peter. Tom had two quick ideas: first, an Absolut bottle spray-painted, as graffiti, on an urban wall, and next, King Kong perched triumphant atop the Absolut bottle. But he soon had an even better idea: Central Park transformed into the Absolut bottle. To his surprise, Lubalin loved it.

In order to produce the ad, McManus needed a special map to play with. After exhausting his usual sources, he hired a photo researcher named Mona Yuter to help, but before she even began looking, her husband, Kurt, found an infrared poster from NASA in a Grand Central bookstore. It was perfect. Tom did a cut-and-paste job, trimming off some of Manhattan's East Side that included wiping out Lexington and Third Avenues. (After the ad appeared, people excitedly reported that they'd spotted their apartment buildings, not realizing they'd been left on the cutting-room floor.)

By now, a strategy had emerged. We knew we had to select cities with landmarks, attitudes, or perceptions that would be appreciated and understood not just by natives but—to justify the cost of producing one of these ads, which could sometimes run to $100,000—by people all over the country. As ABSOLUT L.A. showed, there are often good marketing reasons to support a particular city. There are now about two dozen Absolut city ads, with more being added every year. They're a lot like major sports teams—people want an Absolut ad to honor their city, to show that it's arrived.

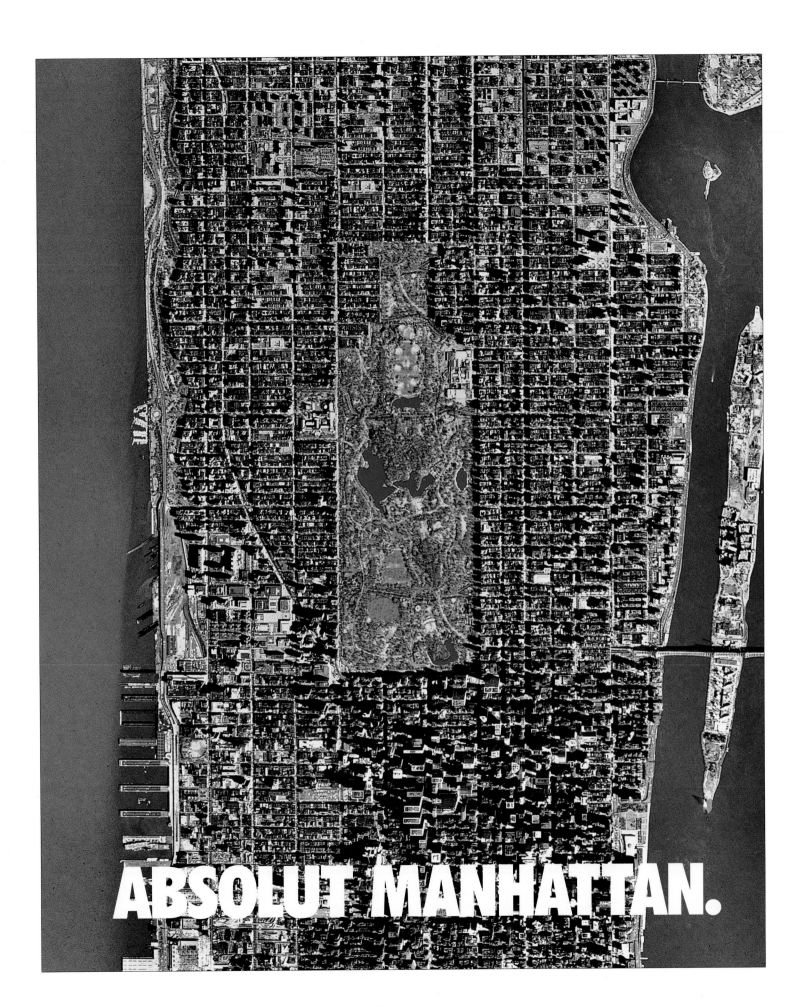

ABSOLUT MANHATTAN.

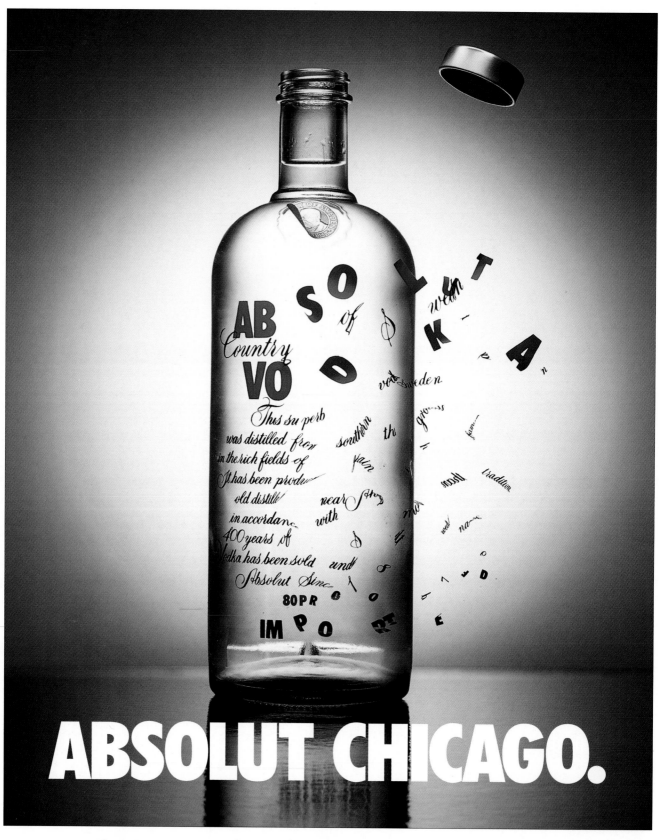

The ABSOLUT CHICAGO ad originated not as a magazine ad but as a painted billboard in downtown Chicago. When Tom and Dave suggested that it could also work in a magazine, the skeptics lined up, predicting, "People won't get it. It has to be called ABSOLUT WINDY CITY, or something like that." People got it.

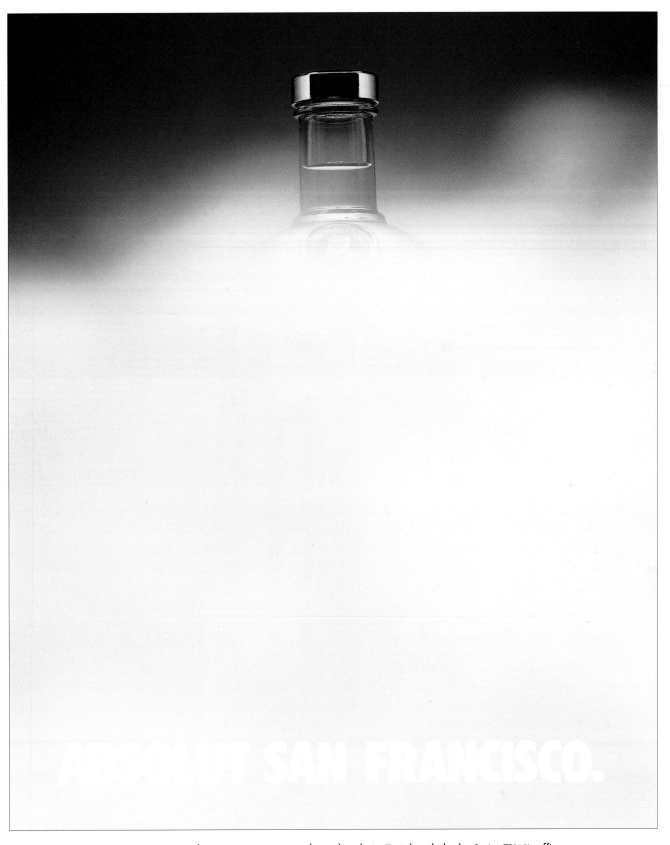

ABSOLUT SAN FRANCISCO. Tom and Dave were on a rare boondoggle in Zurich to help the Swiss TBWA office on a Swissair pitch. (Actually, TBWA often sends creative teams to its other offices, on assignment, to provide some fresh blood and fresh thinking.) Looking out a hotel-room window, they watched the fog rolling into the city. Dave remarked, "Hey, Tom, it looks just like ABSOLUT SAN FRANCISCO." It was the start of a time when Absolut bottles were showing up everywhere you turned.

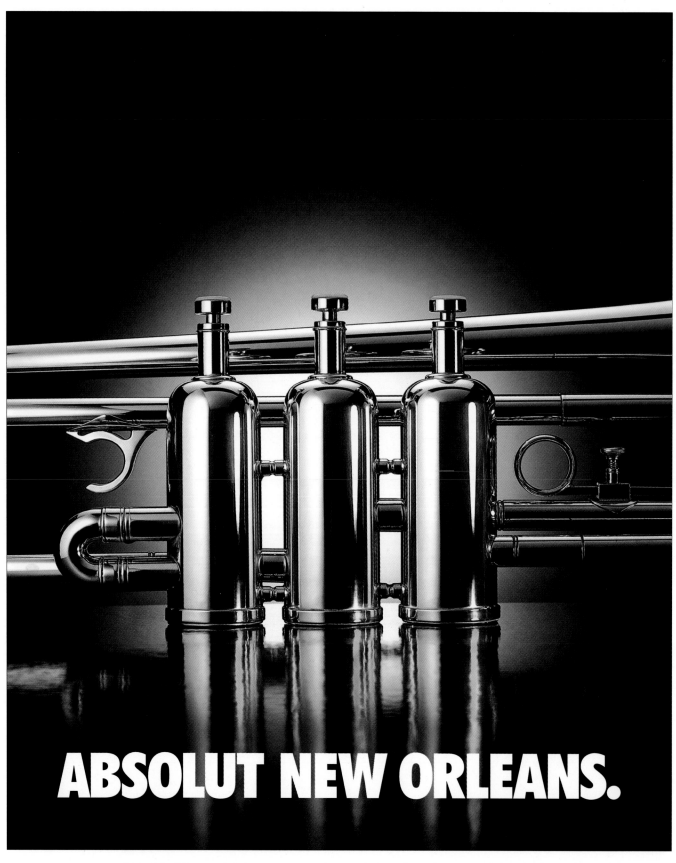

ABSOLUT NEW ORLEANS.

ABSOLUT NEW ORLEANS. Since New Orleans is famous for its hot jazz, ABSOLUT NEW ORLEANS not surprisingly employs a hot jazz trumpet. Although we originally presented a gold trumpet, Vin & Sprit's Curt Nycander convinced us to use silver, an Absolut color. Curt is now retired, so we won't score any points for this, but I still say he was right.

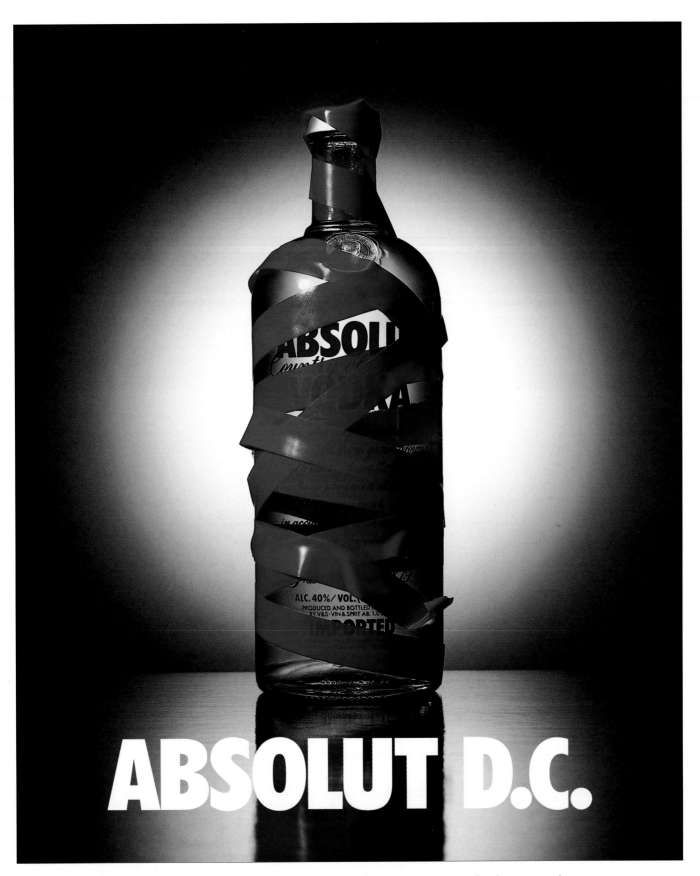

ABSOLUT D.C.

ABSOLUT D.C. We brought this ad back from the dead. First presented in '91, it was rejected as being too political, and Washington, D.C., too easy a target. But the image of an Absolut bottle mired and constricted in bureaucratic red tape was worth fighting for, and the ad finally debuted, along with the 101st Congress, in January 1995.

Behind The Scenes: The Making of ABSOLUT MIAMI

Photographer Steve Bronstein adjusts the light on the Absolut bottle cum condominium, the product of five weeks of intensive construction by Mark Borow's team.

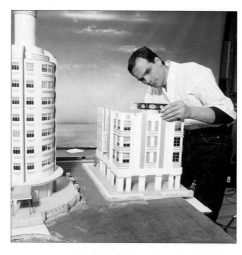

Borow's assistant, Mark Varvoutis, used a level to make sure the structure next to the Absolut building was perfectly positioned. The camera detects even the slightest variance.

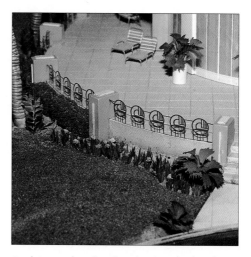

God is in the details: The hundreds of tiny plants and shrubs take many hours to position properly. Etched brass in art deco motifs is used in the railings and wall decorations. Plexiglass "windows" give a transparent feel.

After a long day on the set, it's difficult to find a comfortable chair.

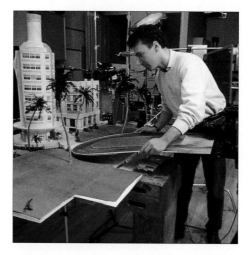

Borow places the "driveway" into position. The asphalt is a piece of styrene, spray-painted several times, adding paste to create a pebbly-looking surface.

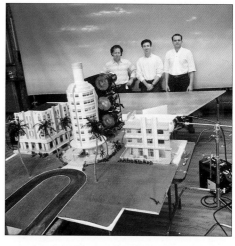

Standing between the "ocean" and the "sky" Bronstein, Borow, and Varvoutis survey the finished set.

ABSOLUT MIAMI. Miami was experiencing something of a rebirth as a hot city in 1990. Steve Feldman and writing partner Harry Woods, envisioning a great art deco apartment building built in the 1930s, commissioned the most elaborate miniature ever created by Mark Borow for the campaign. The challenge was very much about seeing how real the model could look. Feldman even claims that when he pulled the first color print and showed it to Dick Costello, TBWA's President, Costello asked, "When did you go to Miami to shoot that?"

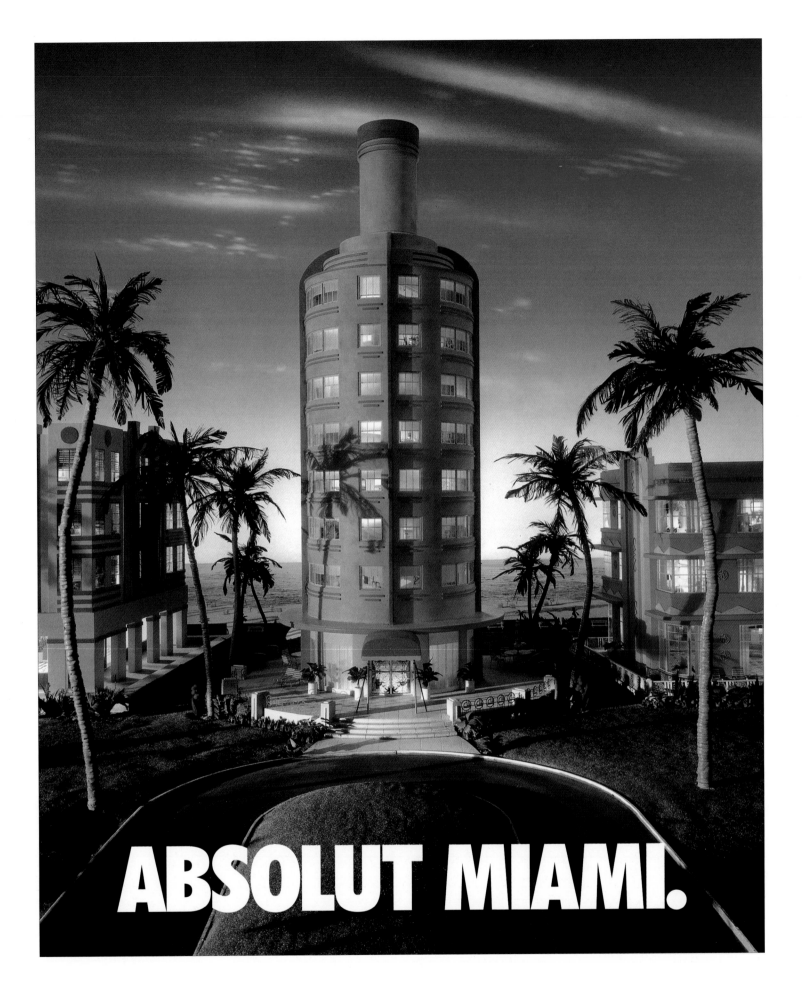

ABSOLUT MIAMI.

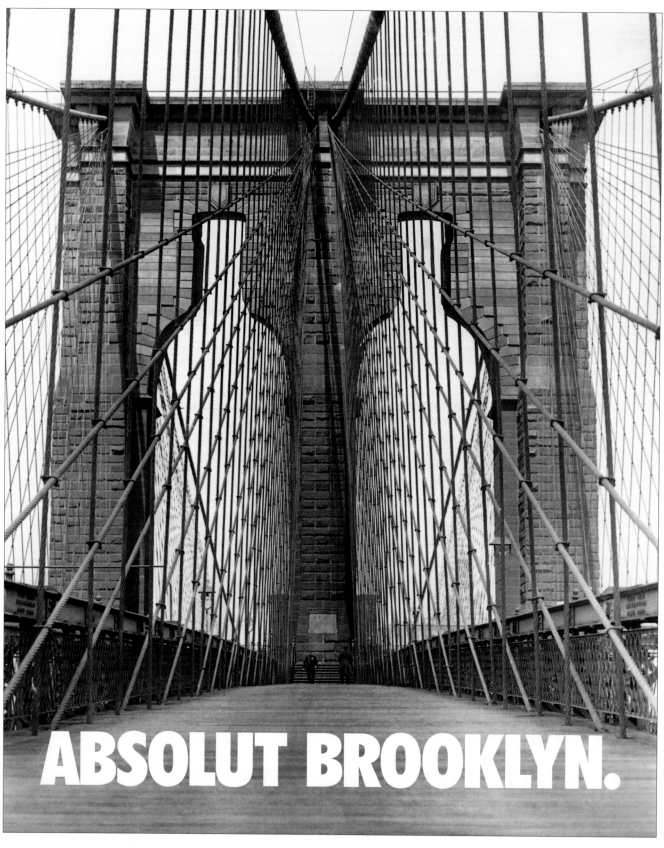

ABSOLUT BROOKLYN. I've heard from more than one Brooklynite that this ad is the best thing to have happened to Brooklyn since the Dodgers left, nearly forty years ago.

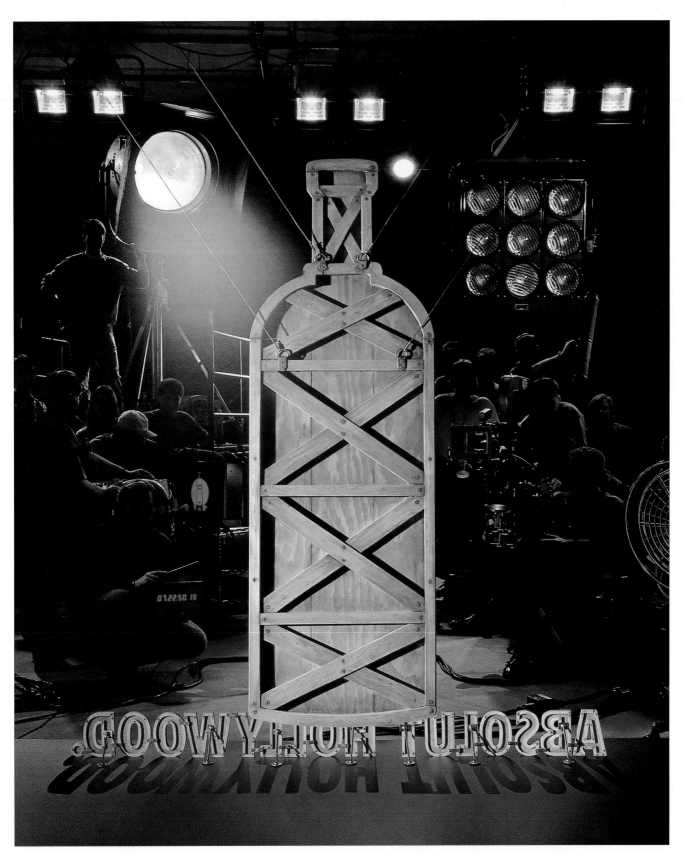

ABSOLUT HOLLYWOOD. Dan Braun runs the TBWA graphics studio, and Bart Slomkowski is a graphic artist on his staff. In their spare time, they've become the most productive Absolut creative team over the past two years. ABSOLUT HOLLYWOOD was the first ad of theirs to be produced. Photographed on Thanksgiving eve 1993, the darkened movie-set background features a number of TBWAers, including Arnie Arlow (right front) and Braun himself (left front). Naturally, the Absolut bottle is the ad's legitimate Hollywood star, and as such is bathed in light.

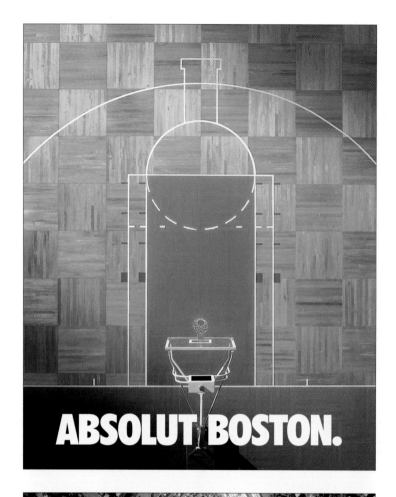

ABSOLUT BOSTON. Andy Judson was a terrific account executive and an even bigger Boston Celtics fan. It was already well known by '92 that the Boston Garden would no longer be the team's home in '95; ABSOLUT BOSTON was Judson's going-away present to the Celts. He camped out in art director Dave Oakley's office and tortured him until he agreed to comp up this ad.

ABSOLUT LOUISVILLE. This ad, of course, celebrates the Kentucky Derby; it also scores very high on the realism meter. I've even received a few phone calls from people who live in Louisville and wanted to know whether the ad was actually photographed on Derby Day. Maybe these callers were among the people in the overflowing crowd that model-maker Mark Borow represented with candy sprinkles and jimmies.

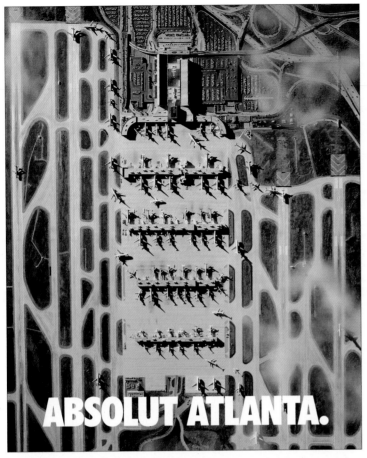

ABSOLUT ATLANTA.

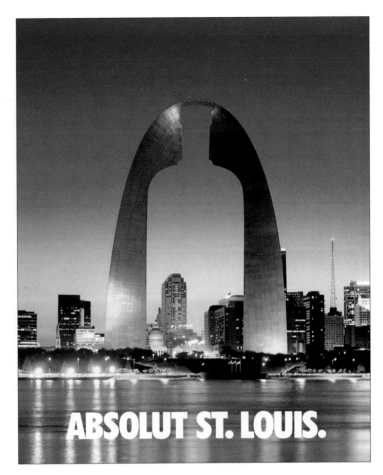

ABSOLUT ST. LOUIS.

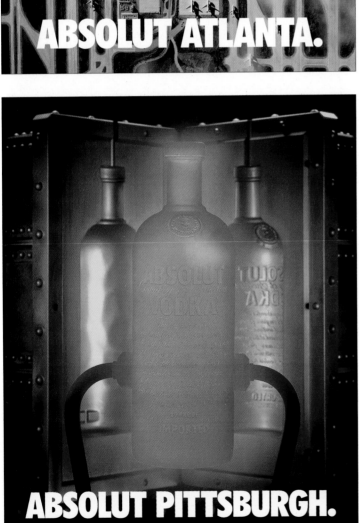

ABSOLUT PITTSBURGH.

ABSOLUT ATLANTA. There's an expression in the southeast that "You can't get there without going through Atlanta..." which should explain why we transformed Hartsfield International into Absolut's airport.

ABSOLUT ST. LOUIS. When the client finally approved an ad honoring his beloved hometown, Bill Tragos gave everyone involved a kiss...and an extra day off.

ABSOLUT PITTSBURGH. I suppose you could say that our ode to Pittsburgh's reputation as the steel manufacturing capital is a bit dated; if so, then let it serve as a memorial.

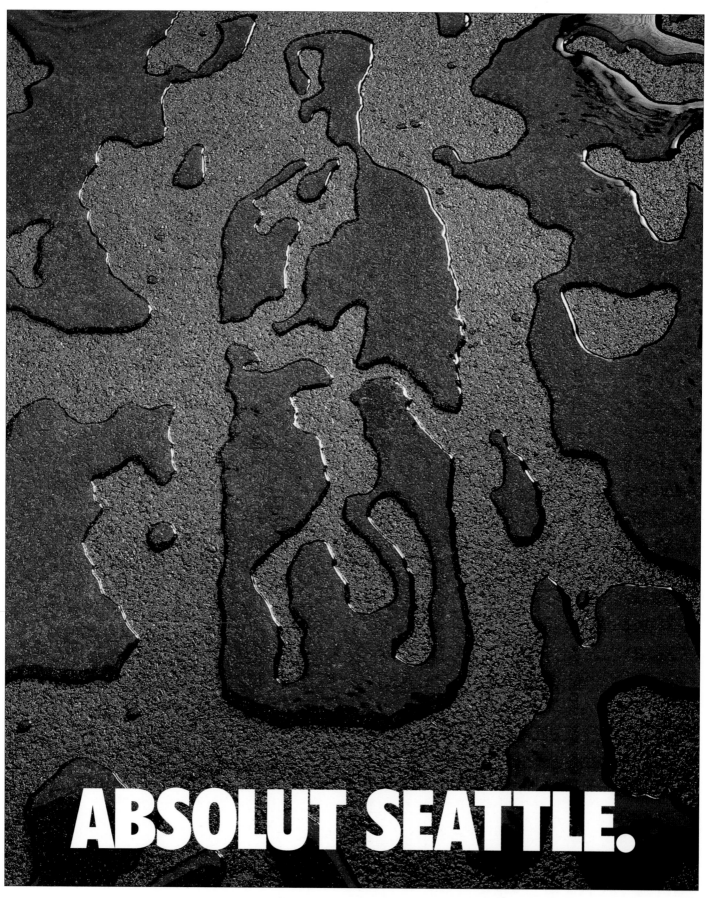

ABSOLUT SEATTLE.

ABSOLUT SEATTLE. We tried to capture Seattle's reputation as a very rainy town with this Absolut puddle, but Kitty Roux, Michel's wife, saw something else: "It looks like an Absolut oil slick!"

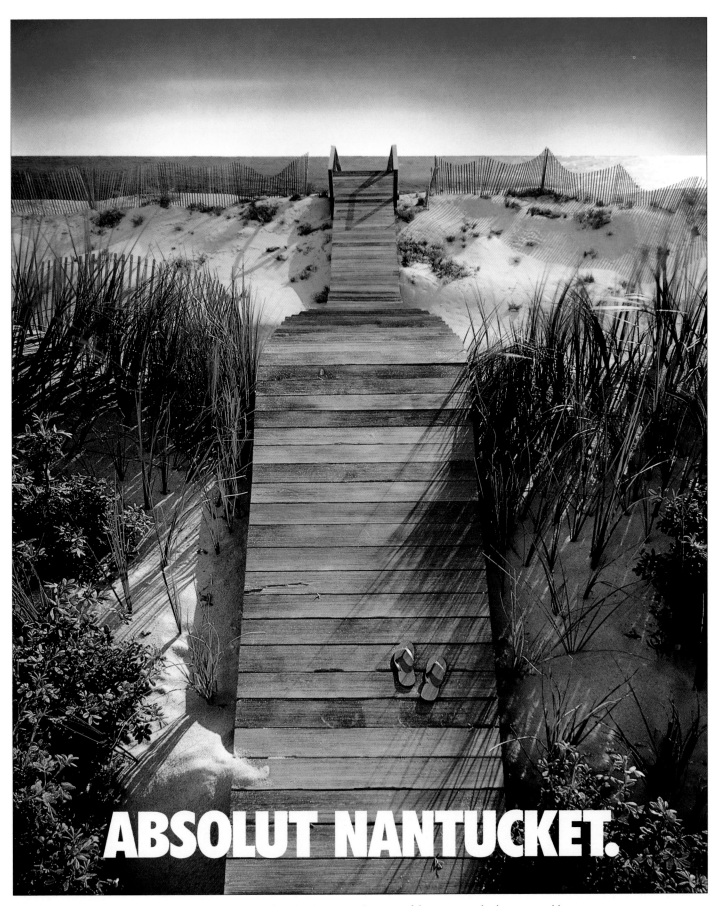

ABSOLUT NANTUCKET.

ABSOLUT NANTUCKET. OK, Nantucket isn't a city, but who can resist this peaceful outpost on the bay created by
Lisa Lipkin and Maria Kostyk-Petro, utilizing the realest fake water of model maker Mark Borow?

ABSOLUT

ABSOLUT

ABSOLUT

ABSOLUT

ABSOLUT

ABSOLUT

ABSOLUT
ART

ABSOLUT

ABSOLUT

ABSOLUT

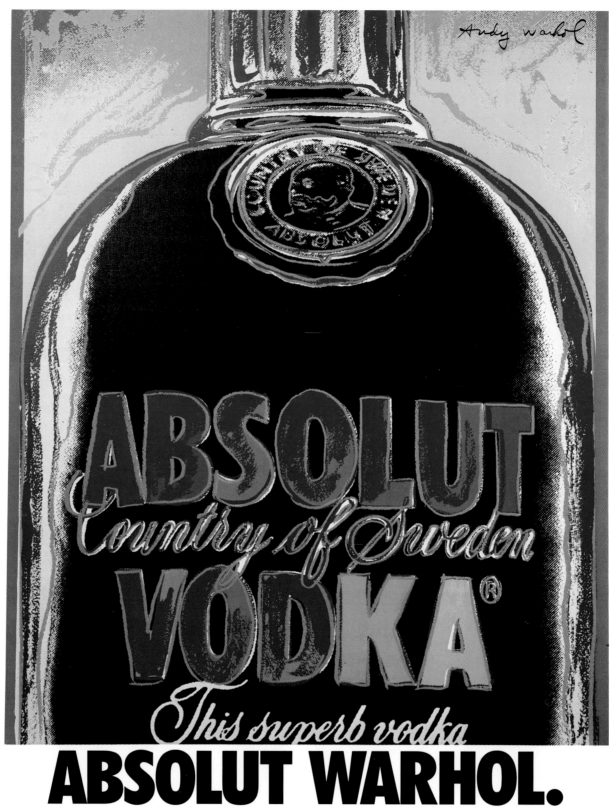

ABSOLUT ART.

It's 1985; Absolut business is booming, and the brand is closing in on Stolichnaya. The campaign, while stylish, is still, however, quite conservative. Michel Roux, Carillon's President/CEO since Al Singer's retirement two years earlier, comes up with an idea that will not only remove many of the campaign's self-imposed restraints but also serve to reinforce and magnify the brand's fashionable identity.

Back in 1983, through his friend Paige Powell, Advertising Director of *Interview* magazine, Michel had met *Interview*'s editor, publisher, and owner, Andy Warhol. He had commissioned Warhol to do a painting of a new Carillon product—a concoction of Armagnac and passionfruit called La Grande Passion—and the work was now hanging in his office.

Over dinner one night, Warhol tells Michel that he's enthralled by the artfulness of the Absolut bottle. He reminds him that while he doesn't drink alcohol, he sometimes uses Absolut as a perfume. (Since vodka is virtually without odor, it must have made for a fairly subtle scent; perhaps the artist simply appreciated the alcohol's cooling effect on his body.) Warhol proposes painting his own interpretation of the Absolut Vodka bottle, and Michel agrees, not even considering its use in advertising, but merely thinking, Let's just see what happens.

Michel paid Warhol $65,000 for the painting, a price that would establish the ceiling for all future Absolut artists' works. In years to come, Michel would frequently say, about any one of a number of artists, "He isn't worth more than Andy."

Michel neither made suggestions for nor placed restrictions on Warhol's painting. Then as now, the only requirement for an Absolut artist was that he or she include the Absolut bottle within the artwork. When Warhol was finished, Roux was as surprised as everyone else to see the "black" Absolut bottle, but he loved it and thought it would make a great Absolut ad.

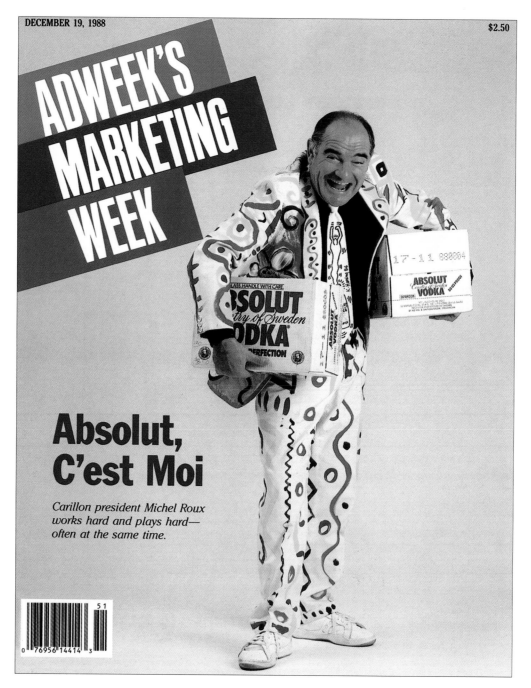

Michel's friends and colleagues, however, disagreed. The campaign and the brand were humming along. "Let's not screw it up" was the conventional wisdom. Michel ignored everybody's advice but he did compromise and agree to place the ad, now dubbed ABSOLUT WARHOL, in only a few select art publications. He remembers his reasoning: "If it was going to be a bomb, let it be a small bomb."

What did Michel see that eluded everyone else?

Absolut Vodka had become a fashionable brand, and in Warhol's work, Michel saw an opportunity to accelerate the process. He wanted to entice what he calls "society people": artists, Hollywood, the rich, the famous. He saw Warhol as something of a "prophet," someone who would lead his friends to Absolut.

The idea was quite revolutionary: no major advertiser before him had thought to use art as a marketing strategy.

ABSOLUT WARHOL was an immediate success. Michel was vindicated and could laugh at all the naysayers. Andy Warhol suggested doing a whole series of ABSOLUT WARHOL paintings, but Michel had a better idea: he would ask Andy to be his seeing-eye dog in the art world and to introduce him to new Absolut

artists. Warhol's first recommendation was Jean-Michel Basquiat. Michel met with him, but Basquiat kept wavering—declining, accepting, declining—so Warhol threw out Keith Haring's name.

Haring had originally become famous in New York as a subway graffiti artist. Michel found him to be down-to-earth, and very excited about doing an Absolut painting. They struck a deal immediately, and ABSOLUT HARING was unveiled in November '86 at a launch party at the Whitney Museum. Warhol invited his friends, and the party became an event: Michel's desire to link the brand with the art world and "society" was paying off.

The art chain continued. Haring introduced Michel to Kenny Scharf. While Scharf was also enthusiastic about the idea of an Absolut project, he was a little more difficult when it came to signing a contract—specifically, he wanted more money than Michel was offering. Michel, citing the $65,000 Warhol precedent, remained firm, even when Scharf countered, "But I'm a better painter." (Scharf denies ever saying this, insisting, "Andy was my hero.") In the end, Scharf accepted the offer and created the first controversial painting, in which the artist's typical cartoon-like characters (some might call them cheerful demons) are seen emanating from an Absolut bottle. Still, Michel would never shy from giving his artists complete freedom, even in the conservative liquor industry.

By 1988, Michel Roux was having great fun with his new guise as art patron. But after working with half a dozen established, high-profile artists, he conceived an even bigger idea: he would find unknown, unestablished artists and get Absolut to help launch their careers through Absolut exposure, rather than trading on the fame and talent of better-known painters to further Absolut Vodka. (I suppose one could call this reverse borrowed interest, as opposed to conventional borrowed interest, whereby a brand hires a celebrity, an athlete, or an expert to serve as a spokesperson for or endorser of its product. Just think of any of the dozens of athletes who help sell Nike equipment, or the entertainers who pitch Pepsi-Cola.)

It wasn't difficult for Michel to implement this strategy, as artists had already begun to besiege him with unsolicited submissions. These artists had seen the published works of Absolut artists, read about the campaign's success in the popular press, and heard the Absolut campaign being discussed in the artistic community. What had begun as an annual artist's ad soon became almost a monthly event, with the artworks coming to include not just paintings but also photography, sculpture, glasswork, woodwork, folk art, computer/digital art, and every other artistic medium imaginable.

A side benefit of this approach was that the cost of the art to Carillon shrank to a typical $2,500 to $5,000. Still, Michel was hardly taking advantage of these struggling artists; for some, it represented their first commercial sale.

Michel took enormous pleasure in his role as the de' Medici of Teaneck. Sometimes his appetite for acquiring new art seemed insatiable, but it was an important way to establish Absolut's identity as a supporter of the arts and a friend of artists—so that art is now an integral part of the brand's character.

And while all of the art in the Absolut collection is not "great" by critical standards, it is good commercial work, directly reflecting Michel Roux's personal tastes and his openness to any style, any execution. And, along the way, Michel has helped hundreds of artists find an audience and pay their bills.

ABSOLUT SCHARF.

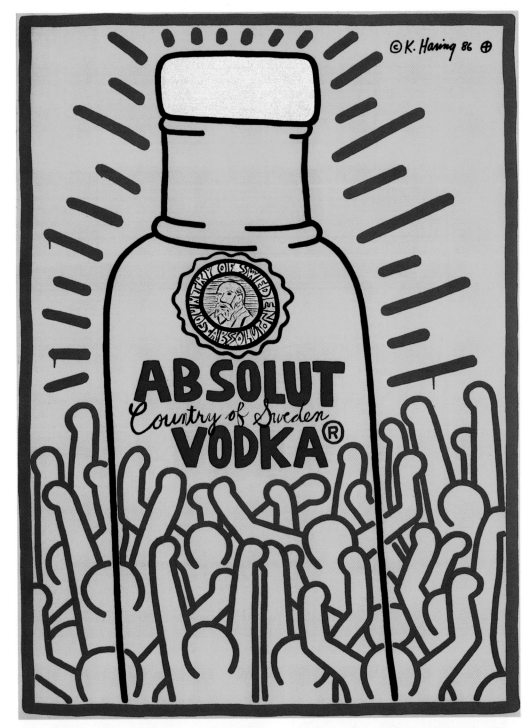

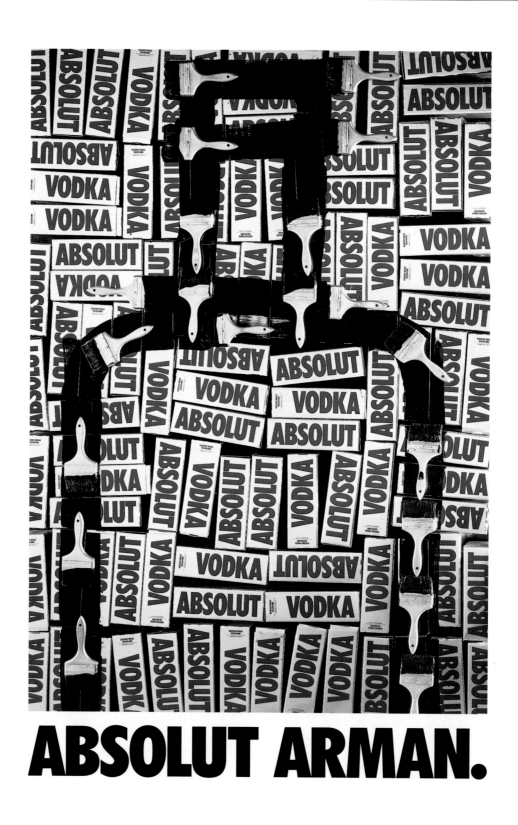

ABSOLUT ARMAN.

ABSOLUT ARMAN. French artist Armand Arman created what amounted to the first Absolut sculpture by attaching ninety-eight Absolut gift boxes and paintbrushes to a piece of wood to form the shape of the bottle.

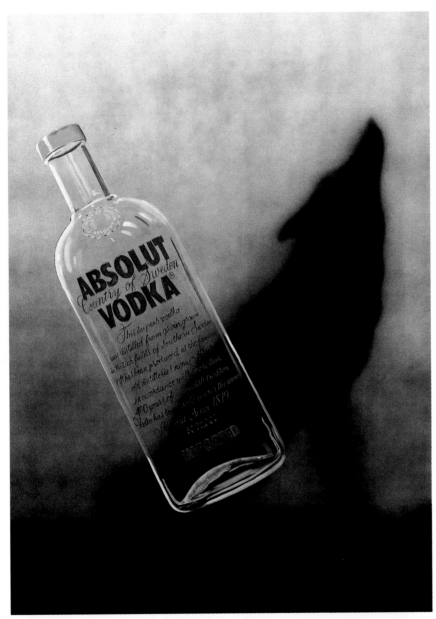

ABSOLUT RUSCHA.

ABSOLUT RUSCHA. Warhol introduced Michel to Ed Ruscha through the gallery owner Leo Castelli. Ruscha holds the distinction of being the only Absolut artist who has refused to renew his contract after its original term. According to his lawyer/agent, "Ed has nothing against Absolut. He's just tired of seeing the ad when he picks up a magazine."

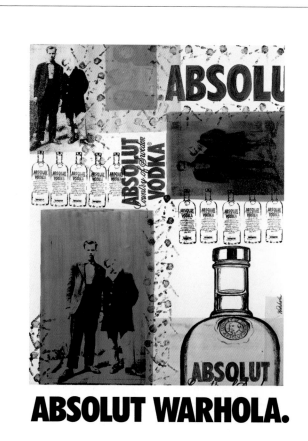

ABSOLUT WARHOLA.

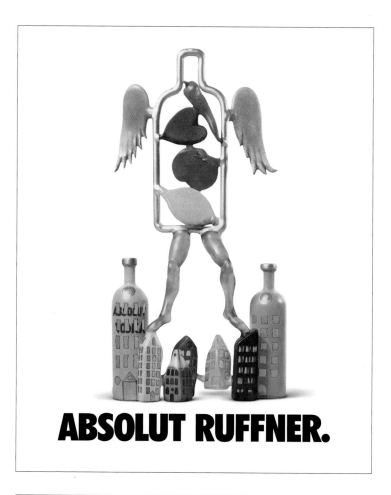

ABSOLUT RUFFNER.

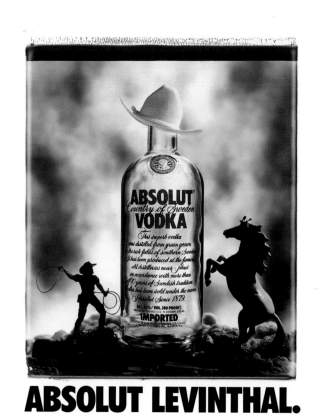

ABSOLUT LEVINTHAL.

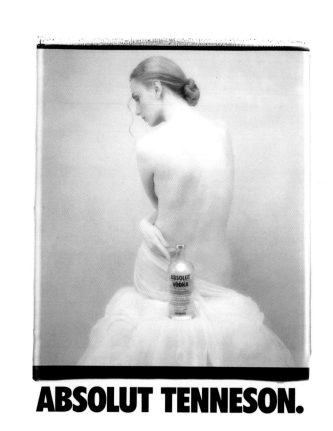

ABSOLUT TENNESON.

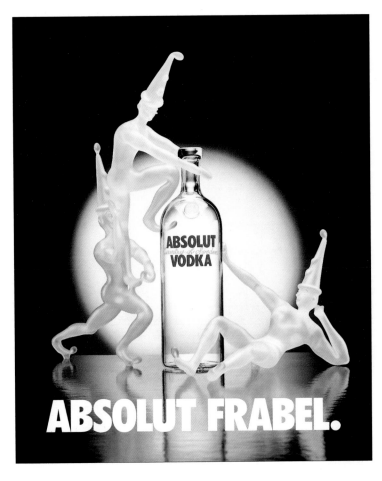

ABSOLUT FRABEL.

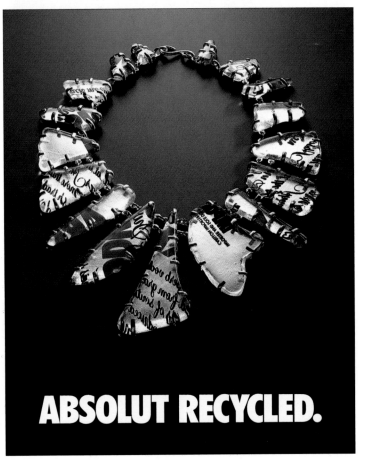

ABSOLUT LYNN.

ABSOLUT WARHOLA. A family affair: this painting is by Andy Warhol's big brother, Paul Warhola.

ABSOLUT RUFFNER. Seattle artist Ginny Ruffner produced an Absolut sculpture that we ran as a hologram.

ABSOLUT LEVINTHAL. Western photographer David Levinthal became the first photographer to rope in an Absolut assignment.

ABSOLUT TENNESON. Photographer Joyce Tenneson was an unlikely choice for Absolut; her gauzy, sensual style of shooting nudes joined a campaign that typically excludes people as subjects.

ABSOLUT FRABEL. When TBWA was shooting Frabel's elegant glass sculpture, someone asked me what the artist's first name was. The first thing that came to mind was "Otto," so that was how the artist credit appeared on the ad. Apologies to Hans Godo Frabel.

ABSOLUT LYNN. Jenny Lynn uses an unusual technique, etched photography, to create her work.

ABSOLUT RECYCLED. Jewelry designer Mariquita Masterson made this necklace from a recycled Absolut bottle.

ABSOLUT RECYCLED.

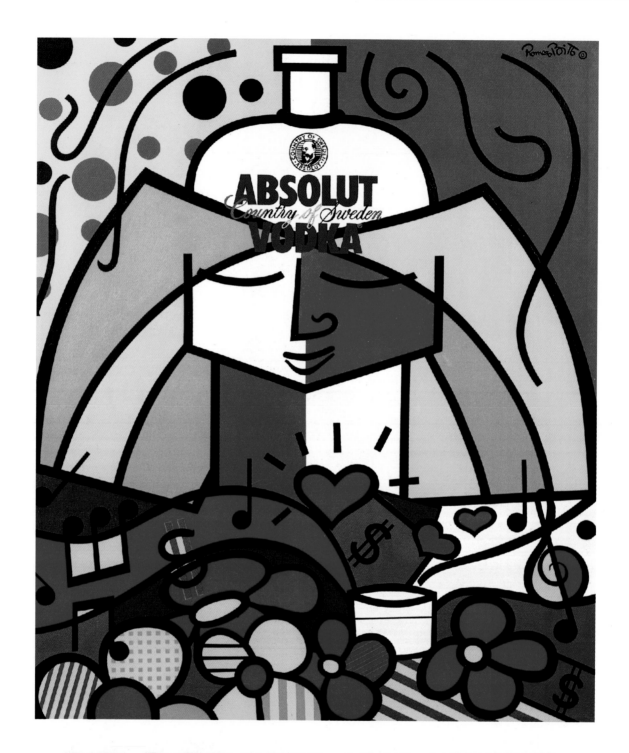

ABSOLUT BRITTO.

ABSOLUT BRITTO. Miami artist Romero Britto is very satisfied with his association with Absolut Vodka: following publication of ABSOLUT BRITTO, sales of the artist's works increased dramatically, as did their prices.

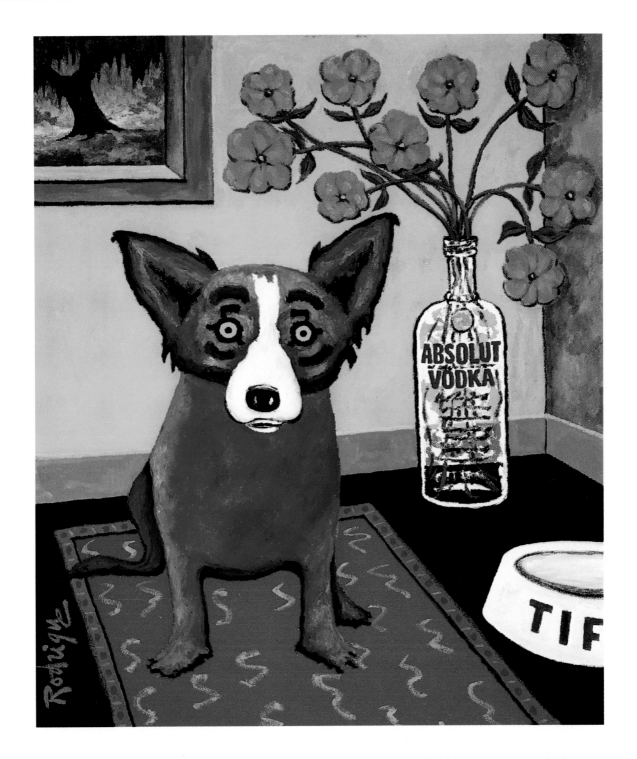

ABSOLUT RODRIGUE.

ABSOLUT RODRIGUE. One of the better-known artists commissioned by Absolut in recent years, George Rodrigue of New Orleans is closely identified with his trademark blue dog, Tif, who appears in all his works.

ABSOLUT HIRSCHFELD.

ABSOLUT HIRSCHFELD. This self-portrait by Al Hirschfeld substitutes eighteen *Absoluts* for the caricaturist's typical hidden-in-the-art *Nina*s (his daughter's name), though one *Nina* remains. On the day I met Hirschfeld's agent, Margo Feiden, a character in her own right, I pointed out that she was wearing her coat upside down.

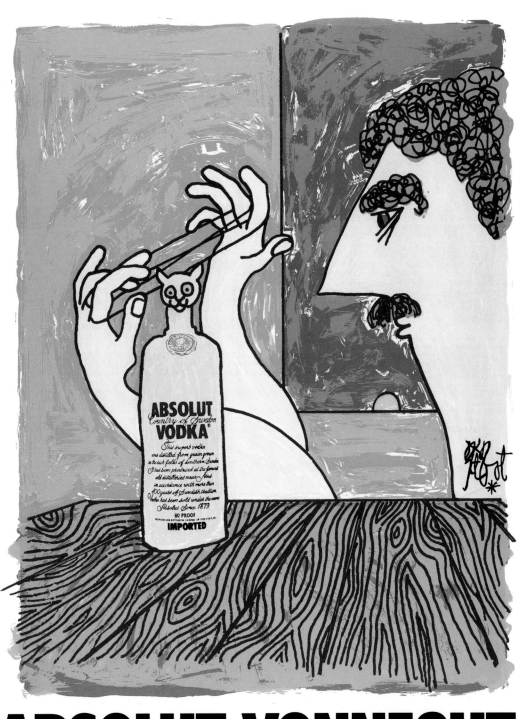

ABSOLUT VONNEGUT.

ABSOLUT VONNEGUT. Although we often like to pigeonhole people, crediting them with but one gift or skill, many artists break that mold by displaying multiple talents. One example is the writer Kurt Vonnegut.

ABSOLUT IMPIGLIA.

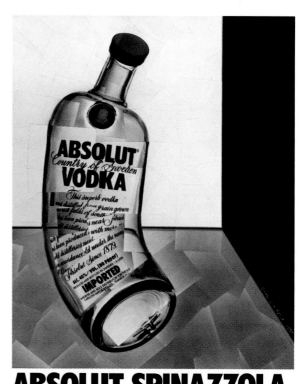

ABSOLUT SPINAZZOLA.

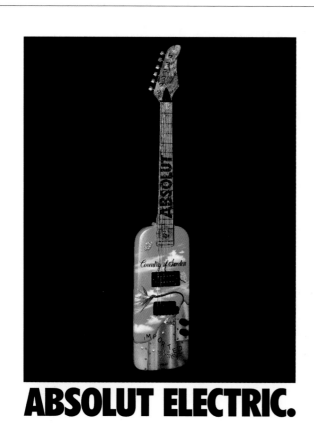

ABSOLUT ELECTRIC.

ABSOLUT PETACQUE.

ABSOLUT LE COCQ.

ABSOLUT NEIMAN.

ABSOLUT AULD.

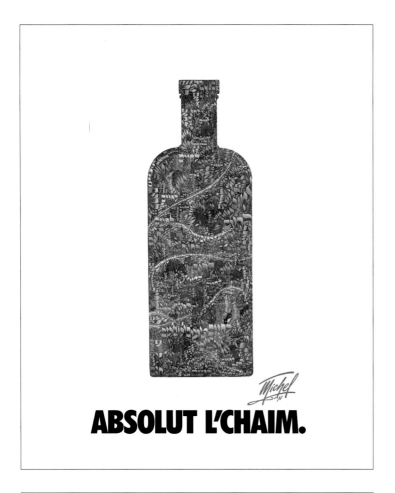

ABSOLUT L'CHAIM.

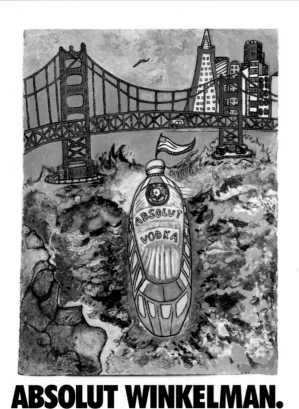

ABSOLUT WINKELMAN.

ABSOLUT L'CHAIM. Artist Michel Schwartz isn't just talented, he's also spent his entire life promoting good works in the Jewish community.

ABSOLUT WINKELMAN. We got both positive and negative publicity when we published the work of homeless San Francisco artist Jane Winkelman. Did Absolut take advantage of her situation? Hardly; we simply called attention to a national problem with a local face.

ABSOLUT MARINÉ. Elizabeth Morse, TBWA account executive and artist talent scout, discovered Spanish artist Oscar Mariné Brandi and his bold, colorful, urban portraits. Oscar completely understood why we chose not to call his work ABSOLUT BRANDI.

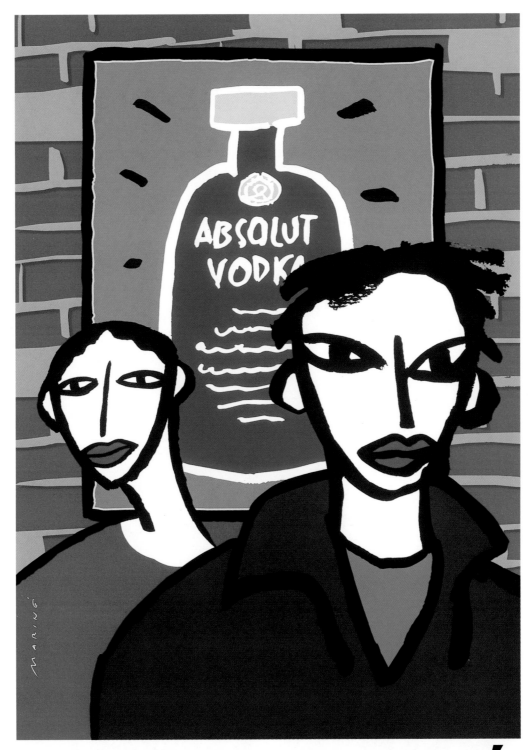

ABSOLUT MARINÉ.

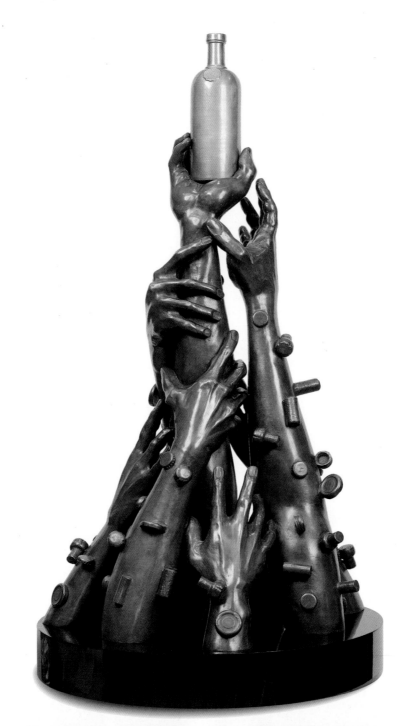

ABSOLUT LORENZO.

ABSOLUT LORENZO. Lorenzo Quinn's sculpture always reminds me of the famous 1945 photo by Joe Rosenthal of Americans raising the flag at Iwo Jima.

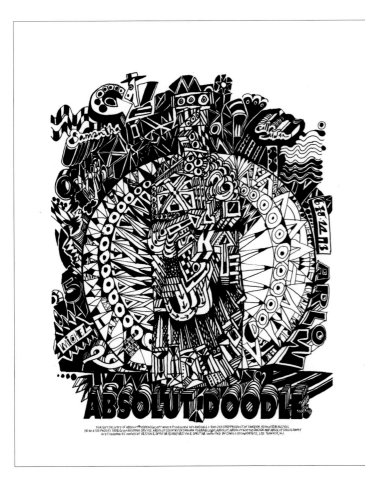

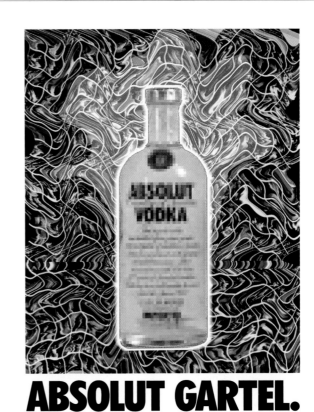

ABSOLUT GARTEL.

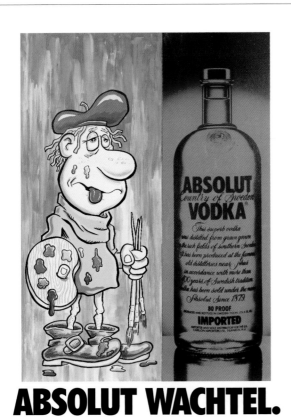

ABSOLUT WACHTEL.

ABSOLUT DOODLE. Creative Director Arnie Arlow is a world-class doodler (in fact, he placed second in the 1983 American Doodling Competition in Atlantic City). Out of respect for his talent, Michel Roux commissioned an ABSOLUT DOODLE from Arnie at a price just below "Warhol money." (I'm kidding.)

ABSOLUT GARTEL. Lawrence Gartel created Absolut's first piece of digital art in 1991.

ABSOLUT WACHTEL. Carillon's top sales exec, Dick McEvoy, best summed up Julia Wachtel's art: "You can't say Michel doesn't give the artists total freedom."

ABSOLUT DOW SIMPSON.

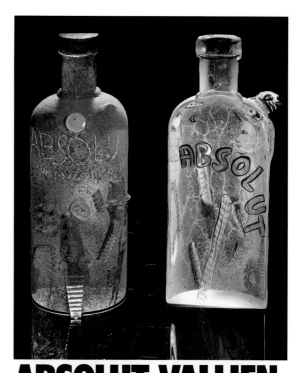

ABSOLUT VALLIEN.

ABSOLUT GUZMAN.

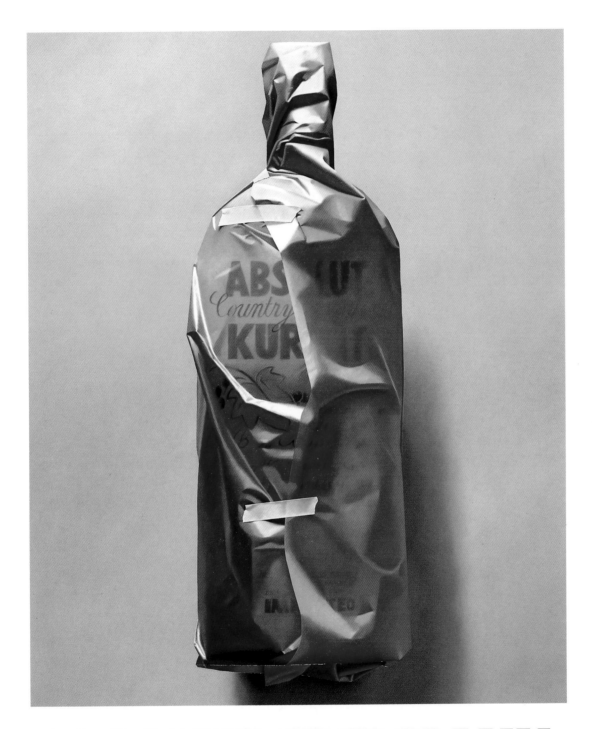

ABSOLUT EDELMANN.

ABSOLUT EDELMANN. This wrapped bottle of Absolut Kurant is actually a painting by Swedish artist Yrjo Edelmann. Its three-dimensional quality fools nearly everyone.

ABSOLUT

ABSOLUT

ABSOLUT

ABSOLUT

ABSOLUT

ABSOLUT
HOLIDAYS

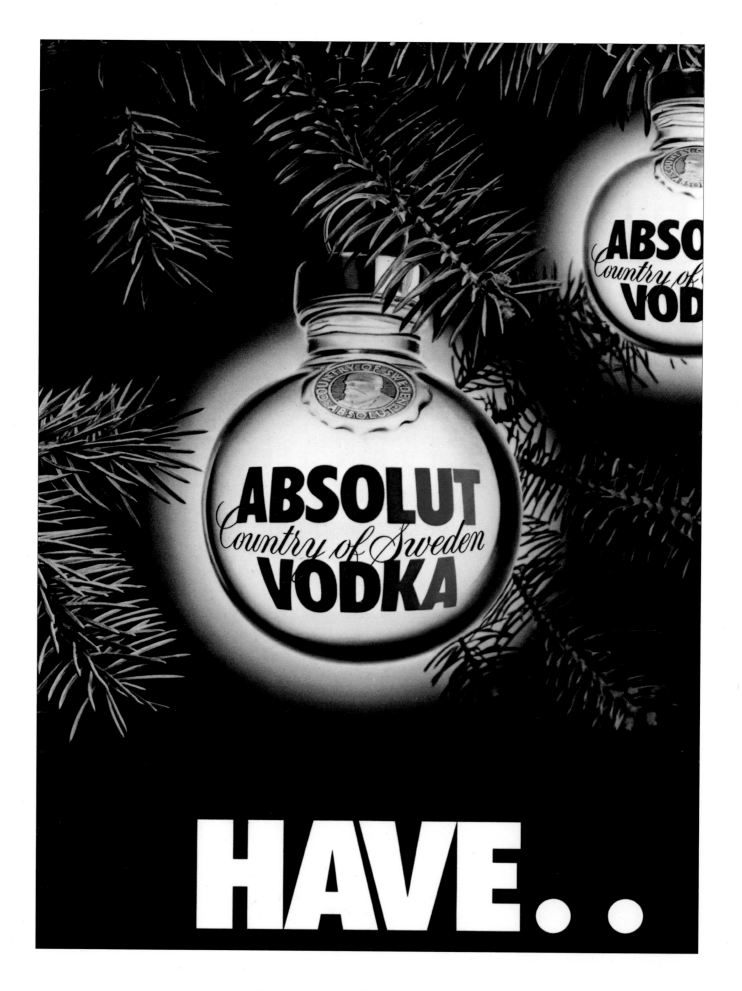

ABSOLUT HOLIDAYS.

Early in 1987, we decided to try to make a big splash at Christmastime. The brand's business the previous year had been spectacular, passing Stolichnaya at a gallop and attaining sales of a million cases, a then-unheard-of volume for the category. Although Absolut and Stoli have always been friendly competitors, it was a sign of how far and how fast Absolut had climbed, even without Russian genes. The holidays represent a disproportionate amount of the spirit business in general and Absolut's business in particular, due to gift-giving and increased entertaining, and we wanted to do something that would be newsworthy and would attract media coverage beyond the audience of readers who would actually see the ad. Carillon committed $1 million for one ad—a huge sum for print, and enough, we hoped, to create an advertising event.

In order to accomplish our goals, we knew we had to do something unprecedented. Otherwise, it would be just another ad—maybe a good ad, but not an event.

A little earlier, the staff of *New York* magazine had been invited by Dick McEvoy to present any special ideas that might be appropriate for an Absolut Vodka ad in their publication. They served up a mixed banquet, but one idea caught everyone's attention: a musical chip. Such chips could play only very short pieces of music and were hardly CD quality; they were also quite expensive. Today, it all seems very quaint, considering that musical greeting cards are now hawked on street corners; but in 1987, it was a big deal.

We developed the idea of embedding on a single chip segments of three different Christmas carols: "We Wish You a Merry Christmas," "Santa Claus Is Coming to Town," and "Jingle Bells." The chip would be mounted inside a heavy-stock, four-page card inside *New York* magazine. In theory, when the reader got to the card and turned the page, the songs would at once begin to play.

Ernie Capria, Carillon's Director of Marketing Services and jack-of-all-trades, went to Korea to supervise the chip's production.

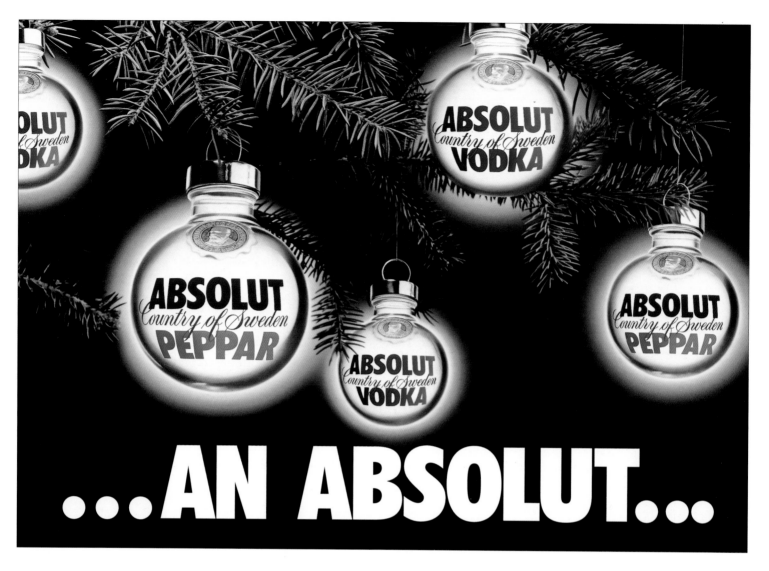

...AN ABSOLUT...

(He can laugh about it now, but he picked up a bug there that laid him up for weeks.) As this was to be the first time a chip was included in an ad, Ernie, working in concert with TBWA Production Director Jeff Greenberg, wanted to make sure that the ad's design would allow it to survive the rigors of the magazine's binding process and the delivery (and folding) procedures of the U.S. Postal Service.

By the Monday after Thanksgiving, we were all set. David Wachsman, head of public relations, had sent out copies of (HAVE AN) ABSOLUT BALL to television stations across the country and given the story to the Associated Press.

Despite all our well-laid plans, however, even we were unprepared for the magnitude of the reaction. Dozens of newscasters demonstrated the ad and actually played with it for their viewers. Columnists described mailboxes "singing" in apartment houses throughout

New York City (yes, some ads did have a tendency to play on their own, with no human intervention). Everybody was talking about this crazy Absolut Vodka ad, and the *New Yorker* even published a cartoon the following month , created by Robert Weber, acknowledging its ingenuity. The ad set a standard for creativity and hype that we've tried to match every year since.

The following year was tense, with the weight of the previous success hanging over us. From the start, I was a big believer in the notion of taking a low-tech route, to strike a contrast with the musical ad. We all kept our eyes peeled for potential ideas. One night at home, as I was saying good night to my six-year-old daughter, Ariane, I noticed a snow globe with a typical winter scene. Picking it up and then shaking it, I thought, I bet we could make a two-dimensional version of this thing and stick it in a magazine. And instead of a snowman we could have an Absolut bottle.

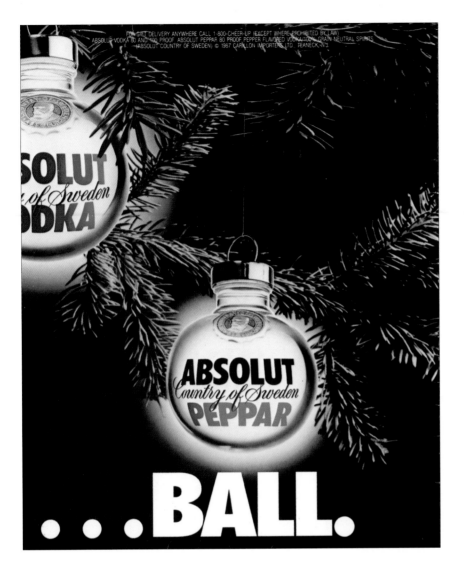

ABSOLUT
Country of Sweden
PEPPAR

....BALL.

The next day I described my idea to Tom McManus and Dave Warren. Tom said, "Richard, that's terrific. The only way it could be better is if we had thought of it."

A few weeks later, on a January morning in 1988, the TBWA team was out in Teaneck for our weekly meeting, this time to discuss the following Christmas. (We'd learned the previous year that these ads take a lot of time to plan and produce.) Arnie Arlow presented some ten would-be spectaculars. Michel Roux wore his cranky mask for much of the meeting. We got some smiles but no big thumbs-up. McEvoy spotted me fiddling with the snow ad. "Richard, what do you have under the table?" It was my turn. I brought out ABSOLUT WONDERLAND and explained what they were seeing. We had dummied up a "dry" version: paper snowflakes inside a plastic packet, which I lamely shook to demonstrate the effect. I added, "Naturally,

there'll be some water or other liquid inside the real ad so the flakes will float and sink."

Michel was half impressed. Ernie Capria vowed that he wasn't going back to Korea. McEvoy said, "Great idea. But forget the water." We had the beginnings of a sale.

Producing the ad was a real adventure. I hired a little company in New Rochelle, New York, called Signature Marketing, to produce it. I had met Signature's President, Howard Terriss, the previous fall, and knew that his company was one of a small handful specializing in this kind of interactive ad production. Jeff Greenberg, the agency's production guy extraordinaire, would supervise and fill me in every step of the way. Nearly every day brought a new problem, or revived one we thought we had already solved.

Once again we had $1 million for the production, but snowflakes don't come cheap. And we had to devise a way to keep the liquid, propylene glycol, safely inside the plastic pouches. (We had promised everybody, especially McEvoy, that they wouldn't leak.) We had a Maryland testing laboratory certify that the liquid was harmless if ingested, and Dave Warren penned a line to appear on the ad to discourage any such experimentation: DO NOT PUNCTURE THIS AD. AND PLEASE, DO NOT DRINK THE LIQUID INSIDE. IT'S NOT FOR HUMAN CONSUMPTION. IT'S NOT ABSOLUT VODKA. (You just never know.)

Jeff Greenberg went to China to supervise the ad's assembly. He'd report in on a daily basis, recounting each potential mishap he had averted. Finally, ABSOLUT WONDERLAND ran in *New York* magazine on December 12, 1988. It was a great issue. The cover story was legendary adman Ed McCabe's account of how Mike Dukakis's team had screwed up his presidential campaign by ignoring McCabe's and other professionals' advice.

The ad got terrific play, and best of all, there were only two reported leaks. One woman claimed the liquid had oozed onto her boots while she was riding the subway; I paid to have them shined. Another woman,

"OH, MY GOD! IT'S ALIVE WITH THE SOUND OF MUSIC."

on the West Side, said it had ruined her antique coffee table. But instead of calling Absolut or us, she contacted one of those problem-solving units on the local TV news, and that was how I learned of it. I raced uptown and met the woman. Her apartment was probably worth $2 million. She showed me a microdot-sized spot. We spent a few hundred dollars to have the entire table refinished. Michel Roux had taught me that when a little mishap occurs, the best thing to do is to overfix it.

One last thing: today, people still rib me for "stealing" my daughter Ariane's idea. Even she has come to think of it as her own.

Over the following years, we began to conceive of these holiday ads as annual pieces of Absolut entertainment for our customers, friends, and readers. They might take the form of a Christmas card, a surprise, an association with a worthwhile charity or cause, or an actual gift that the reader could remove from the magazine and keep. Sometimes we could even combine all of these elements in one ad.

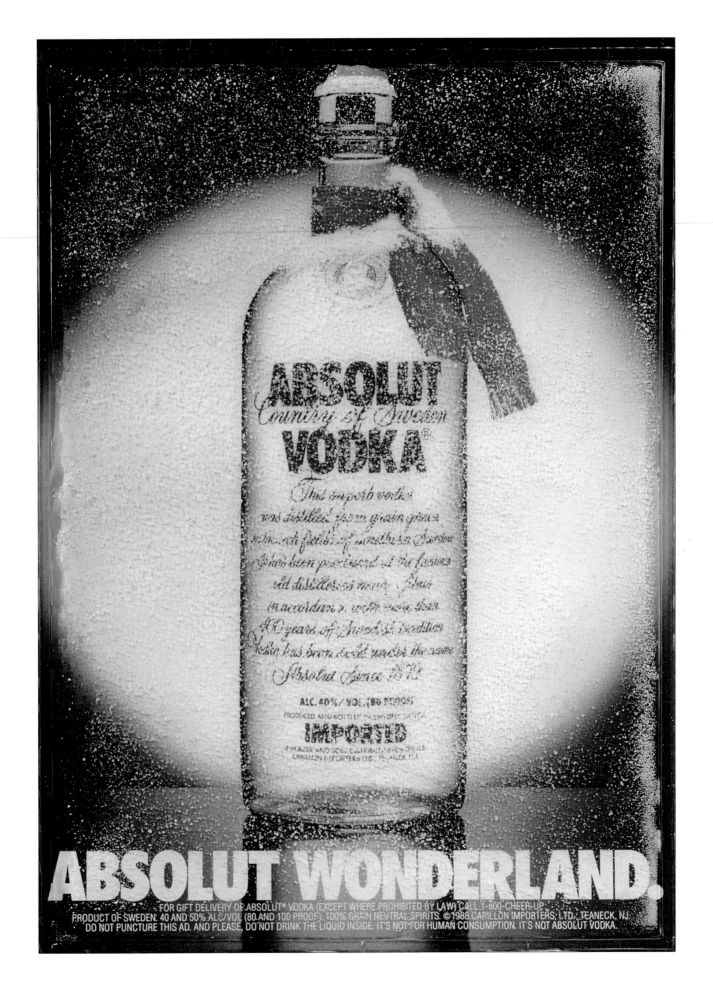

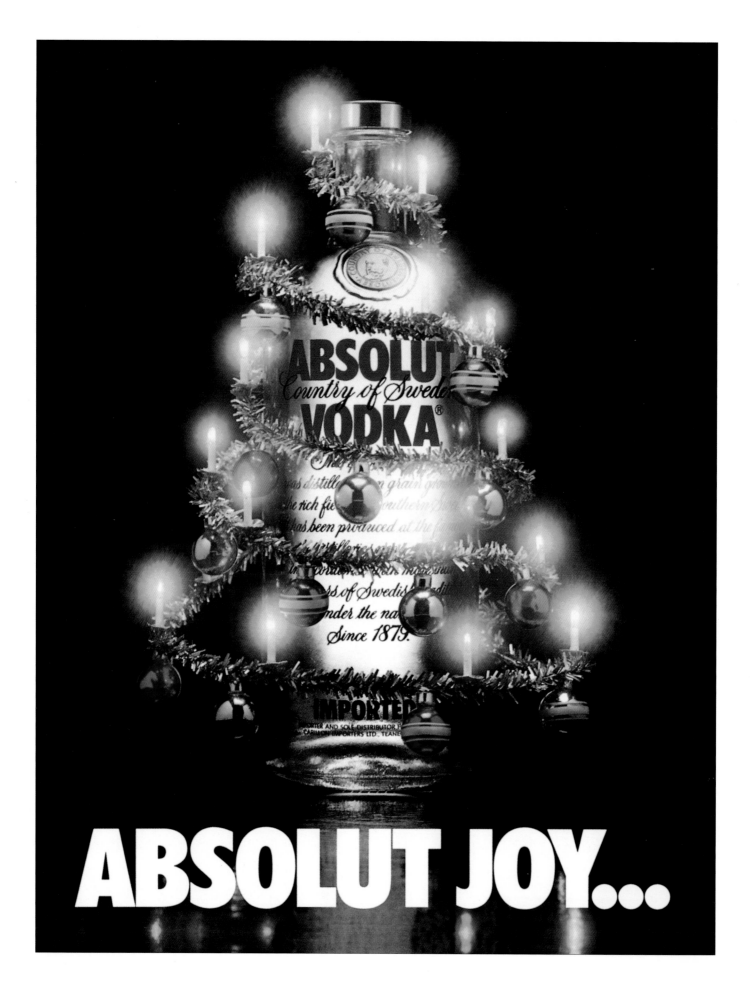

ABSOLUT JOY...

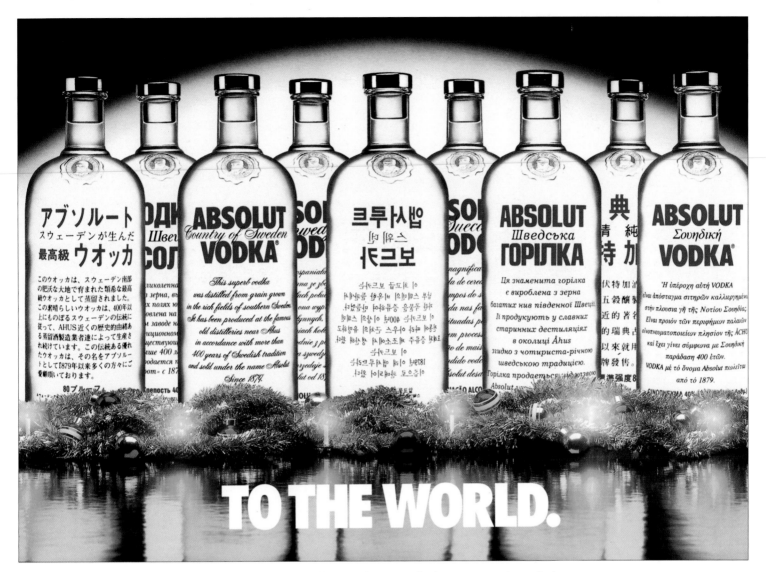

ABSOLUT JOY . . . TO THE WORLD. By 1989, chips were talking, and so was Absolut. We created an ad whose unit cost was greater than the $2.50 that readers paid for their December copies of *Vanity Fair*. ABSOLUT JOY . . . TO THE WORLD pictured an international assortment of foreign-language Absolut bottles—Russian, Japanese, Chinese, Greek (this last on Bill Tragos's insistence)—that had been specially mocked up for the ad. On opening the ad, readers heard the following greeting: "Absolut Vodka wishes you Merry Christmas, Feliz Navidad, Buon Natale, and Happy Hanukah!" Something for everyone.

ABSOLUT ENVIRONMENT.

ABSOLUT ENVIRONMENT. Michel Roux always had an eye out for worthwhile causes that Absolut could become associated with. While some critics were a little cynical about Absolut's role in protecting the environment, readers appreciated the recycling message and ordered thousands of posters of the Arctic environment.

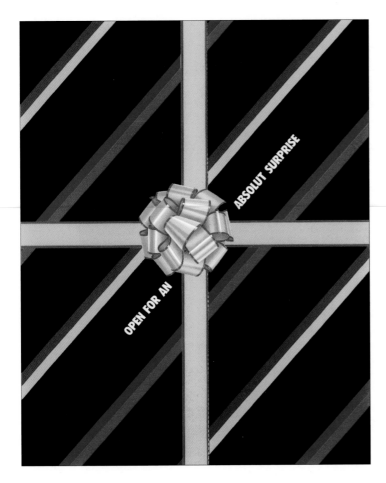

ABSOLUT GIFT. In 1991, the series was revitalized by the addition of a new twist: an actual gift for readers *inside* the magazine. Nicole Miller had recently become famous for her fashion designs, particularly her themed necktie line featuring sports, leisure, and geographic symbols. For Absolut, Nicole created a not-available-anywhere-else item: a silk pocket square emblazoned with Absolut bottles, lemons, peppers, and so on. This unisex accessory was sported by many women in the following months. It's a great example of an ad that keeps on going.

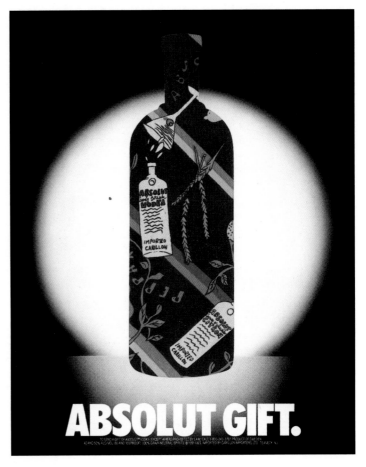

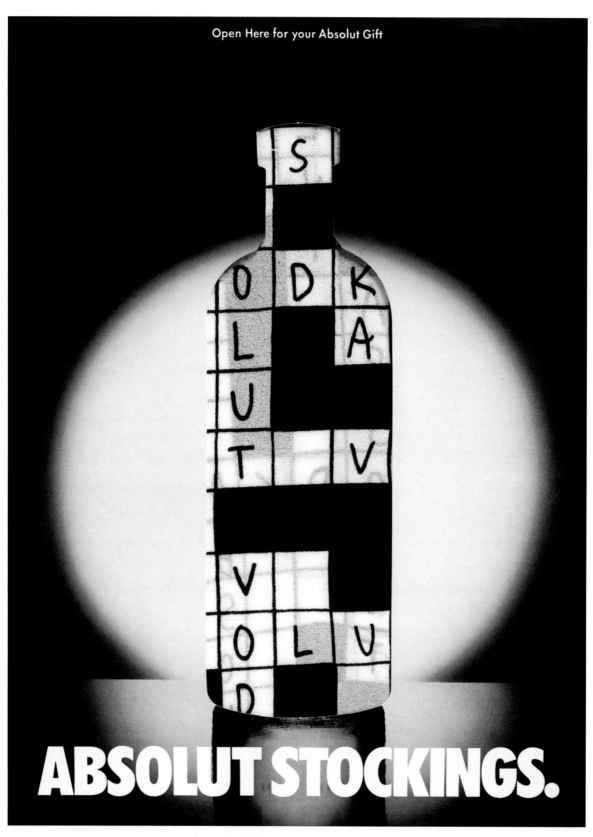

ABSOLUT STOCKINGS.

ABSOLUT STOCKINGS. In 1992, we did a variation on the clothing theme, commissioning Christian Francis Roth to design a pair of stockings. (This ad did produce one glitch that I know about: a charming woman from Staten Island complained that the dye from the stockings had somehow transferred to the interior soles of her gray dress shoes, and said this was embarrassing when she was in public. Of course, I apologized, but I couldn't help asking who would notice that she had black dye on the inside soles of her shoes. "Everyone," she replied, "because I usually remove my shoes when I'm out at a function." Ah. I told her to buy herself a new pair of shoes and promised that we'd reimburse her—so long as she surrendered her old shoes. She agreed, reluctantly. I still have those shoes, a trophy of sorts, on the windowsill in my office.)

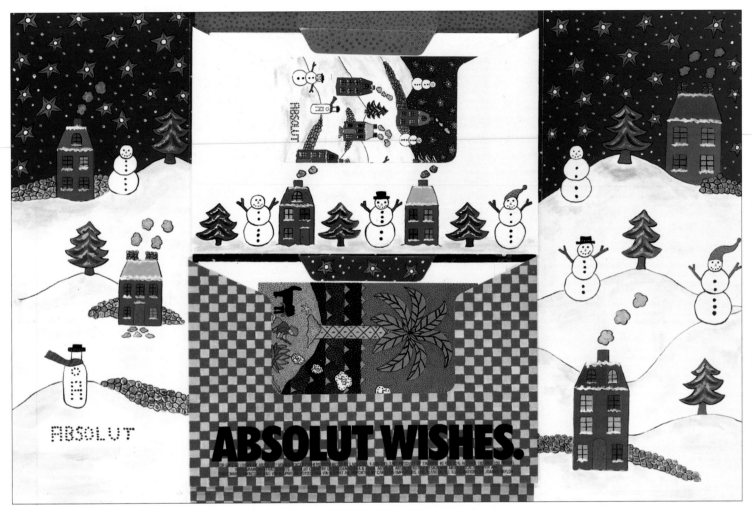

ABSOLUT WISHES. This set of Absolut greeting cards (and envelopes) was designed by artist Joanna Taylor for our 1993 Christmas ad. If less flashy than previous years' offerings, it was nonetheless an elegant little production.

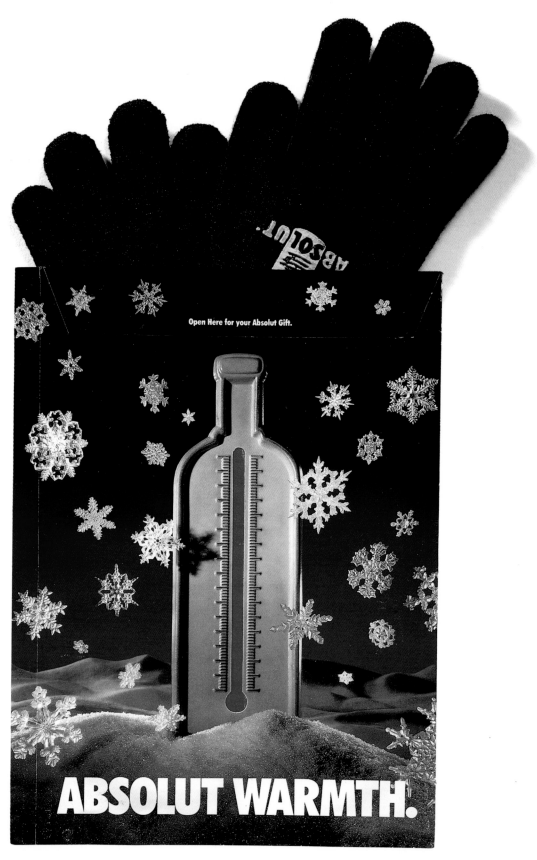

ABSOLUT WARMTH. Absolut recaptured the Christmas magic in 1994. We commissioned Donna Karan to design a pair of Absolut gloves under her DKNY label for *New York* magazine. These "one-size-fits-practically-everyone" gloves were produced in four color combinations, one for each of the Absolut flavors: red (Peppar), yellow (Citron), purple (Kurant), and blue (original). Absolut also donated cash and gloves to New York's Henry Street Settlement. Once again, you couldn't walk down Fifth Avenue without seeing New Yorkers festooned in their Absolut wear.

ABSOLUT BIRTHDAY. Fire-eaters, a "wing-standing lady" performing atop a vintage biplane, and a herd of goats to awaken the honored guest were all part of the week-long festivities for Michel Roux's fiftieth birthday, celebrated throughout Sweden in August 1990. In a calmer moment on birthday night were (left to right) Richard Lewis, Reatha Braxton, Bill Tragos, Michel, Arnie Arlow, Dick Costello, and Claude Fromm.

ABSOLUT

ABSOLUT

ABSOLUT

ABSOLUT

ABSOLUT

ABSOLUT

FASHION

ABSOLUT

ABSOLUT

ABSOLUT

ABSOLUT

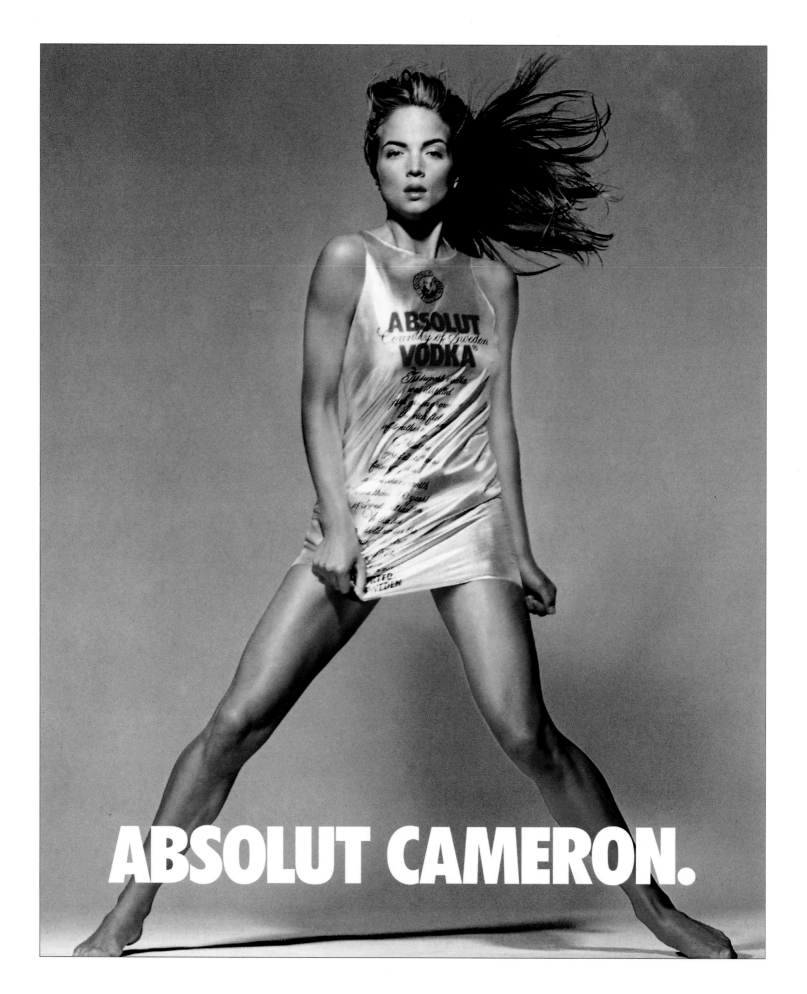

ABSOLUT CAMERON.

ABSOLUT FASHION.

The Absolut series of fashion ads is yet another example of a significant branch of the campaign that sprang from an unexpected source. And it came about largely because Absolut was known to have an open door to new ideas.

Amy Harris, a freckle-faced young advertising sales representative from *Mademoiselle* magazine, came to me in the summer of 1987 with a seemingly crazy idea: "Why not have a fashion designer create an Absolut dress?" I had visions of a tiny little frock draped over an Absolut bottle as if it were a Barbie doll. She quickly set me straight: "A fashion designer will put the Absolut bottle imagery on a dress—logotype, medallion, blue and silver colors, that stuff—and then you'll put it on a beautiful model and photograph it for an Absolut ad." I think I got it then.

Just as Absolut commissioned artists to demonstrate the brand's fashionability among trend-setting and opinion-leading consumers, Amy thought we could use actual "fashion" to much the same end. After all, fashion was another area of culture, popular or otherwise, in which consumers looked to define themselves but required taste agents to guide them.

Michel Roux understood the concept much more quickly than I had and soon gave us the go-ahead to pursue it.

Amy Harris knew a young, talented, and struggling fashion designer who might be interested in participating: David Cameron. He was friends with Steven Meisel, a well-known fashion photographer, and Meisel in turn was acquainted with Rachel Williams, a statuesque model who could wear the dress.

Cameron designed a simple silver minidress that carried the entire Absolut bottle copy on its front. The photo shoot took place on October 20, 1987, stock-market crash plus one. Arnie Arlow and I attended. Between takes of Rachel Williams making great running leaps, spinning, and landing for the camera, Arnie huddled on the phone with his stockbroker, trying, like much of the rest of America, to make sense of the market.

ABSOLUT CAMERON debuted the following February amid an avalanche of publicity. Not everyone understood exactly what we were doing; some reporters, missing the point, even

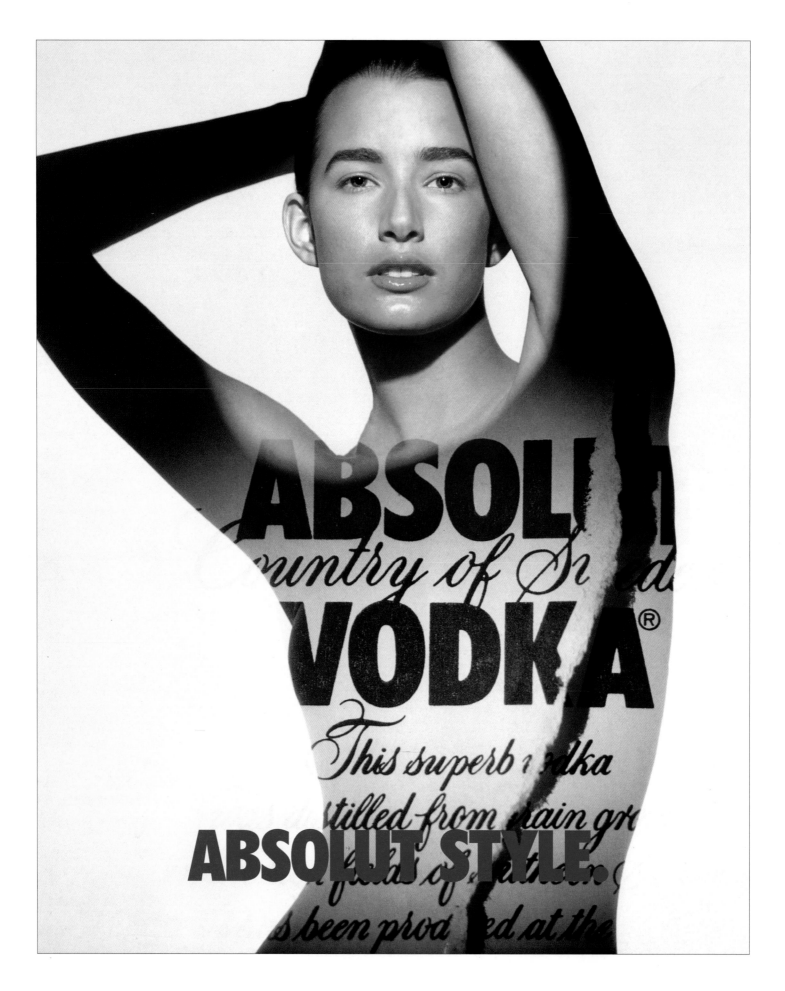

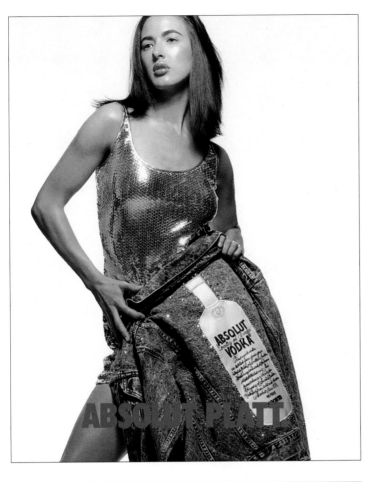

accused Absolut of using sex to sell vodka. Nearly five thousand phone calls were logged by the spirits-by-phone gift service whose 800 number appeared in tiny type at the bottom of the ad. Virtually all of the callers were women who wanted to purchase the dress. Reasoning that Absolut was in the fashion business as much as it was in the liquor business, we were momentarily tempted to reproduce Cameron's creation and sell it to the public, but wiser heads ultimately prevailed: we realized that being in the fashion business didn't necessarily mean we were in the dress business, so we politely turned away the orders.

By the following year, convinced that the fashion branch was a fruitful one, we had begun an annual series of fashion portfolios, each featuring the work of up to sixteen different designers. Just as we had sought up-and-coming artists to paint Absolut ads, we now commissioned mainly young or undiscovered fashion designers. Like the artists, the designers were given total freedom to incorporate the Absolut bottle imagery into their choice of clothing. Since these designs were one-of-a-kind creations for Absolut, they had to please neither Seventh Avenue nor Main Street and could therefore be a little flamboyant, a little tongue-in-cheek, and not always, well, practical. The fashions did, however, make regular appearances at Absolut-sponsored fund-raising events and other Absolut business occasions.

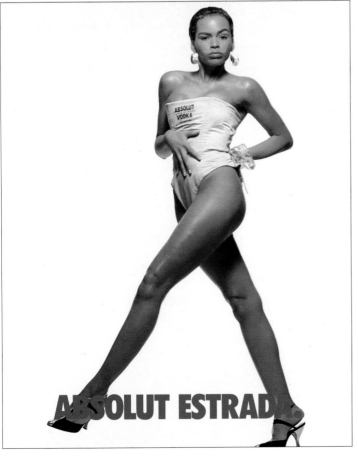

ABSOLUT STYLE. This eight-page spread appeared in *Vogue* in 1989. The designs included Maria Del Greco's boxer's robe and tank-top shirt (her specialty), Marc Jacobs's sweater (photographed inside out), and Carmelo Pomodoro's Absolut Peppar cape and tights.

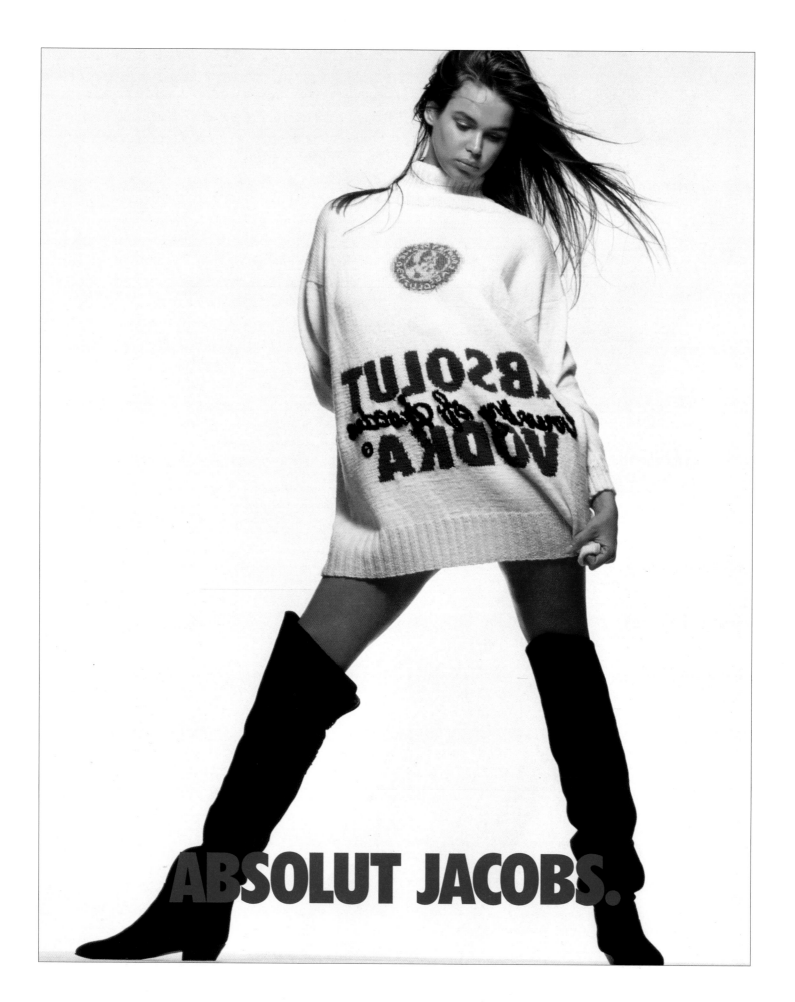

ABSOLUT JACOBS.

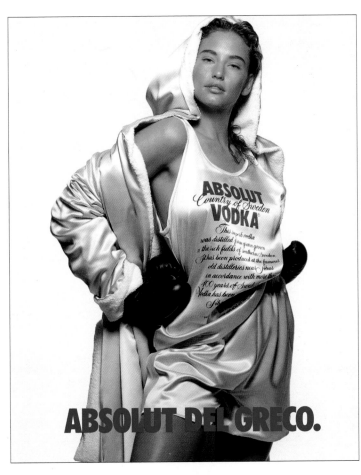

ABSOLUT DEL GRECO.

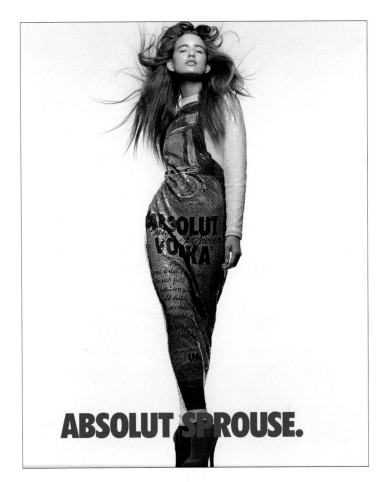

ABSOLUT SPROUSE.

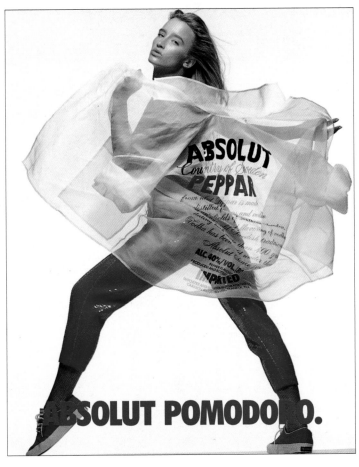

ABSOLUT POMODORO.

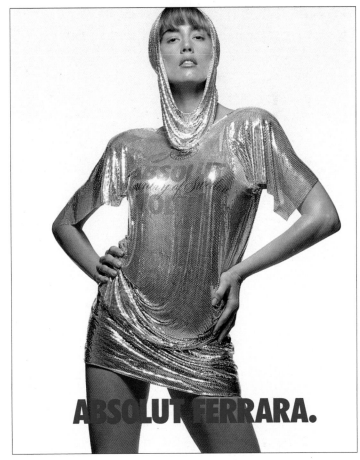

ABSOLUT FERRARA.

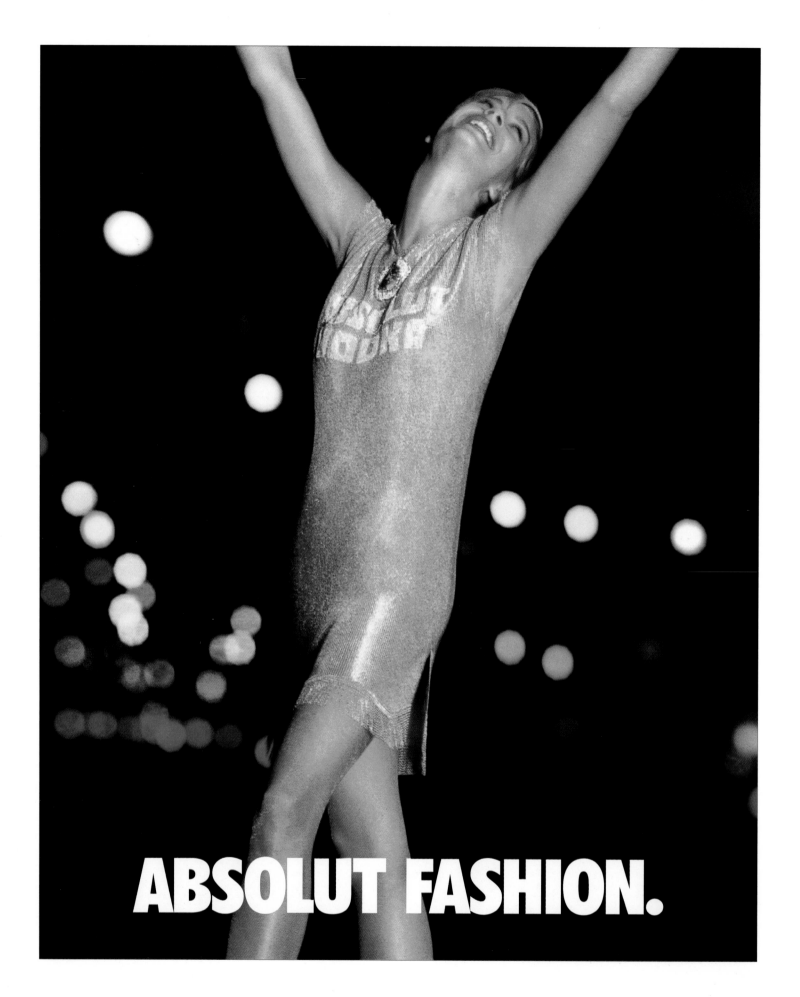

ABSOLUT FASHION.

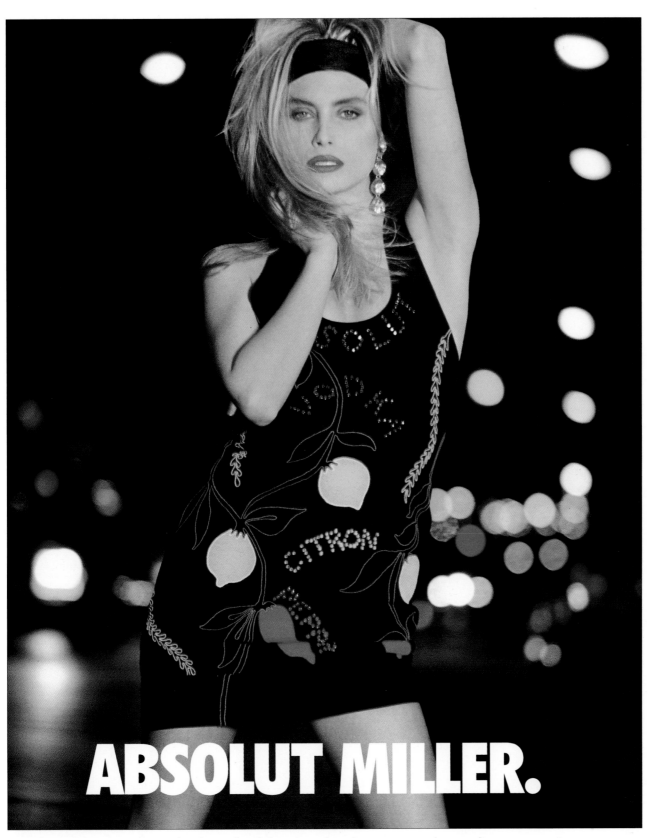

ABSOLUT MILLER.

ABSOLUT FASHION. In 1990 we hired Daniel Mahdavian, a talented newcomer, to photograph a ten-page unit for *Elle*. It was a striking spread as we took the fashions out of the studio and shot them at night on the streets of New York. The background of headlights, taillights, and the reds, yellows, and greens of the traffic lights complemented many of the fashions, particularly Nicole Miller's dress with its Absolut lemons and peppers. Anthony Ferrara's dress, made of solid gold mesh, adorned the opening page and had to be transported to the shoot by armored car and guard.

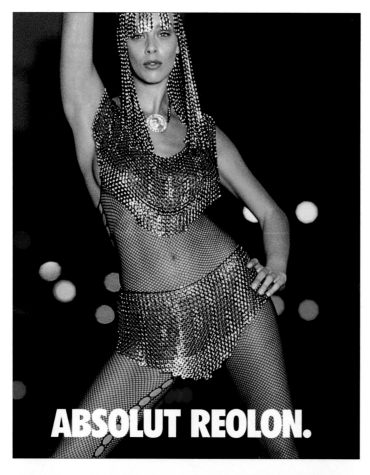

ABSOLUT REOLON.

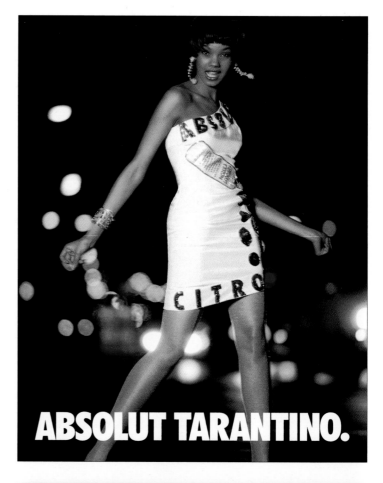

ABSOLUT TARANTINO.

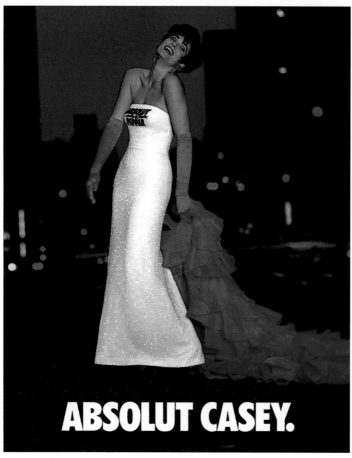

ABSOLUT CASEY.

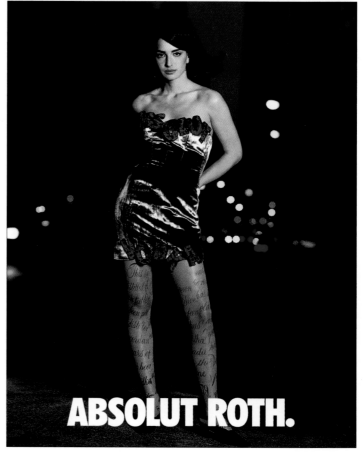

ABSOLUT ROTH.

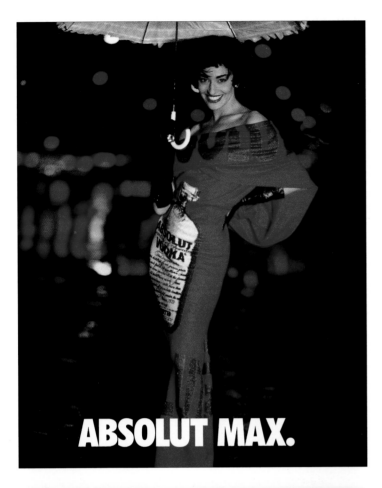

ABSOLUT MAX.

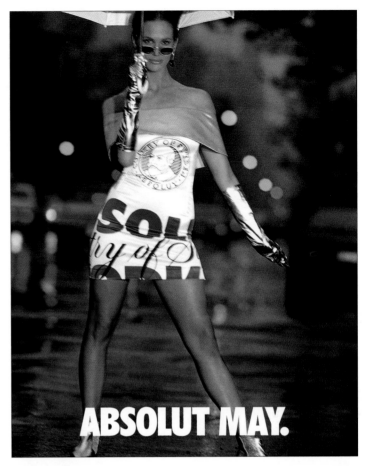

ABSOLUT MAY.

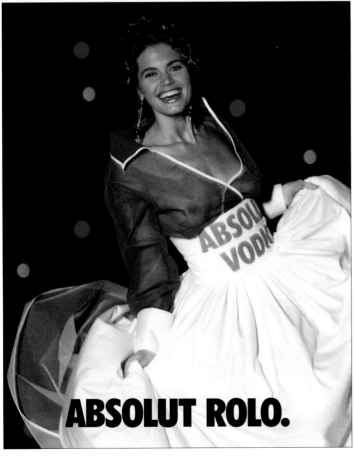

ABSOLUT ROLO.

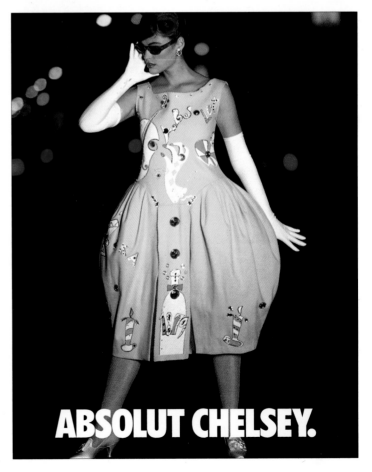

ABSOLUT CHELSEY.

Section photographed by Walter Chin. Styled by Jeffrey Miller. Grooming by Max Pinnell for Bumble & Bumble, NYC.

ABSOLUT GRAHAM

Designer: Nicholas Graham for Joe Boxer

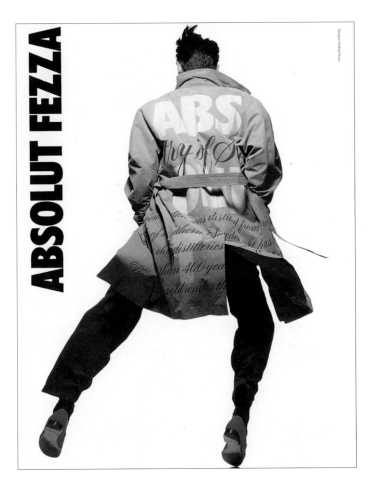

ABSOLUT FEZZA

ABSOLUT GRAHAM. This eight-page spread answered the question "When is Absolut going to do something for men's fashions?" Photographed by Walter Chin, it ran in *GQ* in '91. The designers were more established, and (most of) the fashions more conservative, even practical, better suited to the real world.

The highlights included Andrew Fezza's trench coat and Joyce Michel and Donna Cullen's Western boots. (There was much discussion about the extent to which the shot of the boots should be cropped; suffice it to say, good taste prevailed.)

We also adopted a more flexible typography treatment in this layout. So, for the first time, Absolut headlines also appeared on the top and side of the page—really, wherever they best fitted the particular photograph. If anyone noticed this subtle change it wasn't mentioned to us.

ABSOLUT WILKE · RODRIGUEZ

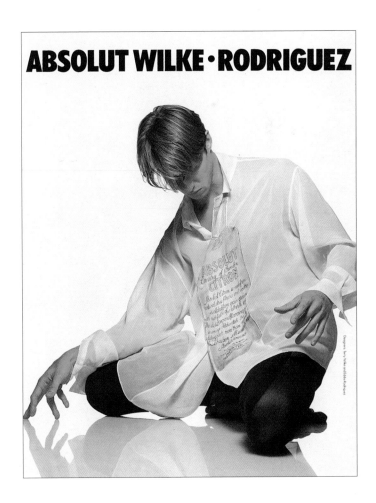

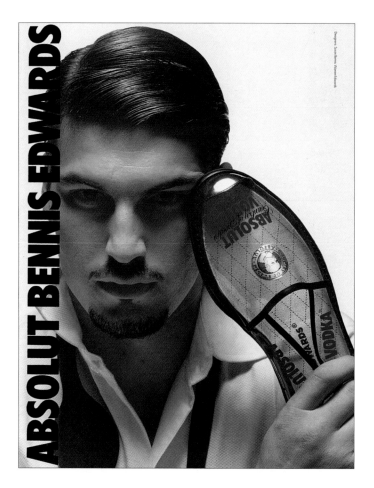

ABSOLUT BENNIS EDWARDS

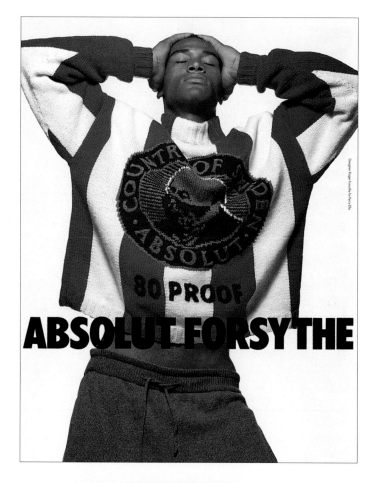

ABSOLUT FORSYTHE

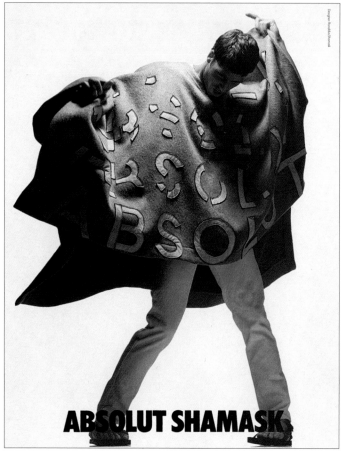

ABSOLUT SHAMASK

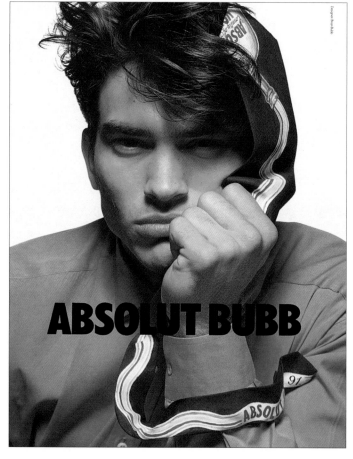

ABSOLUT BUBB

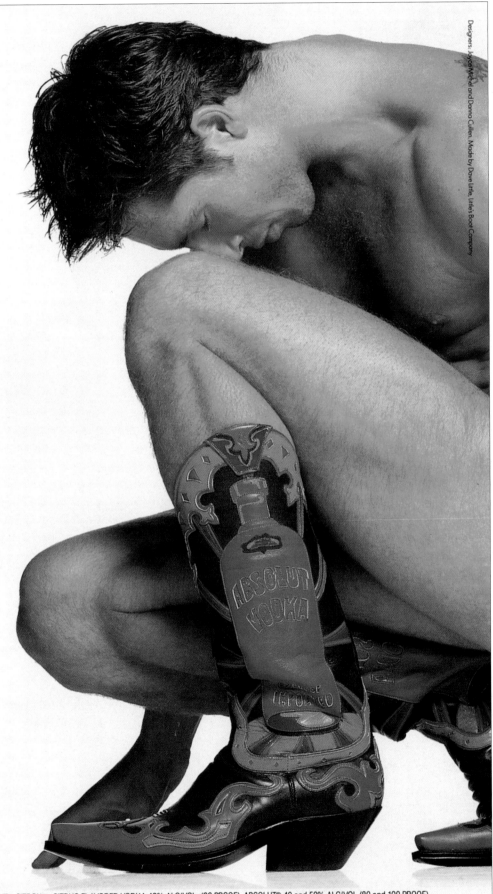

ABSOLUT MICHEL AND CULLEN

Designers: Joyce Michel and Donna Cullen. Made by Dave Little, Little's Boot Company.

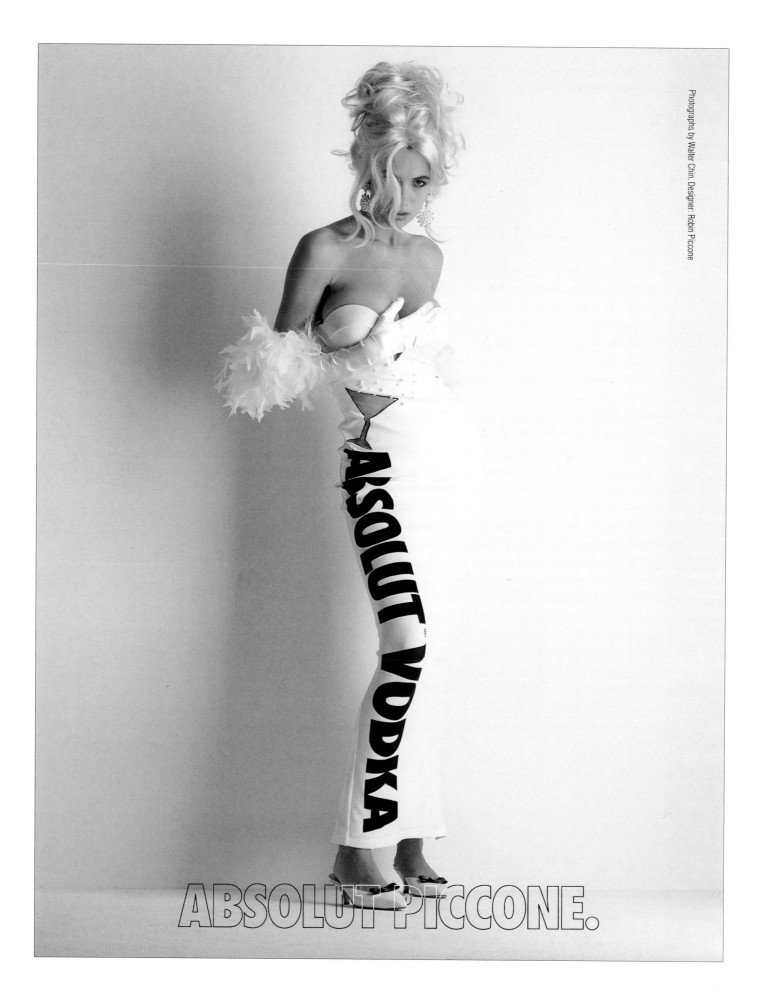

ABSOLUT PICCONE.

118

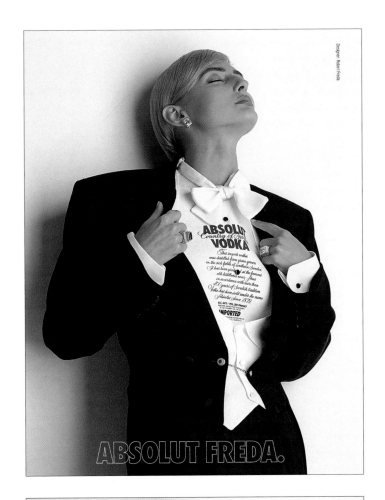

ABSOLUT FREDA.

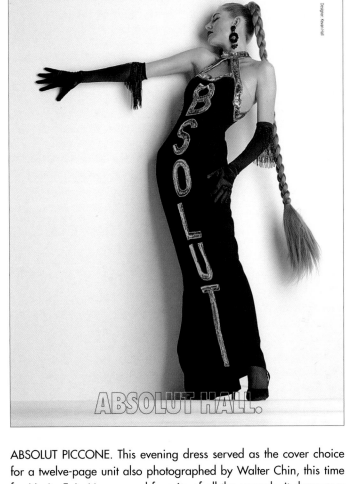

ABSOLUT HALL.

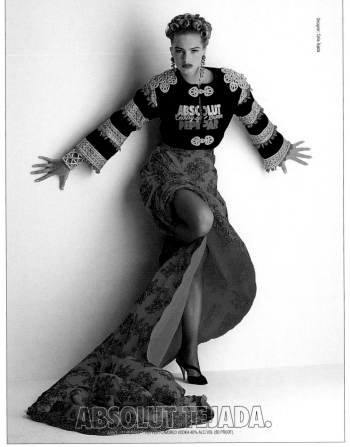

ABSOLUT TEJADA.

ABSOLUT PICCONE. This evening dress served as the cover choice for a twelve-page unit also photographed by Walter Chin, this time for *Vanity Fair*. My personal favorite of all the spreads, it showcases pieces that are highly original (see Randolph Duke's "scuba outfit"), elegant (Celia Tejada's bullfighter's dress) and classy (Michael Leva's evening gown). As an example of fashion consuming art, Jeanette Kastenberg's ABSOLUT JEANETTE included reproductions of ABSOLUT WARHOL, ABSOLUT HARING, and ABSOLUT BRITTO sewn onto the jumpsuit.

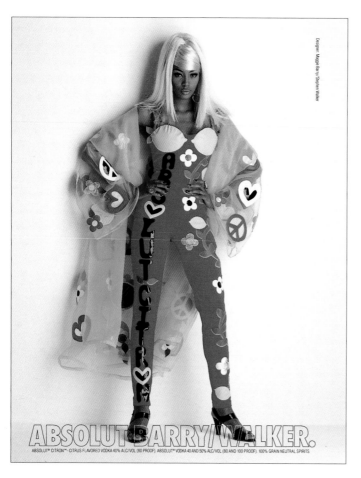

Designer: Maggie Barry / Stephen Walker

ABSOLUT BARRY/WALKER.

ABSOLUT® CITRON™ - CITRUS FLAVORED VODKA 40% ALC/VOL (80 PROOF). ABSOLUT® VODKA 40 AND 50% ALC/VOL (80 AND 100 PROOF). 100% GRAIN NEUTRAL SPIRITS.

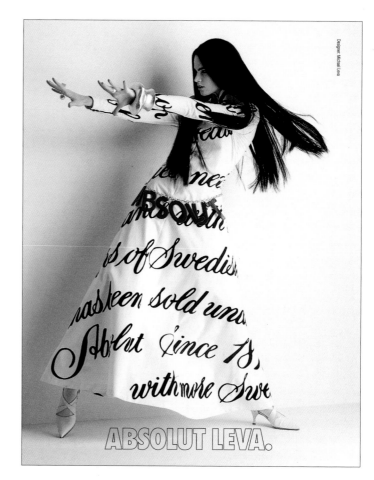

Designer: Michael Leva

ABSOLUT LEVA.

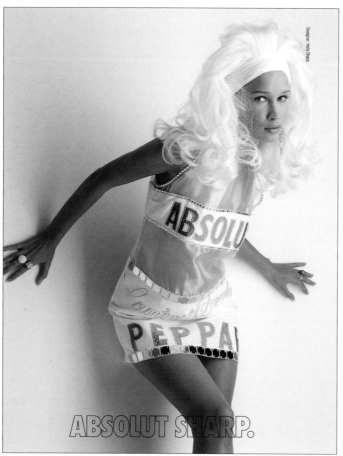

Designer: Holly Sharp

ABSOLUT SHARP.

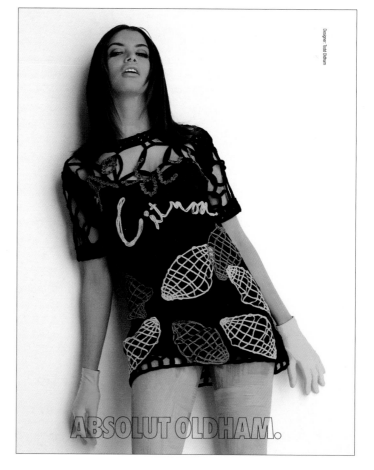

Designer: Todd Oldham

ABSOLUT OLDHAM.

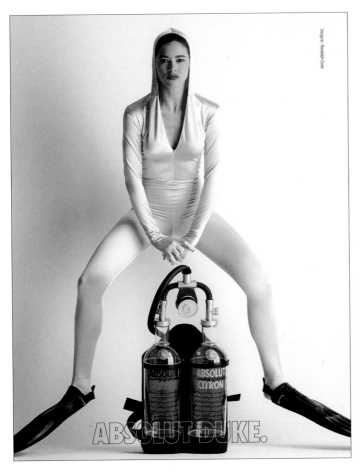

ABSOLUT DUKE.

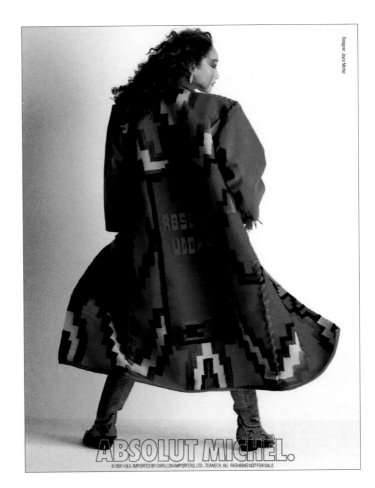

ABSOLUT MICHEL.

© 1991 V&S. IMPORTED BY CARILLON IMPORTERS, LTD., TEANECK, N.J. FASHIONS NOT FOR SALE.

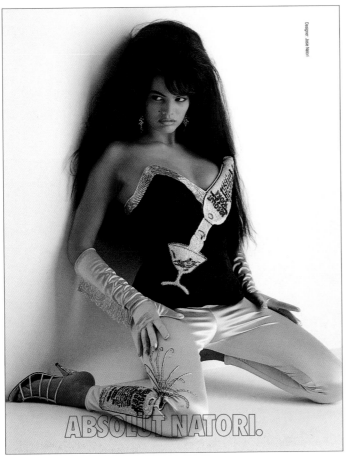

ABSOLUT NATORI.

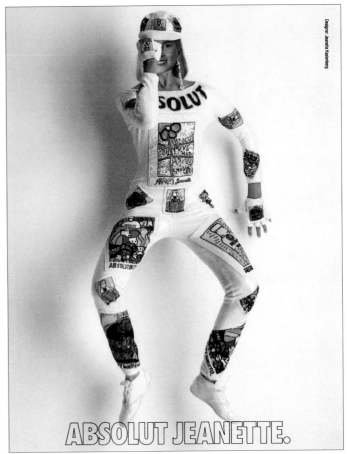

ABSOLUT JEANETTE.

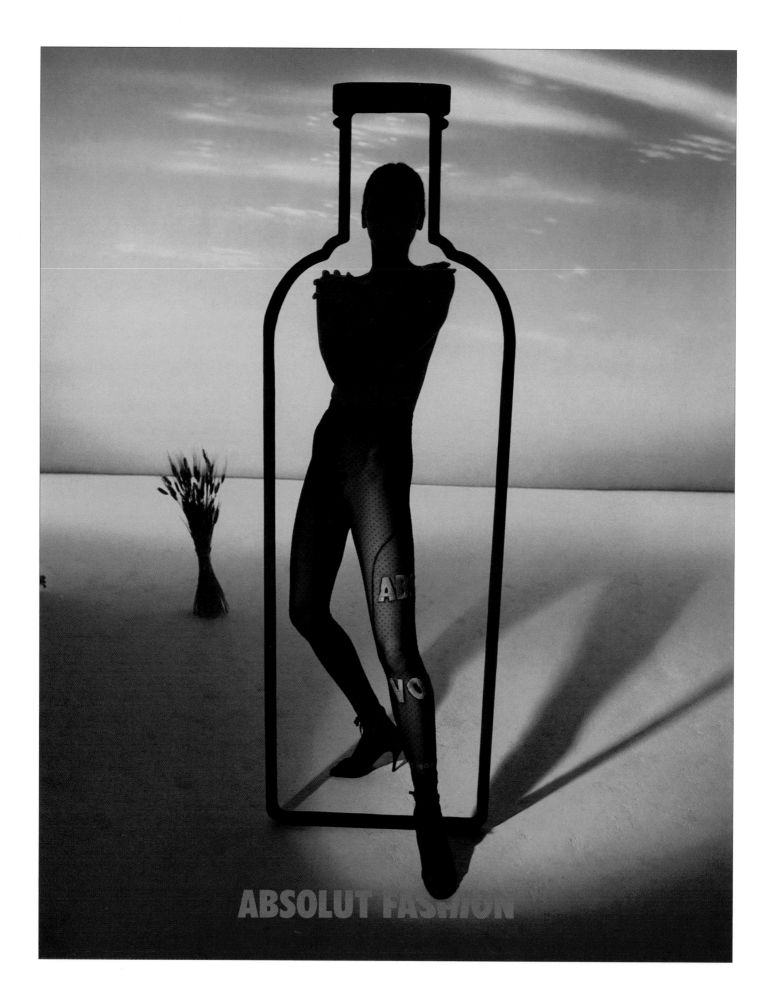

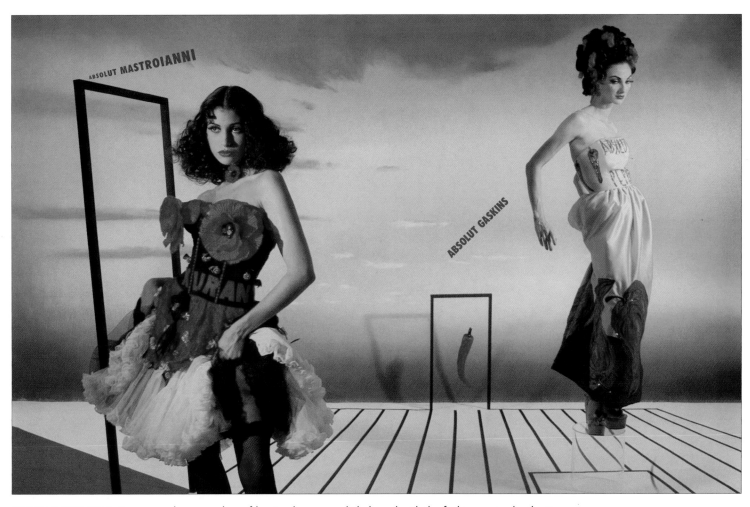

ABSOLUT FASHION. Some people accused us of having become a little bored with the fashion series by the time we produced ABSOLUT FASHION for *Harper's Bazaar* in 1993. Although the fashions really weren't any more whimsical or frivolous than in the past, some readers mistook Josef Astor's sets for a planet discovered by Captain Kirk's crew—a long-forgotten penal colony for fashion sinners. (Hey, we took a chance.)

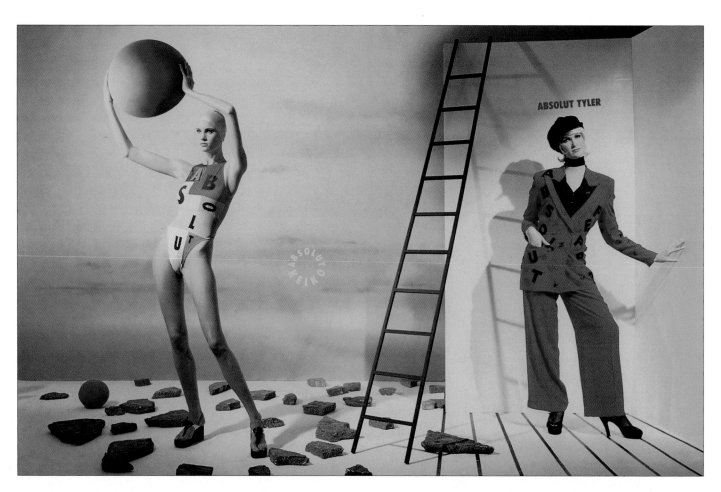

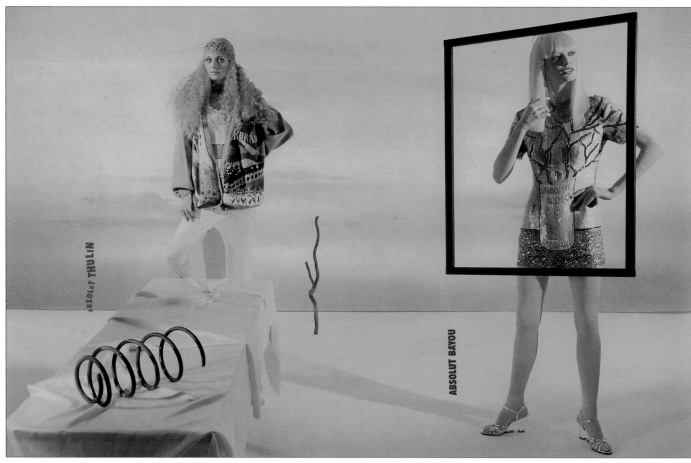

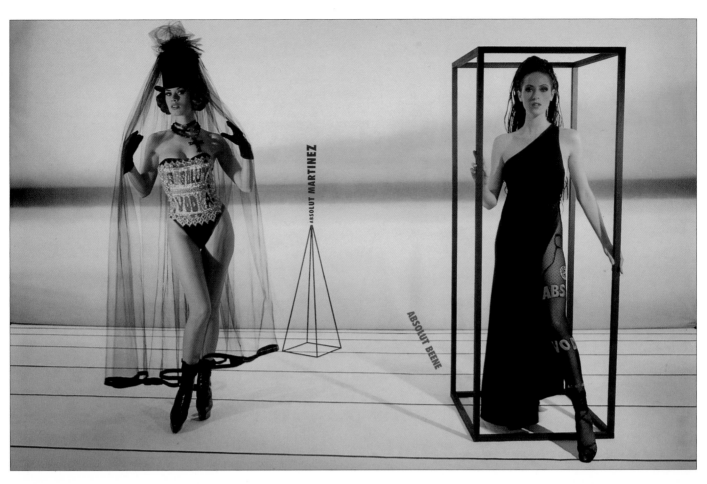

ABSOLUT MARTINEZ

ABSOLUT BEENE

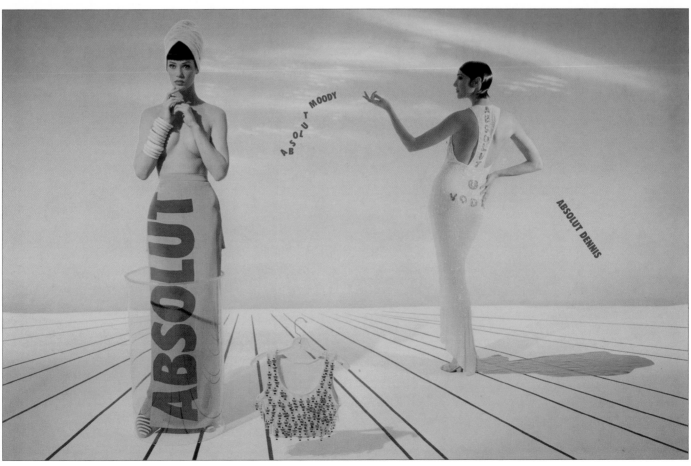

ABSOLUT MOODY

ABSOLUT DENNIS

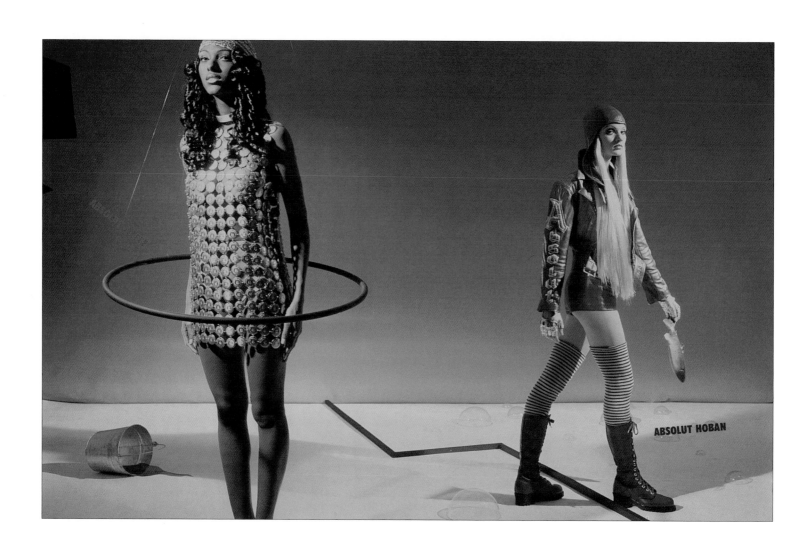

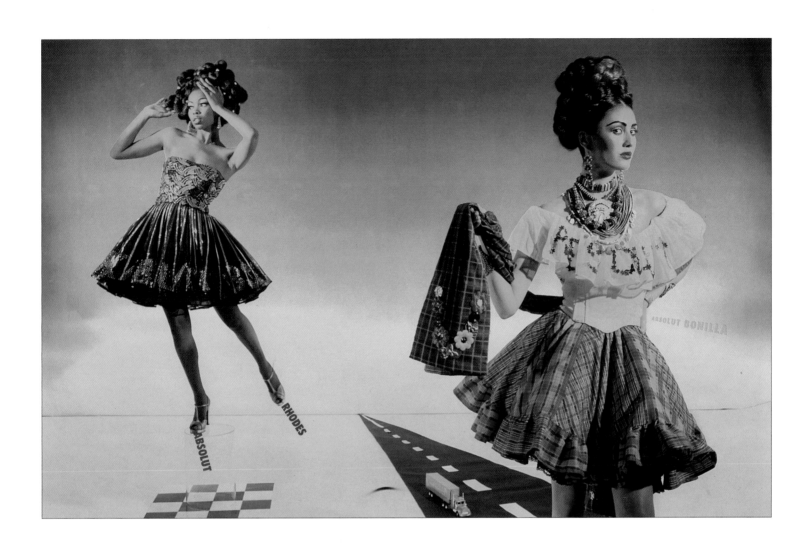

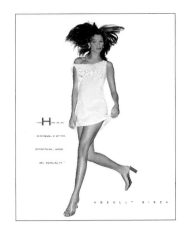

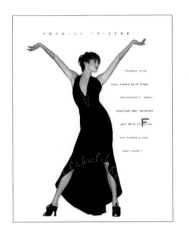

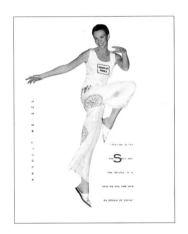

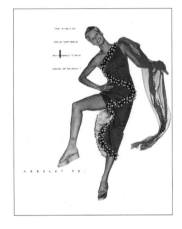

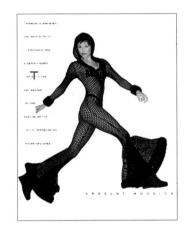

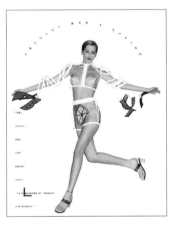

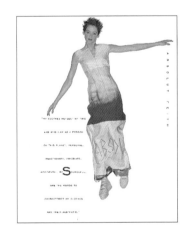

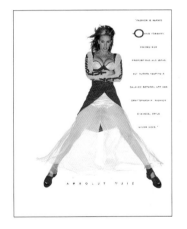

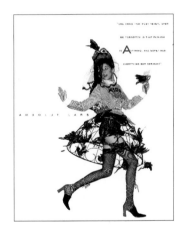

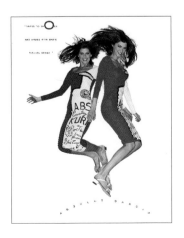

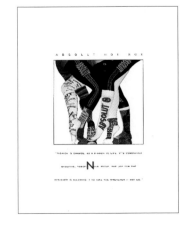

Continuing the evolution in the fashion format begun the previous year, the 1994 insert in *Elle* opted for tiny-type Absolut headlines and incorporated sound bites from the designers themselves, expressing their design philosophies. Byron Lars best summed it up: "One thing that must never, ever be forgotten is that fashion is anything, and sometimes everything, but serious." The layout, photographed by Gilles Bensimon, also included a Pauline Trigère evening dress and a half-dozen besocked calves from Gary Wolkowitz, co-founder of Hot Sox.

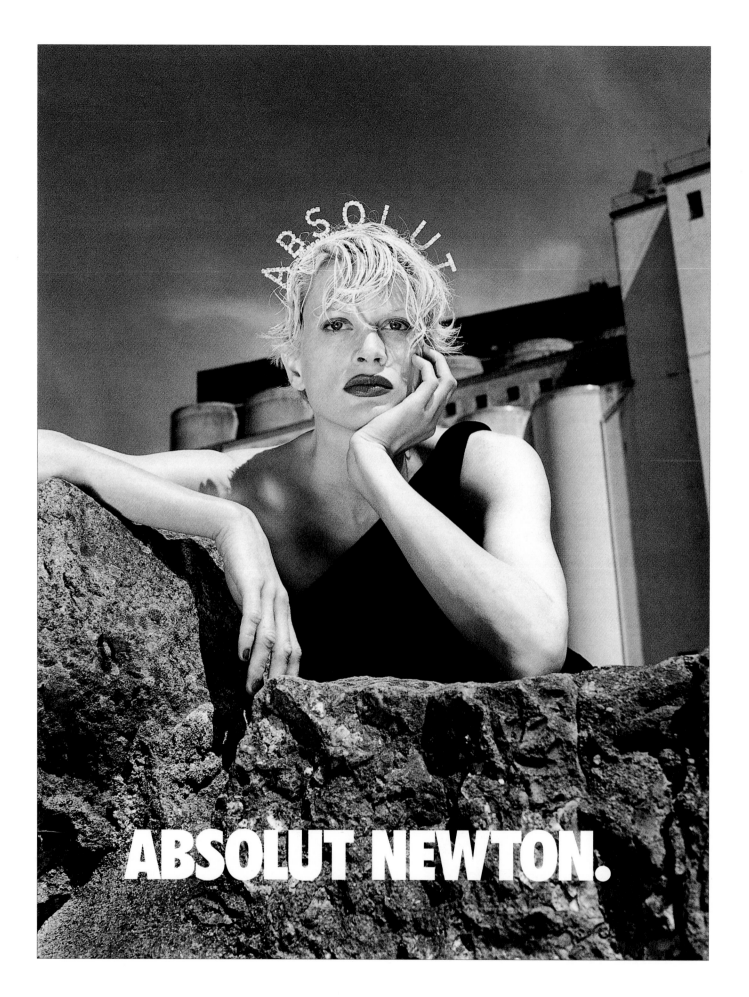

ABSOLUT NEWTON.

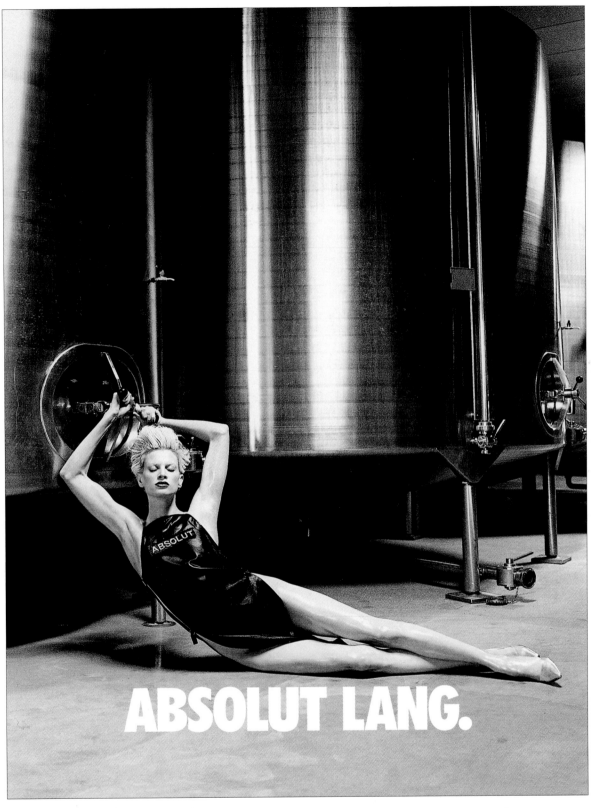

ABSOLUT LANG.

ABSOLUT NEWTON. In a marriage of fashion and tradition, Helmut Newton photographed this portfolio for *Vogue* in 1995 in his signature black and white style. Shot in Åhus, Sweden, the ad marked the first time we used an international ensemble of designers: Azzedine Alaïa and Martine Sitbon (France), Victor Alfaro (U.S.), Manolo Blahnik and John Galliano (U.K.), Helmut Lang (Germany), and Anna Molinari (Italy). Reflecting this international cast, the ad ran in a half dozen editions of *Vogue* throughout America, Europe, and Asia. Newton was inspired by Swedish traditions and myths and placed the piece's sole model, Kristen McMenamy, in various settings in and around the Absolut distillery. Kristen was extremely flexible; she was only uncomfortable when frogs jumped into her Blahnik-designed leather boots: "I became the Frog Lady of Åhus."

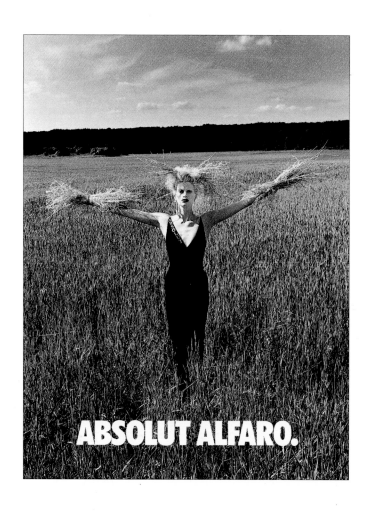

ABSOLUT ALFARO.

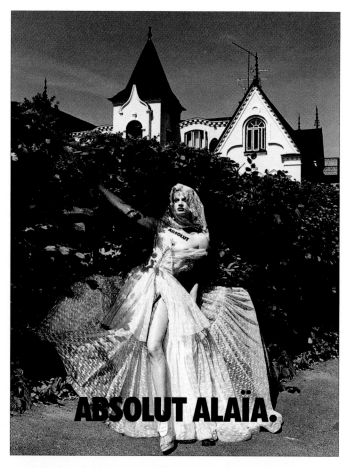

ABSOLUT ALAïA.

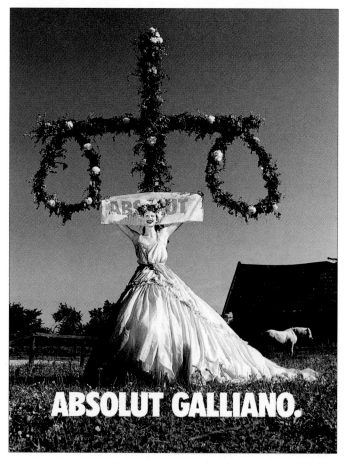

ABSOLUT GALLIANO.

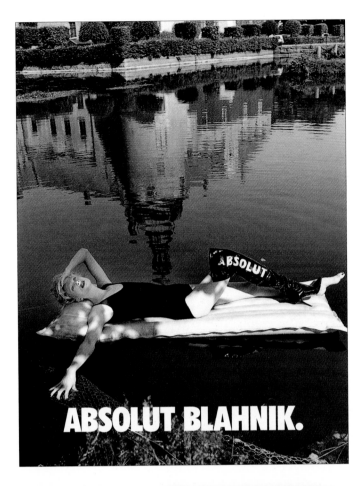

ABSOLUT BLAHNIK.

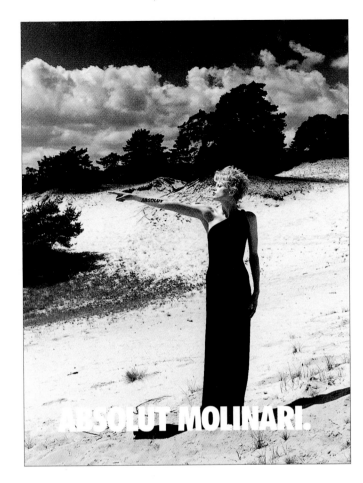

ABSOLUT MOLINARI.

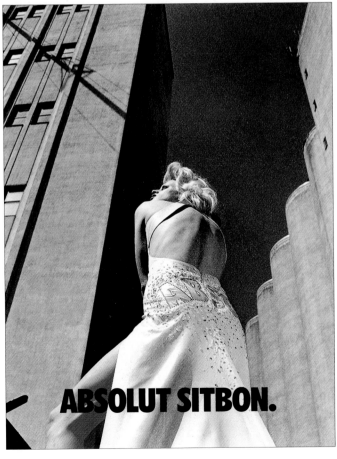

ABSOLUT SITBON.

ABSOLUT

ABSOLUT

ABSOLUT

ABSOLUT

ABSOLUT

ABSOLUT
THEMED ART

ABSOLUT AMERICANA.

ABSOLUT THEMED ART.

By 1989, the Absolut business was soaring, and the Absolut advertising had become, well, famous. That spring, Absolut won the first of what would be two Stephen E. Kelly Awards presented to it by the Magazine Publishers of America. The Kelly Award was particularly noteworthy because in an industry often accused, and rightly so, of overawarding itself, this was a one-award evening—that is, a single award was presented for the best magazine campaign in America. And there's also the little matter of a $100,000 cash prize, to be split among the ads' creators. (Agency President Dick Costello was the splitter; to his credit, there wasn't a single grumble among the recipients as to their respective shares.) Absolut was the first—and remains the only —alcoholic-beverage campaign to have won this prestigious award, further testament to the brand's ability to transcend the traditional life of a vodka. There seemed to be almost a frenzy at times as people thought, talked, and sometimes even drank Absolut.

In 1989 we also began the first of several themed artist magazine inserts. This meant assembling eight, twelve, sixteen, or twenty-four artists or more and having each one create an Absolut ad that would appear with the other artists' ads. The artists in a particular group were linked by membership in a similar school or a shared specialty or common heritage; sometimes, to be frank about it, they were together because Michel Roux thought they *belonged* together.

One unusual aspect of many of these inserts was our use of the various magazines' resources to produce them. We would ask the magazine sales and marketing people—the business side—to tap into the knowledge of their editorial people, who were likely to be familiar with many of the industry talents whom they covered and whom Absolut wanted to partner with. It was a simple idea, but it was rather revolutionary at the time.

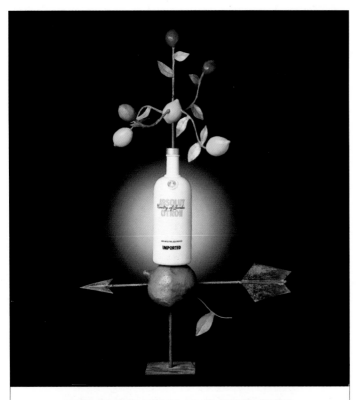

ABSOLUT LANGAN.

ABSOLUT NYESTE.

ABSOLUT CROSS.

ABSOLUT ZELDIS.

ABSOLUT JAKOBSEN.

ABSOLUT SHELLEY.

ABSOLUT NORBERG.

ABSOLUT AMERICANA. Our first artists' insert, ABSOLUT AMERICANA, presented the work of eight American folk artists selected in consultation with the Museum of American Folk Art in New York City, with a big helping hand from *Country Home* magazine, the carrier of the insert. The works included a fabulous quilt by JoAnn O'Callaghan and Angie Roth (page 136), and a pair of wooden chess players drinking Absolut, carved by John Cross.

ABSOLUT SOUTHWEST.

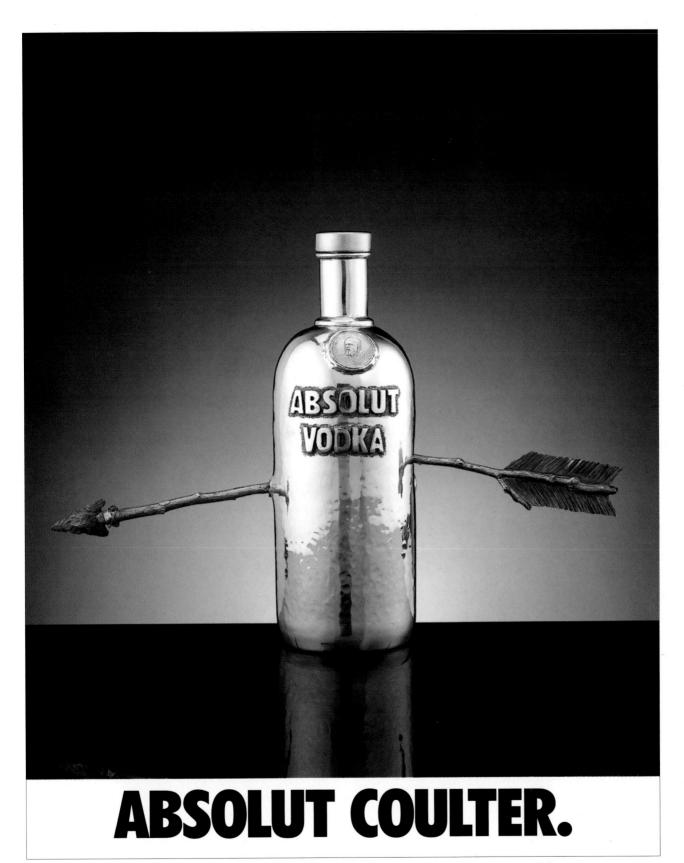

ABSOLUT COULTER.

ABSOLUT SOUTHWEST. The following year (1990), ABSOLUT SOUTHWEST appeared in the same publication. (*Country Home*'s ambitious young Advertising Sales Director, Dan Lagani, like many of us, learned a lot about art from his Absolut relationship.) The insert highlighted sixteen folk artists from the American Southwest, and as expected (and desired), all the art employed typical imagery of the area: rodeo, coyote, cactus, desert. Also, of course, Absolut bottles.

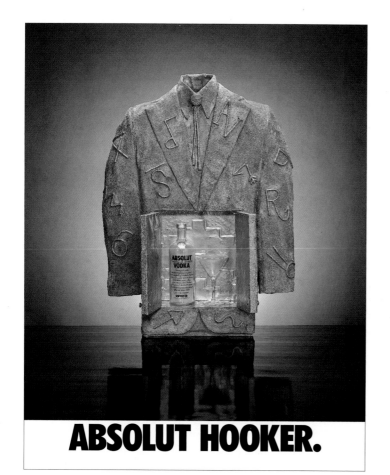

ABSOLUT HOOKER.

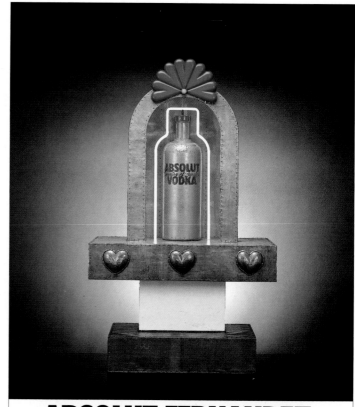

ABSOLUT FERNANDEZ.

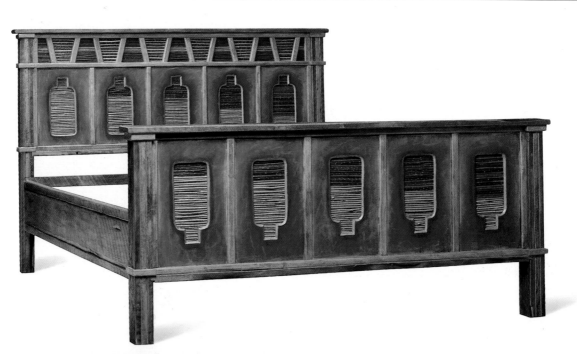

ABSOLUT RIGGS.

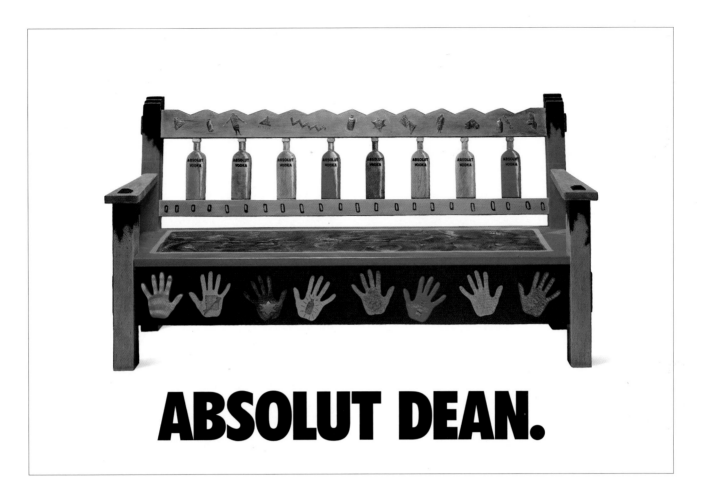

ABSOLUT DEAN.

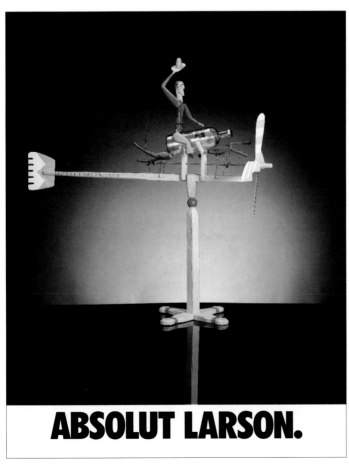

ABSOLUT LARSON.

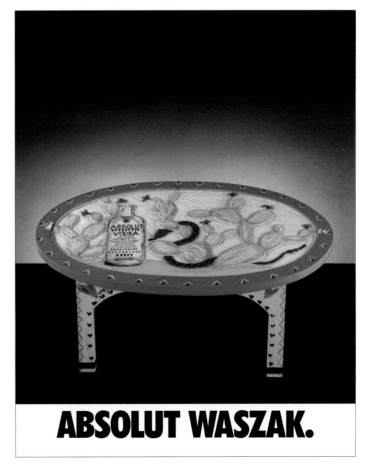

ABSOLUT WASZAK.

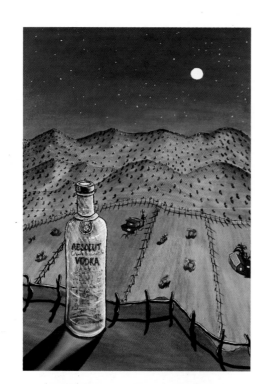

ABSOLUT VIGIL.

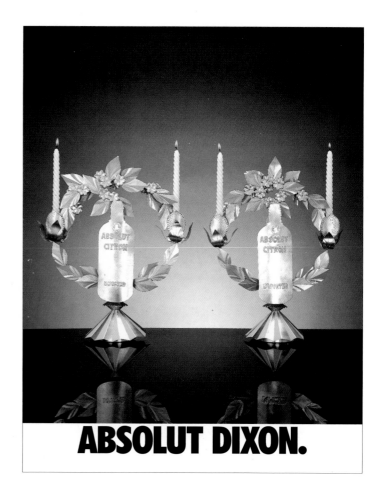

ABSOLUT DIXON.

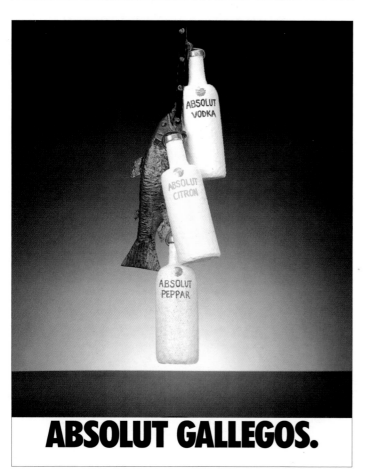

ABSOLUT GALLEGOS.

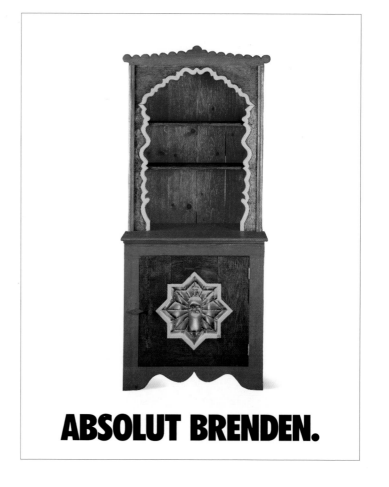

ABSOLUT BRENDEN.

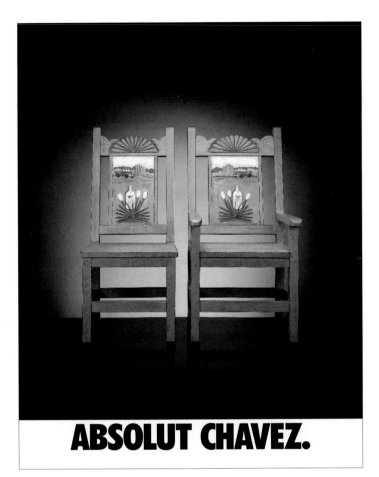

ABSOLUT CHAVEZ.

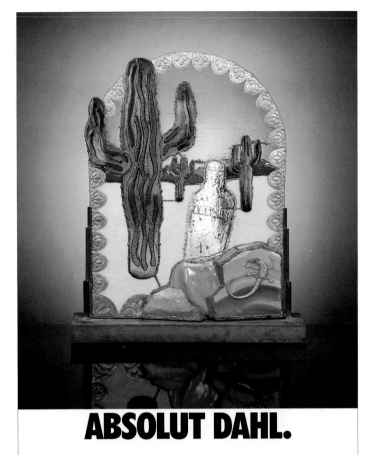

ABSOLUT DAHL.

ABSOLUT BURKE.

ABSOLUT PARSONS.

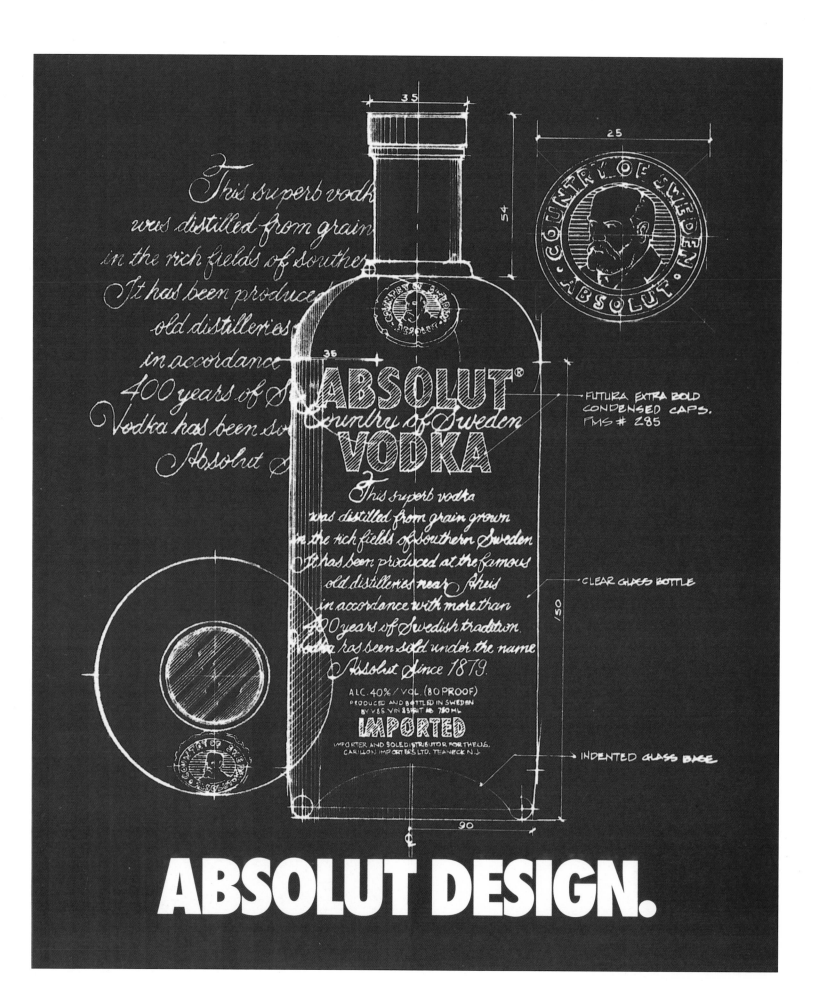

ABSOLUT DESIGN.

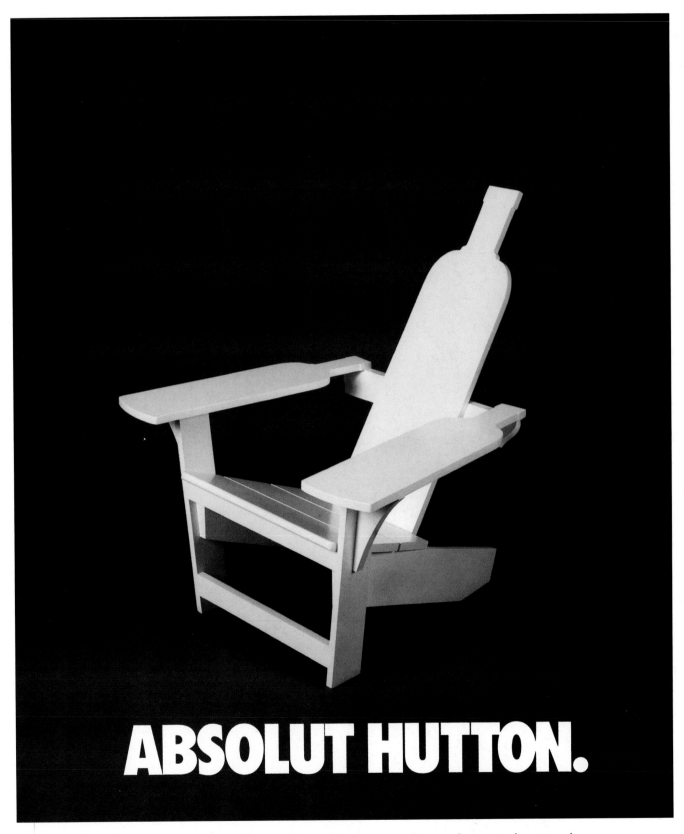

ABSOLUT HUTTON.

ABSOLUT DESIGN. In discussions with the publication *Metropolitan Home*, we discovered a previously untapped talent pool: designers. (That is, designers of furniture and interiors, both commercial and residential.) For what many consider to be Absolut's pièce de résistance of artistic commissions, we gathered eight design stars for this insert, which was titled simply ABSOLUT DESIGN. Each designer interpreted Absolut in his or her particular style or medium. Every piece was museum-quality, from Dakota Jackson's bar stool to John Hutton's Adirondack chair. Michael Watson's photo on the last page shows the assembled team of designers, with Michel, the captain, in the center.

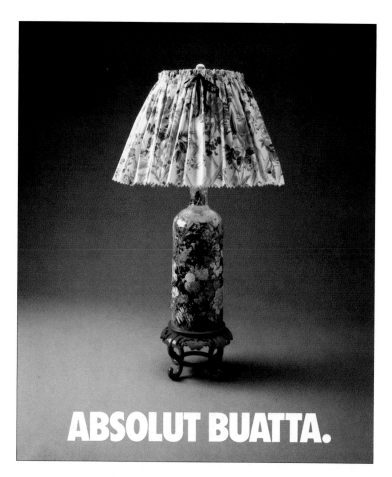

ABSOLUT BUATTA.

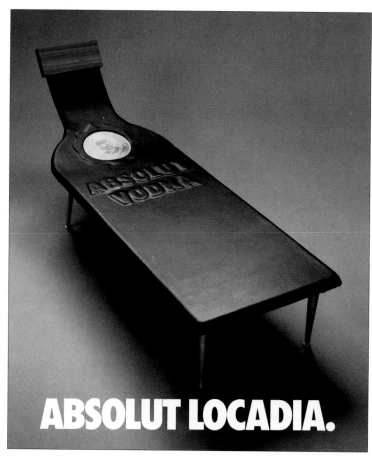

ABSOLUT LOCADIA.

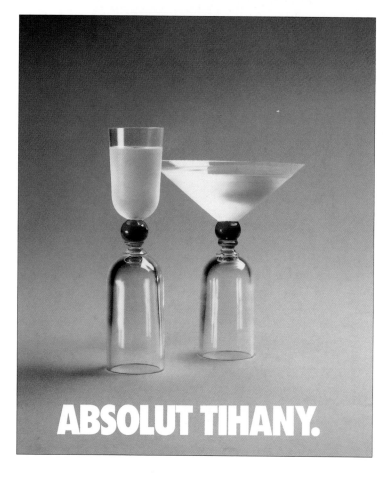

ABSOLUT TIHANY.

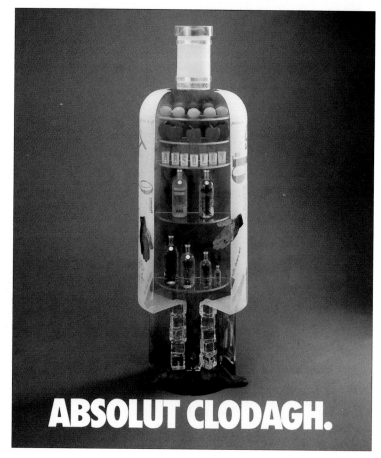

ABSOLUT CLODAGH.

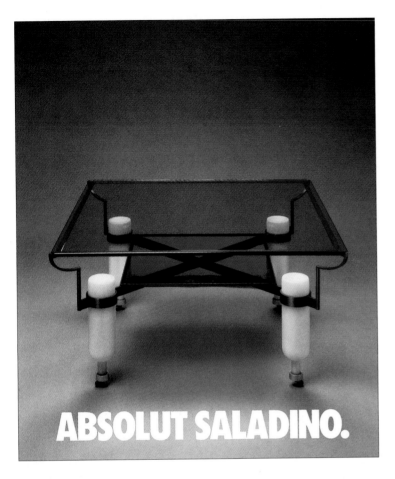

ABSOLUT SALADINO.

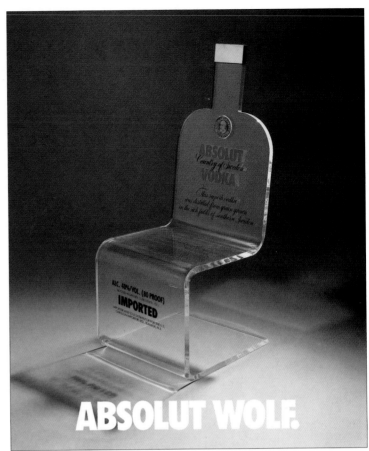

ABSOLUT WOLF.

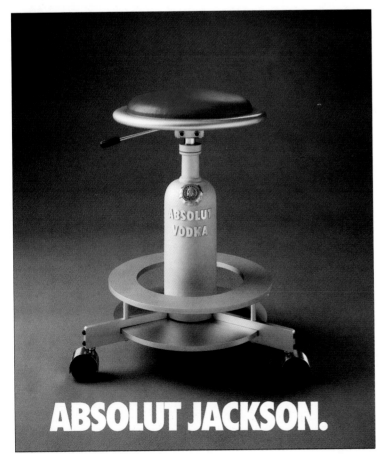

ABSOLUT JACKSON.

ABSOLUT DESIGNERS.

As we stand on the brink of a new century, new forms of expression

ABSOLUT

are being created all around us. We are, in fact, witnessing an

ARTISTS

explosion of creativity unrivaled in our time. Absolut has chosen

OF THE

the following artists because they are at the forefront of this activity.

NINETIES.

They represent to us the emerging trends of art in the 90s.

Michel Roux
President/CEO
Carillon Importers, Ltd.

ABSOLUT BLUM.

ABSOLUT ARTISTS OF THE NINETIES. Forget "less is more." More is more. As Michel Roux was exposed to the work of more and more young artists whom he admired, he began to feel the need for a vehicle to package and present some of that work to the public. That ultimately led to ABSOLUT ARTISTS OF THE NINETIES, a collection of thirty-six artworks by as many artists, who Michel felt represented an "explosion of creativity unrivaled in our time [and] the emerging trends of art in the '90s." Essentially an entire gallery within a magazine, the insert appeared in *Art and Antiques* and *Connoisseur* magazines in 1990.

ABSOLUT ECHO.

ABSOLUT SUAREZ.

ABSOLUT DUARDO.

ABSOLUT PARK.

ABSOLUT CARAEFF.

ABSOLUT BECKER.

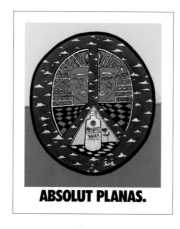

ABSOLUT PLANAS.

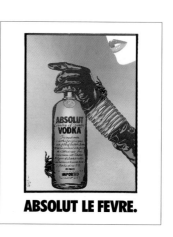

ABSOLUT LE FEVRE.

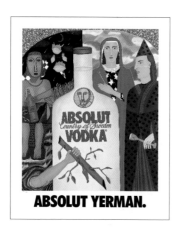

ABSOLUT YERMAN.

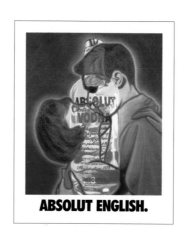

ABSOLUT ENGLISH.

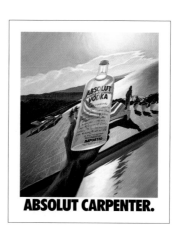

ABSOLUT CARPENTER.

ABSOLUT PACOVSKY.

ABSOLUT POLENGHI.

ABSOLUT MOTHERSBAUGH.

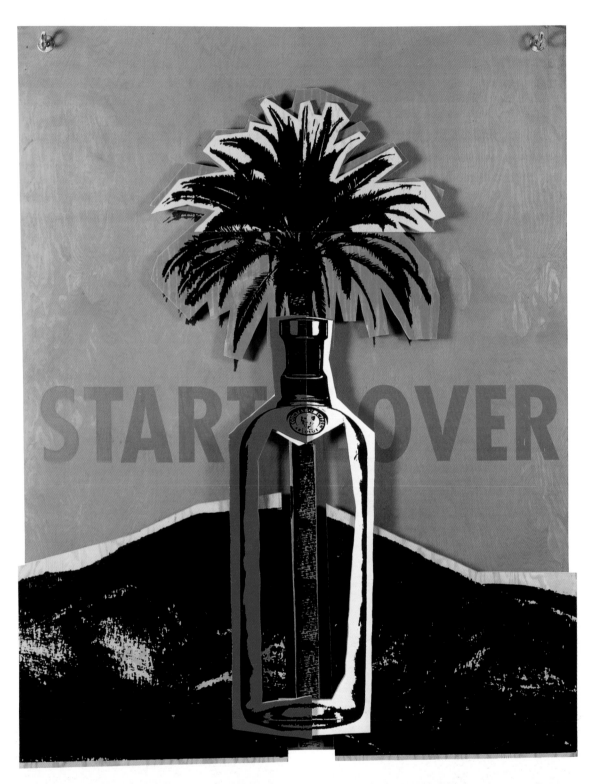

ABSOLUT VAN HAMERSVELD.

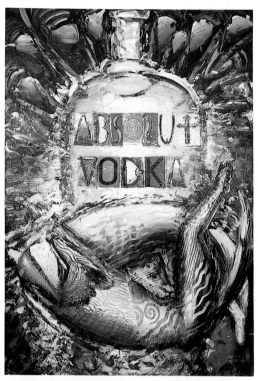

ABSOLUT MAHON.

ABSOLUT MIRIPOLSKY.

ABSOLUT CHRISTOPHER.

ABSOLUT WHITE.

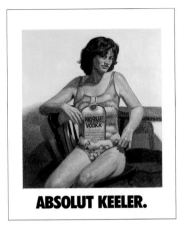

ABSOLUT KEELER.

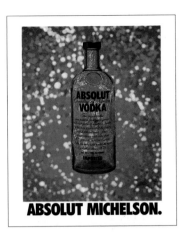

ABSOLUT MICHELSON.

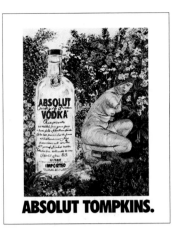

ABSOLUT TOMPKINS.

ABSOLUT JENSON.

ABSOLUT AVITAL.

ABSOLUT ZOX.

ABSOLUT EDERER.

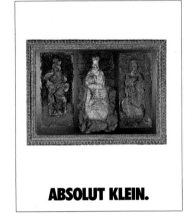

ABSOLUT KLEIN.

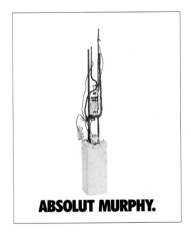

ABSOLUT MURPHY.

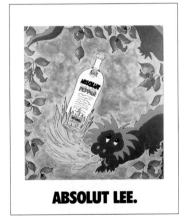

ABSOLUT LEE.

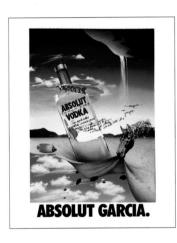

ABSOLUT GARCIA.

ABSOLUT SHIRE.

ABSOLUT DEEN.

ABSOLUT DESPERT.

ABSOLUT ROSSER.

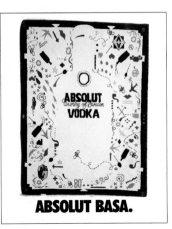

ABSOLUT BASA.

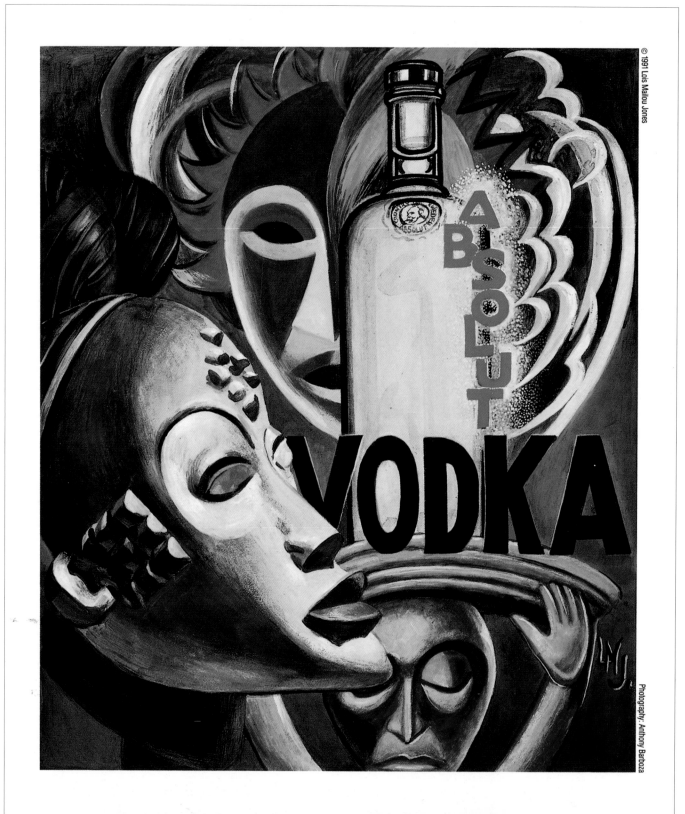

ABSOLUT HERITAGE.

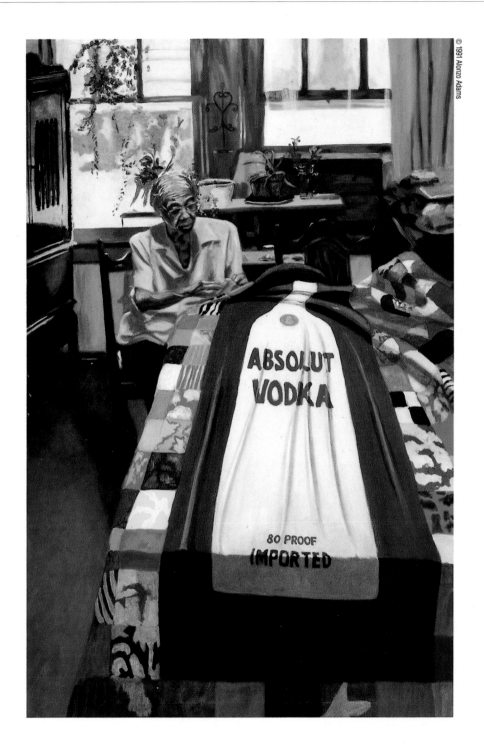

ABSOLUT ADAMS.

ABSOLUT HERITAGE. This insert comprised works by sixteen distinguished African American artists assembled by *Black Enterprise* magazine. Imagine the surprise of this business magazine's readers at being presented with an art collection: Michel Roux wanted to transform everyone into an art lover as well as an Absolut lover.

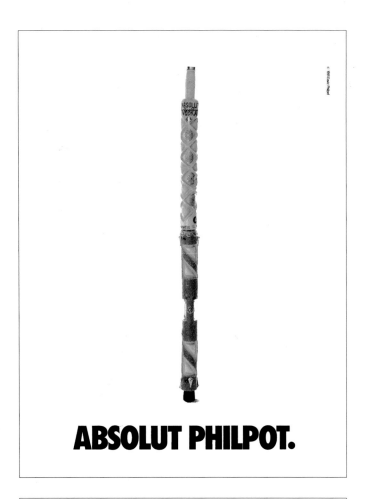

ABSOLUT PHILPOT.

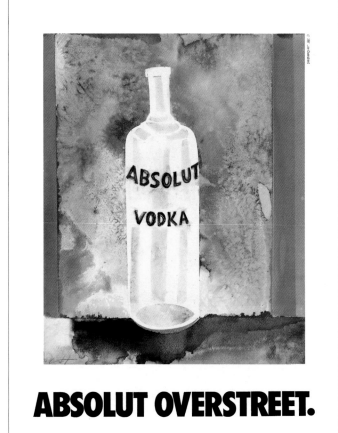

ABSOLUT OVERSTREET.

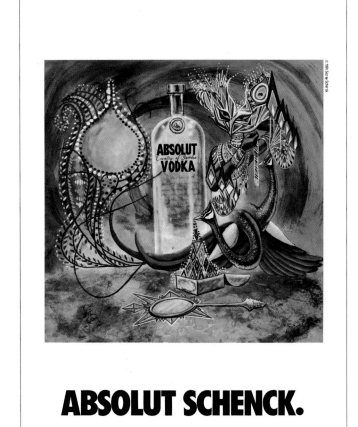

ABSOLUT SCHENCK.

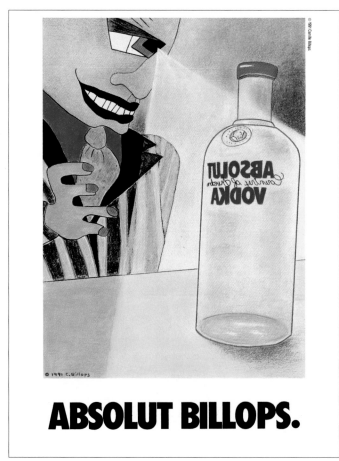

ABSOLUT BILLOPS.

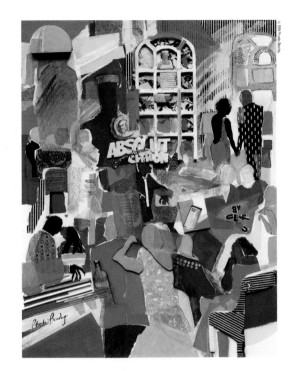

ABSOLUT BEASLEY.

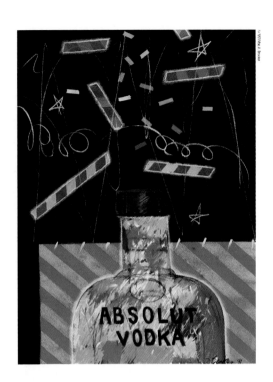

ABSOLUT BROOKER.

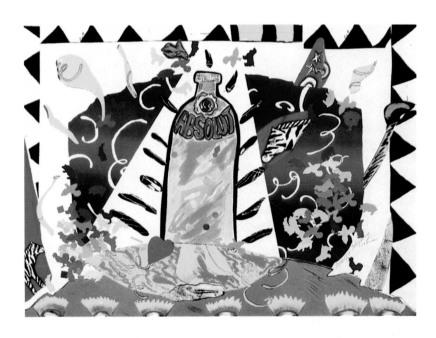

ABSOLUT HUMPHREY.

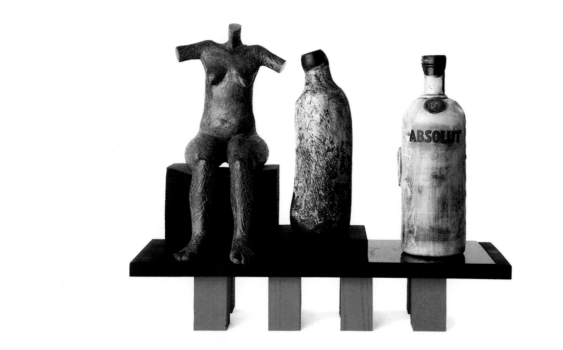

ABSOLUT LOCKE.

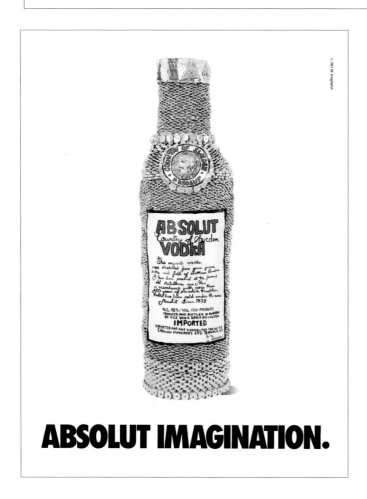

ABSOLUT IMAGINATION.

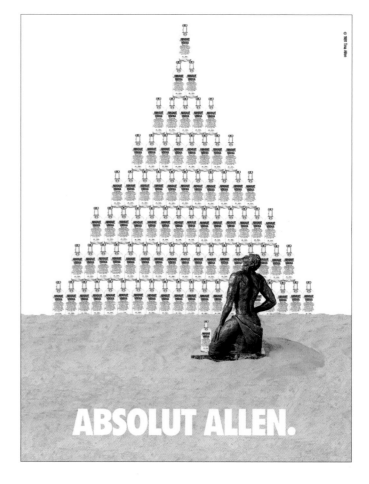

ABSOLUT ALLEN.

ABSOLUT HART.

ABSOLUT JOESAM.

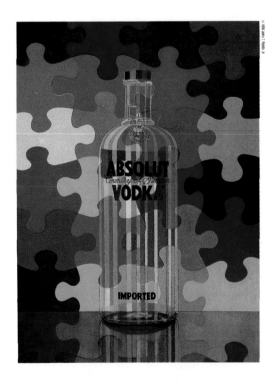

ABSOLUT RIDDLE.

ABSOLUT FULTON-ROSS.

"Appearances seem to indicate that they were quite civilized."

ABSOLUT WEBER.

AS APPEARED IN THE JUNE 10, 1991, ISSUE OF *THE NEW YORKER*.

"Absolut Janie, Absolut Herb."

ABSOLUT HAMILTON.

ABSOLUT CARTOONS. One of our greatest feats was to corral the services of ten topflight cartoonists from the *New Yorker*, whose original Absolut cartoons appeared in that publication in June '91. The magazine's end of the project was led by Ellen Wilk-Harris, one of the industry's best salespersons and certainly the nicest, who garnered the support of her management. We agreed to put the word ADVERTISEMENT on every single page, just in case some unsuspecting reader might regard the cartoons as . . . editorial. We also included a competition inviting readers to create their own cartoons; the winning entry was published in the fall. It, too, said ADVERTISEMENT.

"I came. I saw. I had the Absolut on the rocks."

ABSOLUT ZIEGLER.

ABSOLUT SHANAHAN.

"Now that's an Absolut monarch!"

ABSOLUT LORENZ.

"O.K., C.S., are you ready to deal big-time?"

ABSOLUT BARSOTTI.

"Absolut sublime."

ABSOLUT KOREN.

ABSOLUT CHAST.

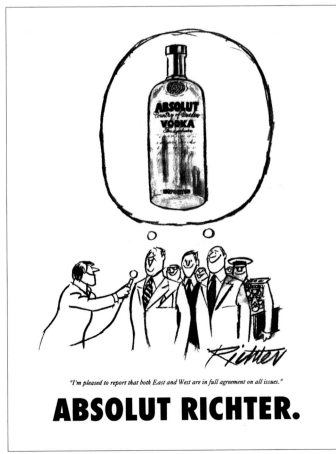

"I'm pleased to report that both East and West are in full agreement on all issues."

ABSOLUT RICHTER.

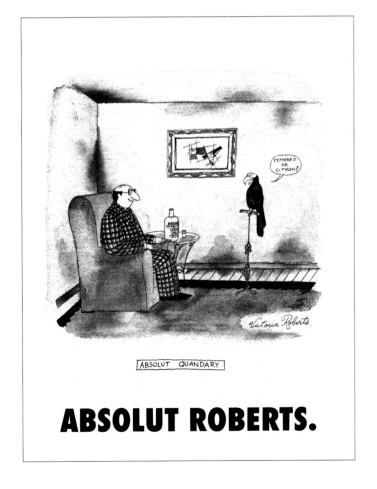

ABSOLUT QUANDARY

ABSOLUT ROBERTS.

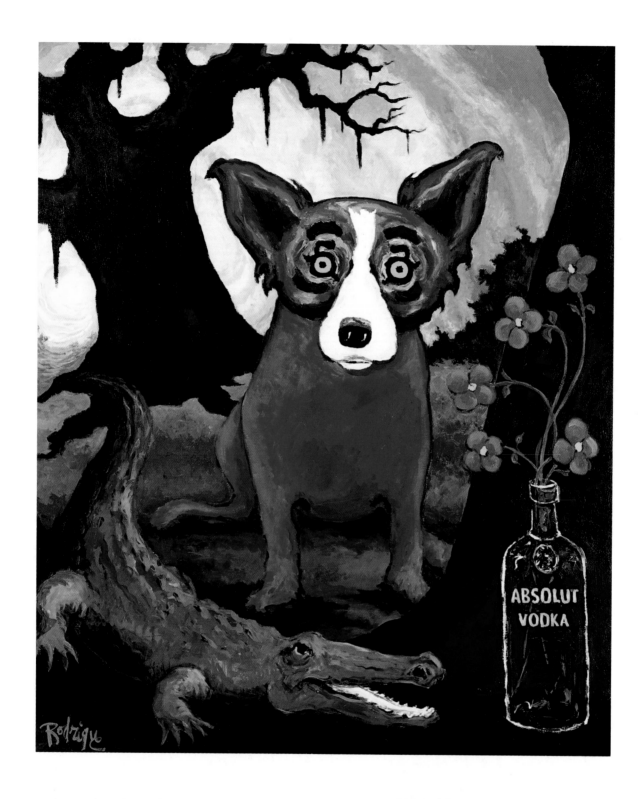

ABSOLUT LOUISIANA.

ABSOLUT CALIFORNIA.

ABSOLUT STATEHOOD. Jay Mills is a very creative guy, and he'd be the first person to alert you to that. He's also the Beverage Alcohol Manager at *USA Today*—at least until he retires, which he threatens to do every year.

A few years ago he was trying to figure out how to get a big Absolut advertising schedule into his paper, something he'd been unsuccessful in doing thus far. (There had been many attempts, as Jay has a lot of ideas.) At last he came up with the big one: Absolut would commission an artist from each of the fifty states (plus Washington, D.C., naturally; I'm

only surprised he forgot Guam) to create an artwork that would communicate his or her impressions of that state, whether through state symbols, personal feelings, or whatever, and, of course, incorporating Absolut imagery. ABSOLUT STATEHOOD would consist of fifty-one ads, from ABSOLUT ALABAMA through ABSOLUT WYOMING. Each full-page ad would be accompanied by an adjoining unit describing art programs in the state and presenting the artist's biography.

ABSOLUT GEORGIA.

Michel Roux added a twist: limited-edition lithographs of each artwork would be sold, with proceeds going toward local relief for AIDS victims. The cause was especially close to his heart as he had met many artists, among them Keith Haring, who later died of the disease.

Even for Absolut, this represented a mammoth undertaking. Artists were located and selected through local art organizations as well as word-of-mouth. Beginning in January '92 and finishing in December '93, a single statehood ad would appear every other Thursday in *USA Today*. Prior to publication, the artwork would be unveiled in the appropriate state capital; Michel attended nearly every unveiling ceremony. Best of all, sales of the lithos through DIFFA, the Design Industries Foundation Fighting AIDS, have raised over $1 million to date for AIDS relief.

ABSOLUT ALABAMA.

ABSOLUT ALASKA.

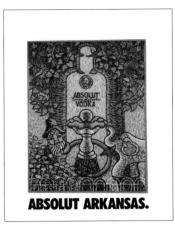

ABSOLUT ARIZONA.

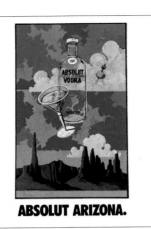

ABSOLUT ARKANSAS.

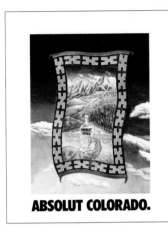

ABSOLUT COLORADO.

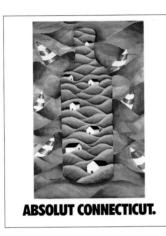

ABSOLUT CONNECTICUT.

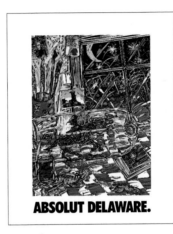

ABSOLUT DELAWARE.

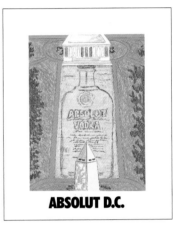

ABSOLUT D.C.

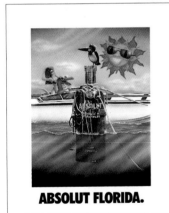

ABSOLUT FLORIDA.

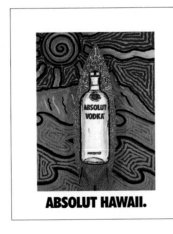

ABSOLUT HAWAII.

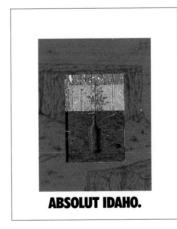

ABSOLUT IDAHO.

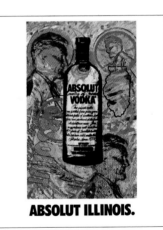

ABSOLUT ILLINOIS.

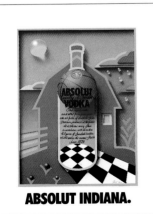

ABSOLUT INDIANA.

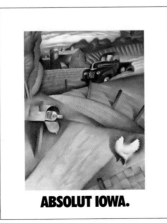

ABSOLUT IOWA.

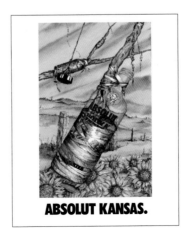

ABSOLUT KANSAS.

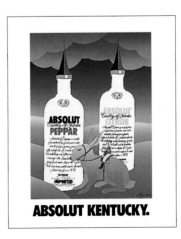

ABSOLUT KENTUCKY.

171

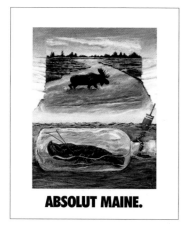

ABSOLUT MAINE.

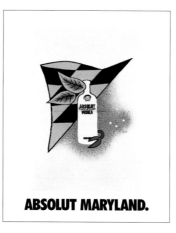

ABSOLUT MARYLAND.

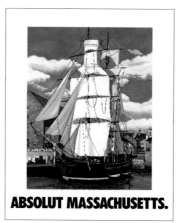

ABSOLUT MASSACHUSETTS.

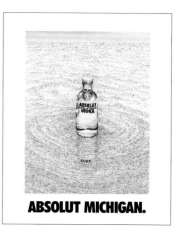

ABSOLUT MICHIGAN.

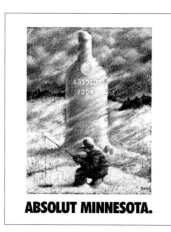

ABSOLUT MINNESOTA.

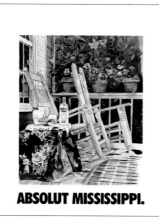

ABSOLUT MISSISSIPPI.

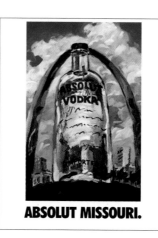

ABSOLUT MISSOURI.

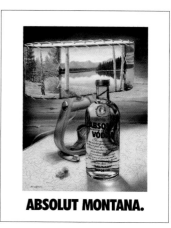

ABSOLUT MONTANA.

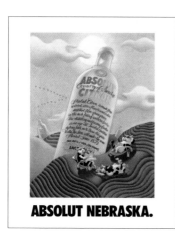

ABSOLUT NEBRASKA.

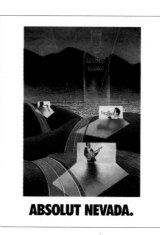

ABSOLUT NEVADA.

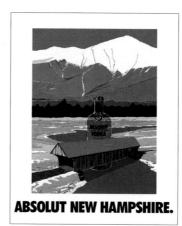

ABSOLUT NEW HAMPSHIRE.

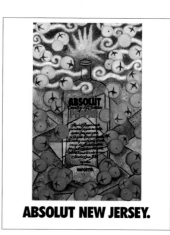

ABSOLUT NEW JERSEY.

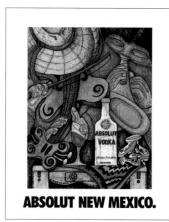

ABSOLUT NEW MEXICO.

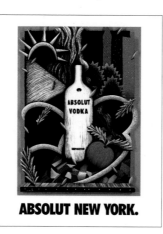

ABSOLUT NEW YORK.

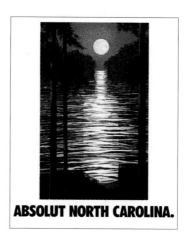

ABSOLUT NORTH CAROLINA.

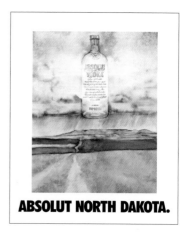

ABSOLUT NORTH DAKOTA.

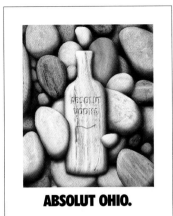

ABSOLUT OHIO.

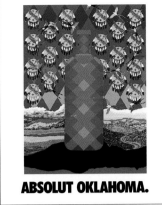

ABSOLUT OKLAHOMA.

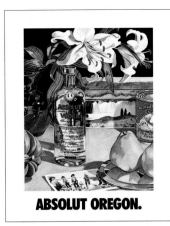

ABSOLUT OREGON.

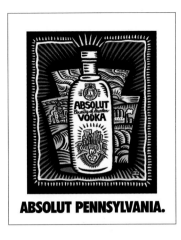

ABSOLUT PENNSYLVANIA.

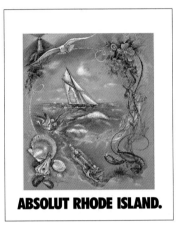

ABSOLUT RHODE ISLAND.

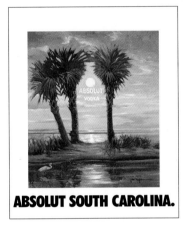

ABSOLUT SOUTH CAROLINA.

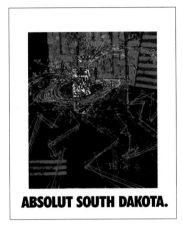

ABSOLUT SOUTH DAKOTA.

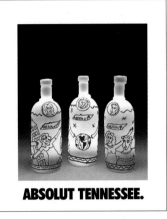

ABSOLUT TENNESSEE.

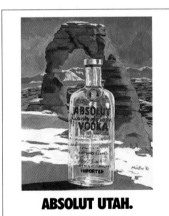

ABSOLUT TEXAS.

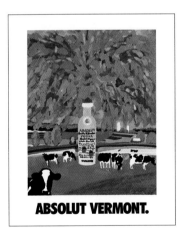

ABSOLUT UTAH.

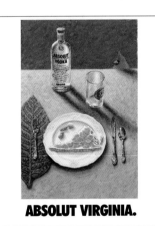

ABSOLUT VERMONT.

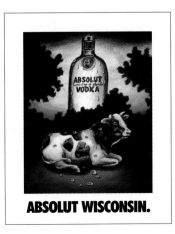

ABSOLUT VIRGINIA.

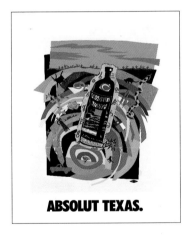

ABSOLUT WASHINGTON.

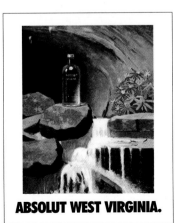

ABSOLUT WEST VIRGINIA.

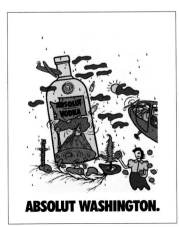

ABSOLUT WISCONSIN.

ABSOLUT WYOMING.

ABSOLUT SPADA.

ABSOLUT NEREYDA.

ABSOLUT SYMBOLS. Absolut has been a supporter of gay publications from the very beginning of the campaign. The twenty-fifth-anniversary issue of the *Advocate* carried ten pages of gay artists' works reflecting their creators' history, heritage, and ongoing struggle for equality.

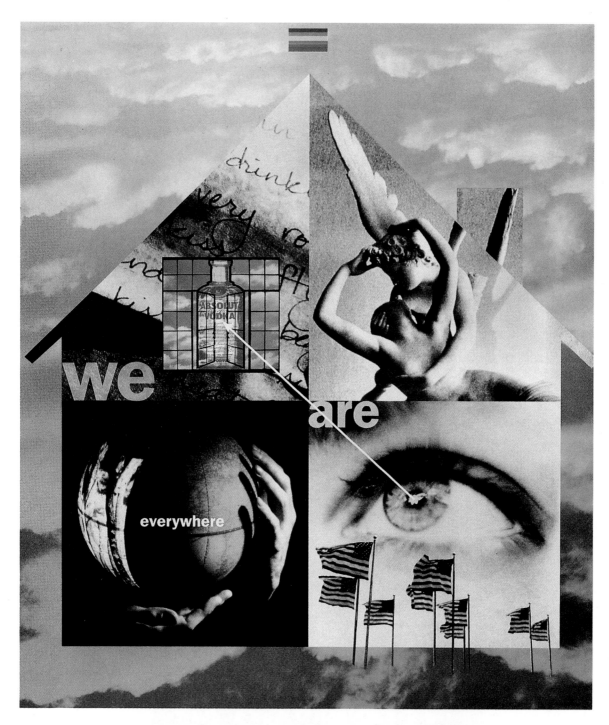

ABSOLUT DORR.

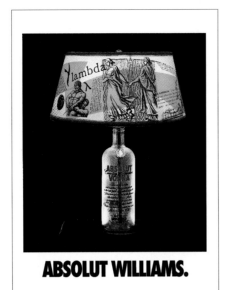

ABSOLUT WILLIAMS.

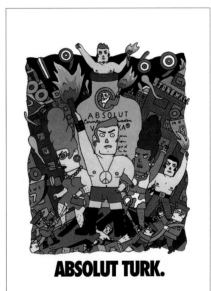

ABSOLUT EISENMAN.

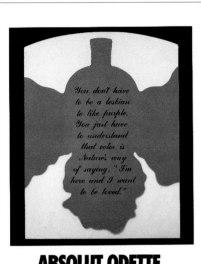

ABSOLUT ODETTE.

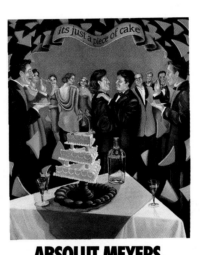

ABSOLUT MEYERS.

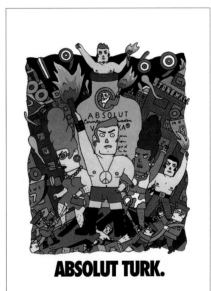

ABSOLUT TURK.

ABSOLUT MAJOLI.

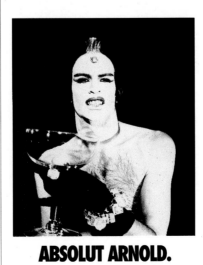

ABSOLUT ARNOLD.

ABSOLUT FALCONER.

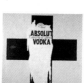
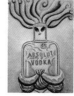

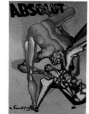

ABSOLUT GLASNOST.

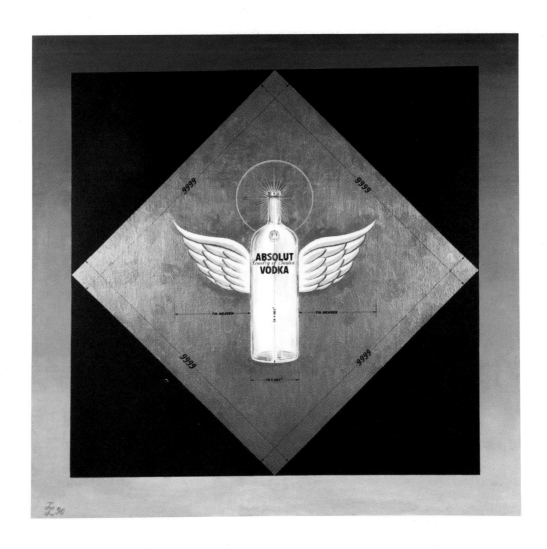

ABSOLUT LAMM.

ABSOLUT GLASNOST. When *glasnost*, the word, was still new to Americans, and the concept of a new openness in the USSR was still taking shape; when Presidents Bush and Gorbachev were periodically meeting and summitting; when Russian artists, both expatriates and those still living in their homeland, had an opportunity to display their talents, Absolut Vodka "cornered" the Russian art market before it could even occur to the marketers of Stolichnaya that there was a Russian art market. The result was this portfolio of twenty-six artists' works, which appeared in *Interview* magazine in 1990 under the banner ABSOLUT GLASNOST.

Paige Powell, *Interview*'s ad director and Michel Roux's emissary on this project, found, organized, and briefed the artists. Naturally, some of them were unfamiliar with Absolut, either the vodka or the advertising. (Incidentally, Absolut today is one of the most popular vodkas in Russia.) As part of the brief, she provided each artist with a bottle of Absolut and some previous examples of the artist-rendered advertising. The result was a remarkable collection of work, including many pieces that openly celebrated a Russia on the brink of change.

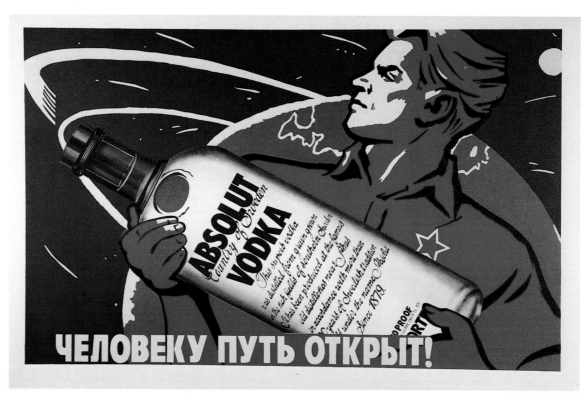

ABSOLUT KOSOLAPOV.

ABSOLUT LATYSHEV.

ABSOLUT YAKHNIN.

ABSOLUT ZVEZDOCHETOV.

ABSOLUT MITTA.

ABSOLUT YAKUT.

ABSOLUT YANKILEVSKY.

ABSOLUT MATROSOV.

ABSOLUT NAKHOVA.

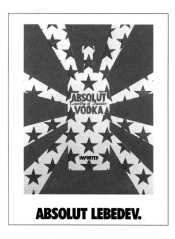

ABSOLUT LEBEDEV.

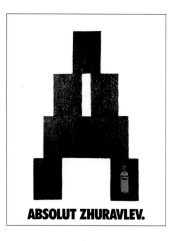

ABSOLUT ZHURAVLEV.

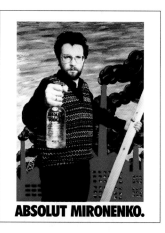

ABSOLUT MIRONENKO.

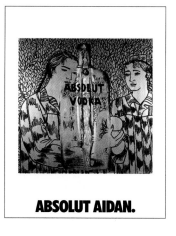

ABSOLUT AIDAN.

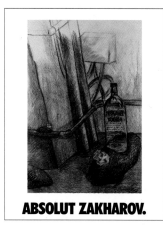

ABSOLUT ZAKHAROV.

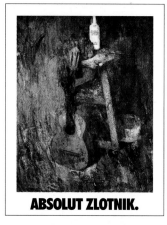

ABSOLUT PURYGIN.

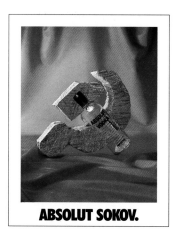

ABSOLUT KRASNY.

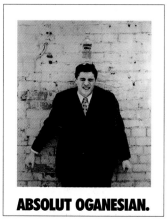

ABSOLUT OGANESIAN.

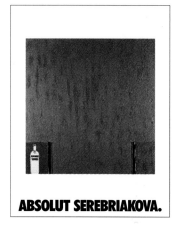

ABSOLUT SEREBRIAKOVA.

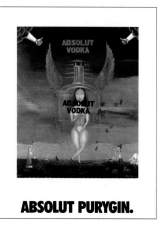

ABSOLUT ZLOTNIK.

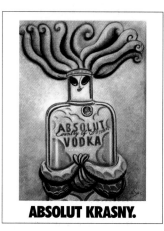

ABSOLUT SOKOV.

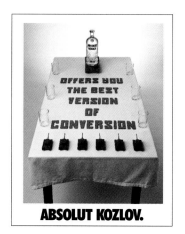

ABSOLUT KOZLOV.

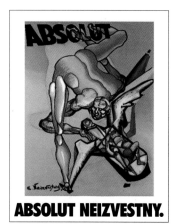

ABSOLUT NEIZVESTNY.

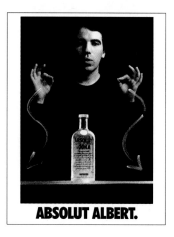

ABSOLUT ALBERT.

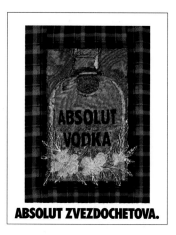

ABSOLUT ZVEZDOCHETOVA.

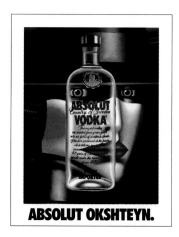

ABSOLUT OKSHTEYN.

A NIGHT TO REMEMBER. Wearing $100,000 smiles at the Kelly Awards were from left to right, Tom McManus, Dave Warren, Geoff Hayes, Page Murray, Dick Costello, Richard Lewis, Arnie Arlow, and Peter Lubalin.

ABSOLUT

ABSOLUT

ABSOLUT

ABSOLUT

ABSOLUT

ABSOLUT
FLAVORS

ABSOLUT

ABSOLUT

ABSOLUT

ABSOLUT

ABSOLUT

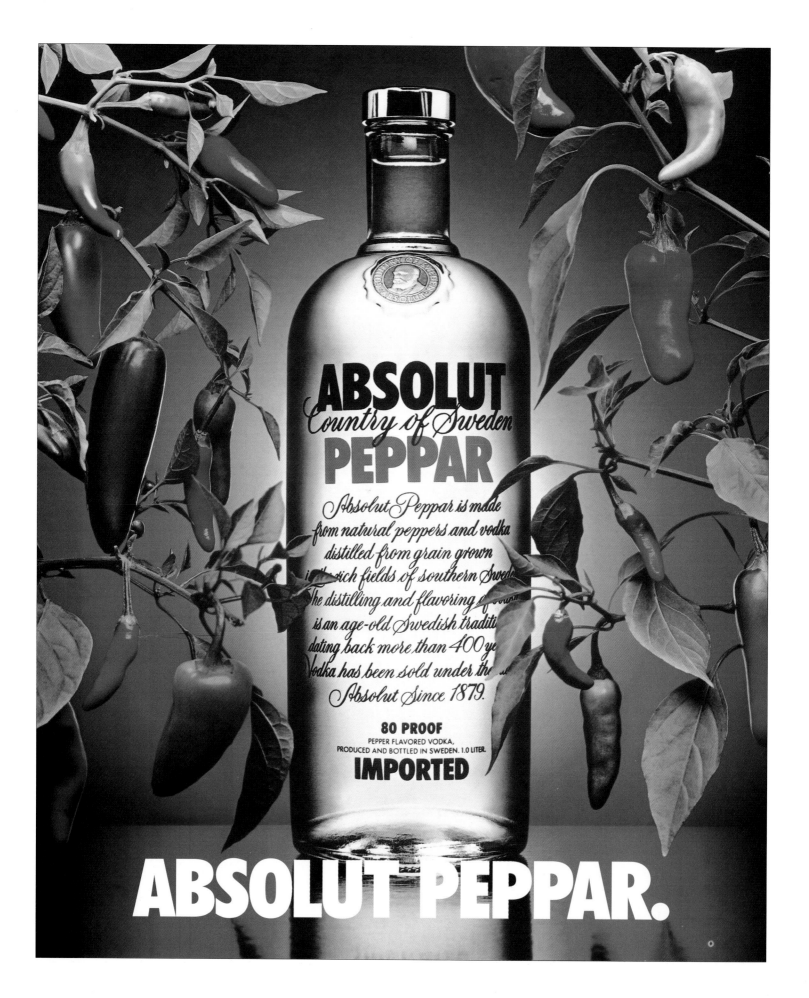

ABSOLUT PEPPAR.

ABSOLUT FLAVORS.

Flavored vodka is as much a tradition in Sweden as vodka itself. To date, Absolut has created three flavors for export, each an authentic recipe, and all based on products that Swedes have been drinking for centuries.

Absolut Peppar, introduced in 1986, is a spicy vodka containing paprika and jalapeño peppers. It's not "flavored down" for the American market, and consumers are sometimes surprised by the degree of its heat. (Just ask the owner of any Chinese restaurant: Americans send a lot of "hot and spicy" dishes back to the kitchen to be hosed down.) Anyway, Peppar makes a great Bloody Mary: you just add tomato juice.

ABSOLUT PEPPAR was the first ad for Absolut Peppar. It shows the bottle emerging from a jungle of peppers. The bottle copy tells the story.

Absolut Citron (1988) is a subtle blend of lemon, lime, mandarin orange, and grapefruit. It's extremely popular, and its cocktail-making possibilities are nearly as diverse as those of the original Absolut.

Absolut Kurant (1992), the most complex Absolut flavor, is created from Swedish black currants, which grow as far north as the Arctic Circle. It has a fresh, fruity taste and is a fine addition to the Absolut family.

As we've introduced each new flavor, we've consciously tried to stamp it with the Absolut identity, while still leaving room for differences among the siblings. This can present a challenge since Absolut's advertising format—bottle plus two-word headline—doesn't include the marketer's typical "Hey, gang, we have a new product, and this is what you do with it" shout. Still, after endless debates, we continue to strive to communicate each flavor's specialness.

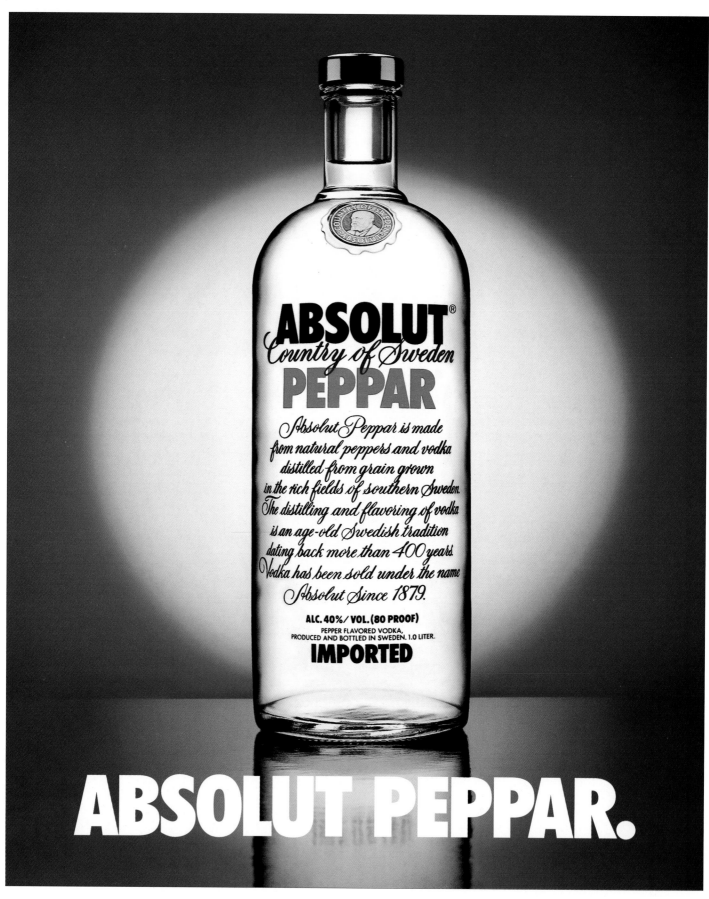

ABSOLUT PEPPAR. Michel Roux was reluctant to advertise this as a hot, spicy product, but we convinced him that people would find that out soon enough.

be aware of all stories that are about to run in his own newspaper. You might even go so far as to say th... lisher, if not aware of the stories before they... at least read the stories once they come ou... they tell you is standard operating proced... nalism school anyway. But, in a situation like... Larry and Sid's full attention was required... a very volatile account roster, such attention... dered frivolous if not out of the question en...

Naturally, Larry was oblivious to the e... must admit he took the news with relative... don't even think that hearing my story d... from calling the Sheriff. I really didn't... led the mess he was in. I was in...

As we pulled into the driv... spread-eagle under a willow... was rather warm and humid... let him in for the night. We da... that, so he managed to find hi... peaceful spot on the proper... know that even though we ha... for the night, he wasn't about...

CHAPTER S...

On Friday morning, Walte... close to looking, and perhaps... live newspaper men. We boldly... armed with notepad, pencils,... camera. Welcome to the glamor... tigative journalism.

We were following a "hot t... been a rash of car radio thefts... had just heard about a woma... information. He was especially... so we jumped into his speedy... to run every stop sign and re...

I discovered just a block... that I had neglected to bring... tantrum. and, in this reporter... reacted quite unnecessarily.... had to stop at several drug s... a roll of black-and-white fil... his life that while the two o... time looking for film, a report... had already interviewed the w... in to his editor.

As we finally drove up... what appeared to be severa... surmised could only have bee... view. It was an ominous sign... dropped my camera on the pav... ominous sign.

We rang the doorbell and withi... impeccably dressed, middle-aged French wom... the door. We introduced ourselves as the reporter and photographer from the Ramsey Review.

"Jour no from de Ramzee Recaw?" Walter and I looked at each other. It was the third and most ominous sign yet.

"We're from the Ramsey Review," said Walter. She looked at us like we were from a different galaxy.

"We're from the Ramsey Review. It's another news- ...She was still baffled. Walter repeated the name, ...ime very carefully, ensuring that she under- ...and every syllable. She looked at us quizzi- ...suddenly she smiled.

...ies," she pointed to the grey lumps on her drive- ...e Ramzee Reyou, si, si, gee Ramzee Reyou." ...ioned for us to come in. We sat down in her ...She was very hospitable. She offered us coffee, ...es, and cake. Walter was insistent we get the

...ts ma'am. Just the facts." Walter asked the ...sh and she gave her answers in a tongue ...er heard before.

...me foo no work." Translation: the ...d broken down.

...e nom Brooky." She took her car ...k Ford.

...igh wich eeem." The car stayed ...ok's lot.

...y, gee engeen goo bu gee casset ...ked up her car the next day, the ...ed, but her cassette radio had ...en.

...sset. Casseet fro o cas oh so ...place nobodee casseet. He say ...reesponseeble." Brook wouldn't ...ayer, claiming that his entire lot ...that night and that it would be ...verything that had been stolen. ...chew nom." I don't know what

...sell me new casseet. Gee as ho. ...k had offered to sell her a new ...declined and threatened to call ...d us she did.

...ty-five minutes to get her story. ...just trying to understand what ...worth the trouble. The story it- ...ven though we were unsure if it ...rall county-wide increase in car

...attractive woman and I really ...me coffee and cake but Walter ...some pictures and say goodbye.

...PTER EIGHT

...ed, but this time I was careful ...d barge right in as usual. I knew ...I really didn't want him to have ...knocked softly. If I were to knock ...own brother's door it would certainly ...oused suspicion.

"It's me, Dan. Can I come in?" I waited several seconds for a reply but there was none, so I decided to open the door. Larry was alone and on the phone. I sat down in front of him and waited patiently for him to get off.

"Are you on hold?" I asked after several minutes had passed without either of us saying a word. He nodded affirmatively. He seemed a little agitated at my question

Coming to terms with the product's true self, this two-page spread acknowledges the searing heat of its formula.

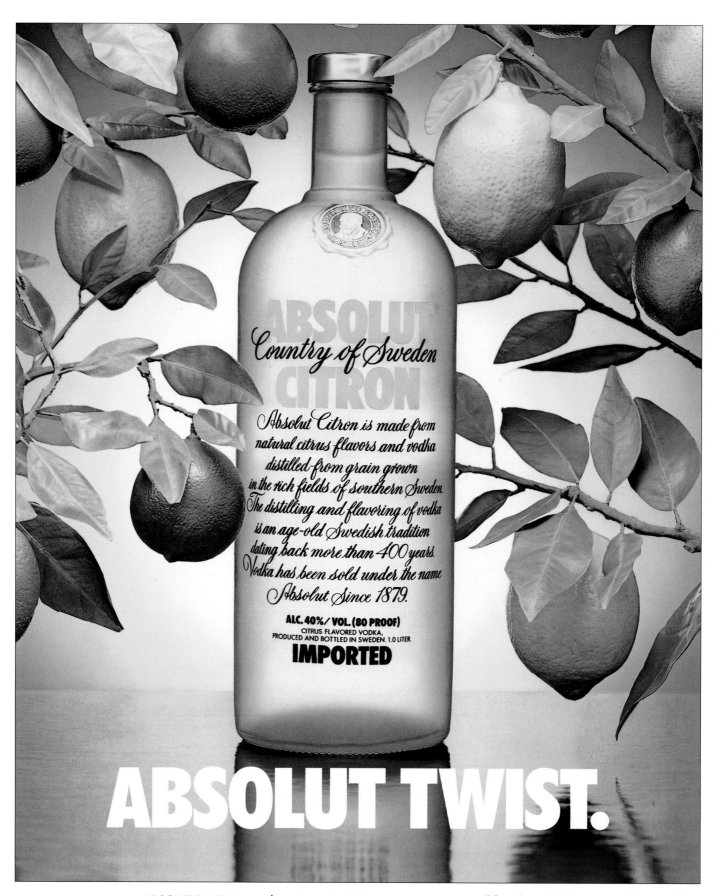

ABSOLUT TWIST. To introduce Citron in 1988, we put out a casting call for all available lemons and limes. Michel, an avid gardener, was never truly happy with the depiction of the fruit in the ad ("It looks fake"), but it helped consumers understand what Citron was about, and they tried it in droves.

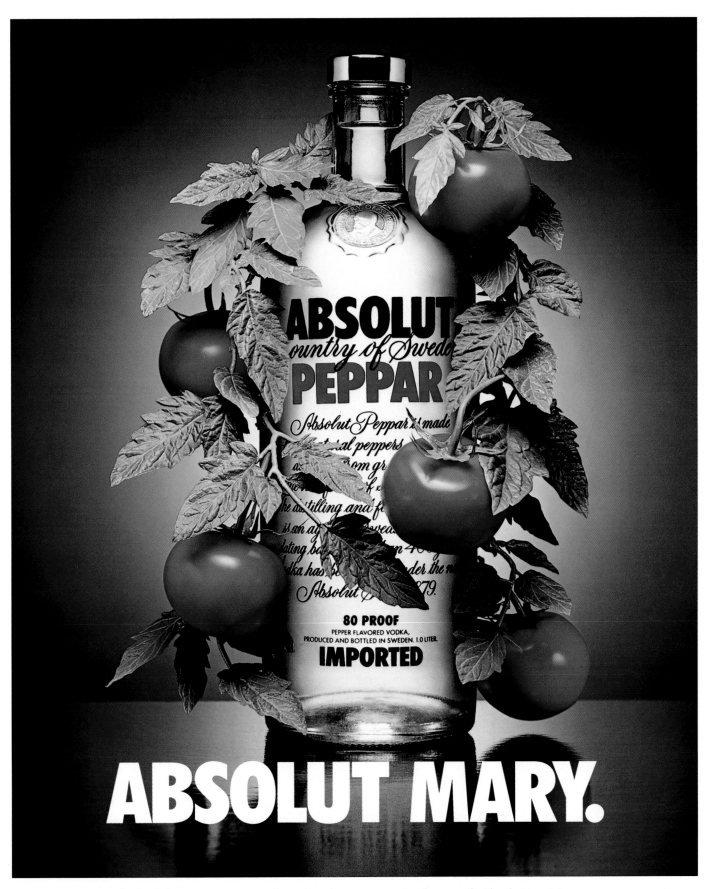

ABSOLUT MARY.

ABSOLUT MARY. Do the bottle-hugging tomatoes make it clear that Peppar makes for a terrific Bloody Mary? As we're usually loath to prescribe the "proper" way of enjoying Absolut, we crossed our tomatoes—I mean, our fingers—that people would get it.

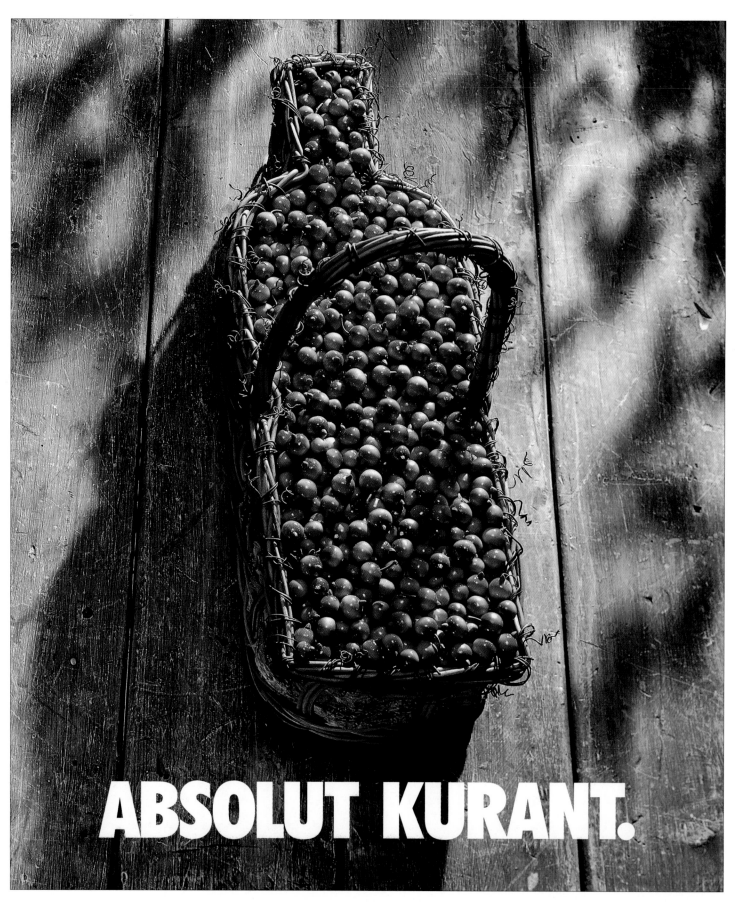

ABSOLUT KURANT.

ABSOLUT KURANT. Art Director Alix Botwin designed this ad. That it so completely transports you right to the little fruit stand out in the country makes it simply the best Absolut flavor ad to date.

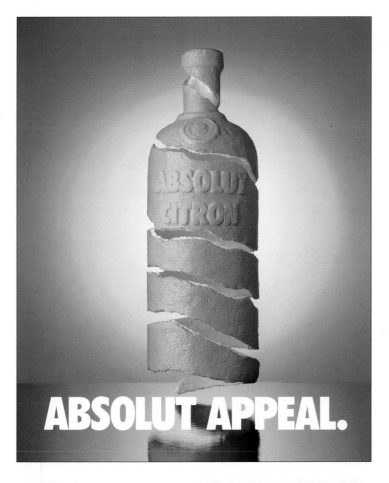

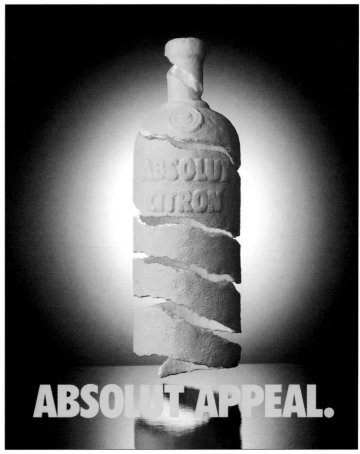

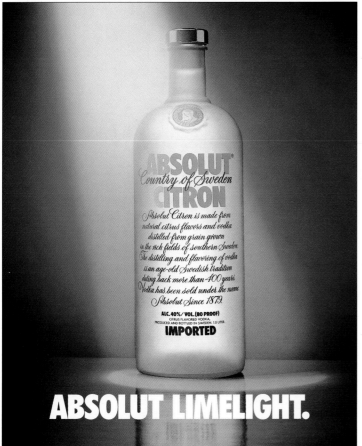

ABSOLUT APPEAL. Every Citron ad should be this good. APPEAL conveys flavor and an Absolut way of looking at things, using a little wit and a great Mark Borow prop.

ABSOLUT APPEAL (second generation). In 1995, Geoff Hayes gave the Citron brand ad series a facelift, and APPEAL was his first patient. He replaced the yellow-green background with Absolut's traditional black and changed the Citron typeface to yellow.

ABSOLUT LIMELIGHT. In the English language, "lime" isn't an ingredient in many words, so when we find one that works for Citron, we grab it.

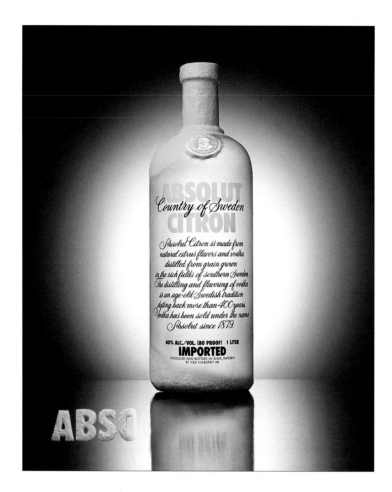

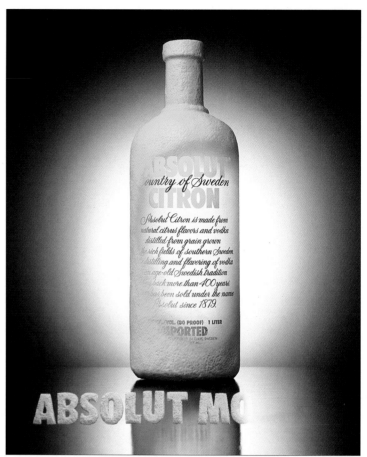

ABSOLUT MORPH. Run over three successive right-hand pages, MORPH plays off the popular Hollywood film technique in which people or objects "morph," or transform, as you watch.

ABSOLUT SQUEEZE. This ultimate bar accessory was created by Dan Braun and Bart Slomkowski. Their quest for perfection in post-production prompted the ad's engraver to dub them "The Retouch Brothers."

ABSOLUT SLICE. This ad was more appetizing as a roughly drawn color layout. That happens sometimes.

ABSOLUT HARVEST. HARVEST is one of those rare cases in which, as soon as the ad was finished, no one would admit to having had anything to do with its creation.

ABSOLUT CITRON. If there really are a limited number of ways to express lemon-limeness, I think Art Director Lisa Kay added a new one.

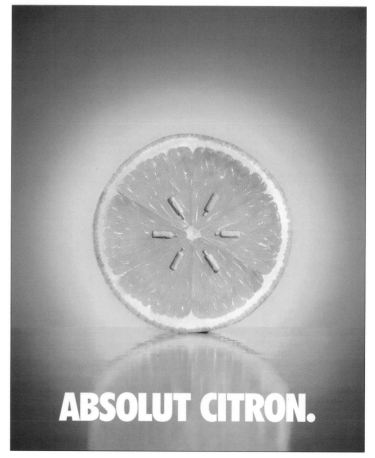

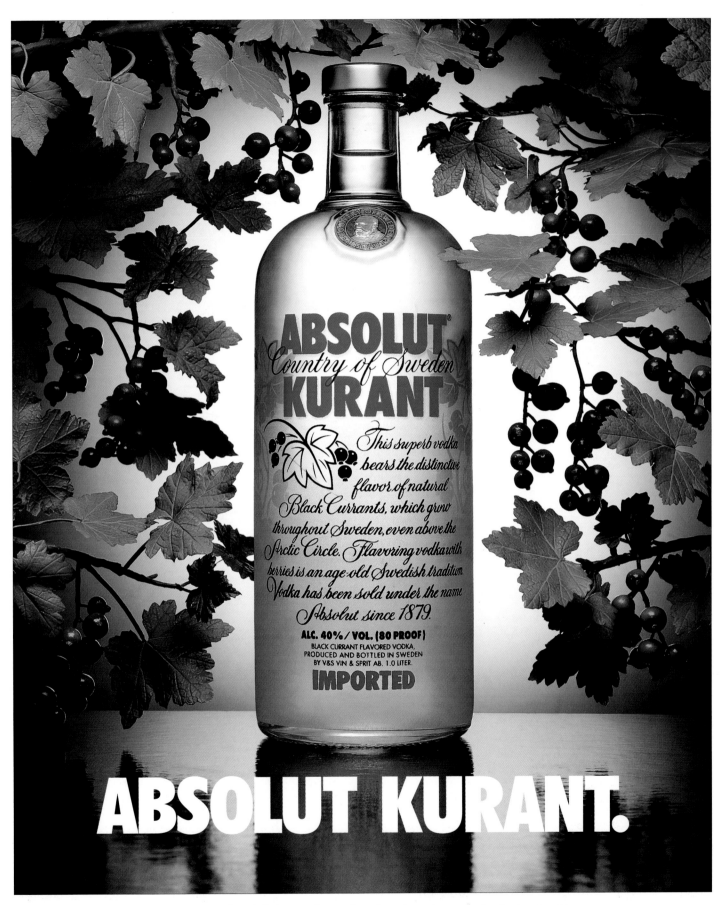

ABSOLUT KURANT. I think we're getting rather skilled at producing these fruit-draped-over-the-bottle shots, and it doesn't hurt that the currant is a good-looking berry. This first Absolut Kurant ad debuted in 1992.

ABSOLUT

ABSOLUT

ABSOLUT

ABSOLUT

ABSOLUT

ABSOLUT
SPECTACULARS

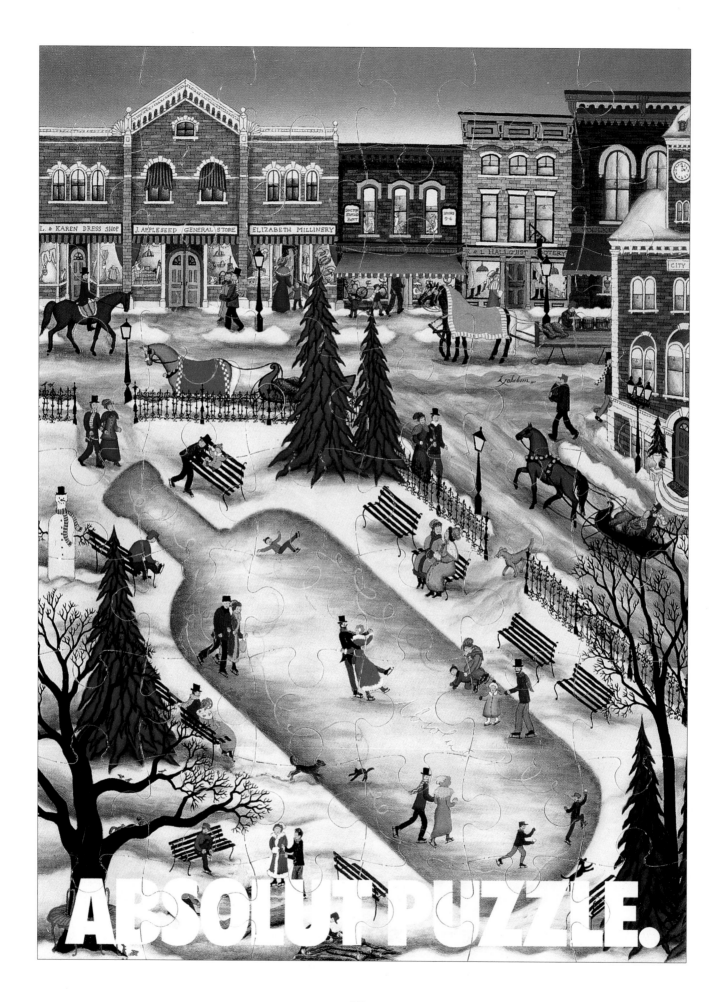

ABSOLUT SPECTACULARS.

When we started the series of Absolut holiday ads, among ourselves we actually called them spectaculars. We did this with a collective straight face: no false modesty from us. We were building a spectacular. (However, as I look at the word now, I get a little squeamish. I know what we meant; it just looks so arrogant.)

We set out to create an advertising event. We wanted to get people to talk about the Absolut ad, get the press to talk about the Absolut ad, get the press to talk about the people talking about the Absolut ad. And somehow we wanted all this to translate into more Absolut business. Most of the time, it actually worked.

Whether we called them spectaculars or unicate ads (pronounced YOO-nih-KAH-tay, this word coined by Wolf Rogosky, a German copywriter, refers to an ad that appears just once), these tricky and expensive productions paid off for Absolut, so we decided to transfer our good luck and smarts to other, nonholiday periods during the year. After all, it's a long wait from one Christmas to the next, and we had to fill our idle time. To be honest, we in fact did two of these ads before we had a strategy or a system in which to place them. Back then they were just called good ads.

Occasionally, other advertisers and agency people would complain to magazine publishers that they didn't want their ads to run in the same issues as these Absolut spectaculars, reasoning that the Absolut ads would get all the attention. What they failed to understand was that the entire issue would receive greater reader scrutiny because of our efforts, as the publishers themselves would attest.

Since we had become so expert at breaking all the established rules of what could be done in magazine advertising, especially in the unlimited range of objects and materials we could use, I mentioned at the 1991 Carillon sales meeting that the following year we planned to produce an ad that included a working lawn mower. The audience wasn't sure if I was joking.

ABSOLUT PUZZLE. (page 202). We borrowed Kathy Jakobsen's folk art painting to serve as the image for a working forty-eight-piece jigsaw puzzle that appeared in *New York* magazine in the winter of 1990. My wife, Isabel, swears this was her idea.

Unfortunately, I can't show you our first holiday spectacular, the "white ad," because there's no way to reproduce it here. That's because it was simply an embossed piece of heavy paper stock printed without any ink. It appeared in *New York* magazine in May 1987 under the headline ABSOLUT IMPRESSION. Geoff Hayes created it.

ABSOLUT TRICK OR TREAT. The reader saw a normal Absolut bottle on the right-hand page, headlined ABSOLUT TRICK. Turning the page revealed that the bottle shape had been die-cut out of the first page and was actually printed on the following right-hand page, headlined ABSOLUT TREAT. It worked better than I've explained it. Steve Feldman and Pat Hanlon created this sleight-of-hand for *Rolling Stone*'s Halloween issue in 1987.

ABSOLUT SOFTWARE. Continuing the tradition of creative account executives at TBWA, Pete Callaro dreamed up the Absolut Museum, an interactive archive of more than two hundred Absolut ads set in a virtual-museum environment. Available on three floppy disks, for both PC and Mac platforms, the museum allows the consumer to use his or her mouse to walk through and visit various Absolut exhibits (arranged by subject and reprising many of the Absolut artist inserts) as well as salons devoted to cities, flavors, and more. The ABSOLUT SOFTWARE ad was created to promote sales of the Museum, net proceeds from which go to AmFAR, the American Foundation for AIDS Research. To order a copy call 1-800-568-1566.

ABSOLUT FIRST CLASS. Art Director Jim Peck came up with the idea for a sheet of Absolut stamps, which eventually evolved into a sheet of Warhol/Haring/Scharf/Ruscha stamps. These thirty-five images, kept fresh in a glassine envelope, were delivered to the readers of *New York* magazine in June 1990. The following week, someone called to report hearing that people were using them as actual postage stamps on their mail . . . and they were working. It was a good story, but I didn't believe it until I tried it myself. I sent out five pieces of mail with nothing but Absolut stamps, and all five arrived. As these things go, somebody tipped off a WPIX-TV reporter, who, with camera in hand, went to check out the story at New York's General Post Office. There the reporter was assured that Absolut stamps, sporting a denomination of 80 Proof, could never get through the postal service's "sophisticated equipment"—which, of course, with cameras rolling, they did. Although I still have a generous supply of stamps, I'm planning to refrain from using them for a few years—until first-class postage goes up to eighty cents.

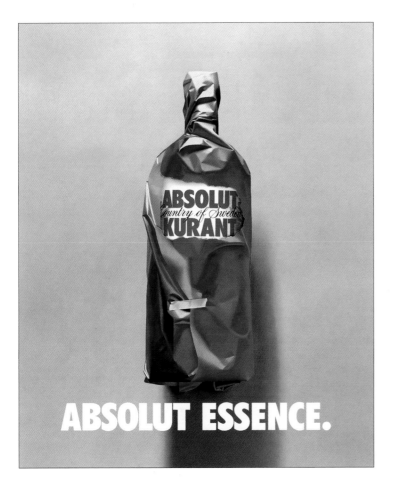

ABSOLUT ESSENCE.

ABSOLUT ESSENCE. If you place your nose on this page and use your imagination, you'll be able to smell the Absolut Kurant scent we hid inside Edelmann's painting in a 1995 issue of *Saveur*.

ABSOLUT X-RAY. This ad, conceived by our London office, appeared in *GQ* magazine in England. What made the ad unique was that in every copy of the magazine, the bottle was reproduced on a real piece of x-ray film.

ABSOLUT JOBIM. In 1989, Michel Roux inaugurated Absolut's association with music by sponsoring a Carnegie Hall concert by the late Brazilian composer Antonio Carlos Jobim. To mark the occasion, Jobim recorded the "Absolut Song," a not-too-serious salute to the brand. (The lyrics included such gems as: "you're my sweet, my salt; you're my grapes, my spring; you're my grain, my malt . . . you're my celery, my love, my dearly, my softly, my song, my broccoli)" As a promotion for the concert and something of an ode to the 1950s, we distributed the record, in flexible plastic, in *Rolling Stone*.

ABSOLUT X-RAY.

ABSOLUT JOBIM.

ABSOLUT ARTISTS.

ABSOLUT

WARHOL

ABSOLUT
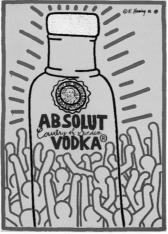
HARING

ABSOLUT

SCHARF

ABSOLUT POSTCARDS. A very simple idea: reprint the Warhol, Haring, and Scharf artworks as actual postcards that readers could remove and send to their friends. The ad appeared in *Vanity Fair*.

ABSOLUT INDEX. A parody of the well-known Harper's Index of esoterica, which appears monthly in *Harper's* magazine, this ad contains such items of trivia as the number of jelly beans needed to fill an Absolut bottle (222), and the number of ex-Presidents who have tried it (1). Naturally, we placed ABSOLUT INDEX immediately following the Harper's Index in a 1993 issue of *Harper's*. The magazine's maverick publisher, Rick MacArthur, got his wrist slapped by the American Society of Magazine Editors for allowing us to do this.

ABSOLUT SPRING. This colorful ad featured a packet of actual wildflower seeds that the readers of the *Atlantic Monthly* could plant.

ABSOLUT INDEX

Number of people who think Central Park is actually shaped like an Absolut Vodka bottle: 19,842. ▢ Chances an Absolute Vodka drinker has been to college: 3 in 4. Chances that an Absolut drinker would notice the misspelling in the previous sentence: 1 in 10. ▢ Number of jelly beans needed to fill an Absolut bottle: 222. Number of ex-presidents who have tried this: 1. ▢ Number of times Absolut was given as a gift to a boss in 1992: 396,229. Number of promotions to vice president, 1992: 396,229. ▢ Rank of Absolut among imported vodkas: 1. Percentage of drinkers who drink Absolut for this reason only: .0000002. ▢ Number of bars and restaurants in New York City that feature Absolut: 11,000. Number that serve water: 11,000. ▢ Average number of Absolut bottles needed to fill an Olympic-size swimming pool: 315,418. Number of times this has been done: 0. Are you kidding? Waste fine vodka? ▢ Number of people who have been inside the Absolut Miami building: 0. Number of people who have been swimming in the Absolut LA pool: 0. Percentage of Americans who know the reason why: 2. ▢ Percentage of alcohol advertising that features bikini-clad women: 27. Percentage of Absolut advertising that features bikini-clad anything: 0. ▢ Longest solo flight (miles) in the Absolut hot air balloon: 2,345. ▢ Amount of money raised by Absolut Artists Against AIDS: $750,000. ▢ Number of homes in Sweden heated with energy generated from the Absolut purification process: 10,000. ▢ Distance (km) reached by lining up world supply of Absolut bottles around the equator: 27,300, or once around the United States, or 14 times around Sweden. ▢ Average dress size used in Absolut fashion show: 6. ▢ Ratio of calories in 1 oz. cheesecake to 1 oz. Absolut: 9 to 1. ▢ Number of people who can identify the man on the Absolut bottle: 47. Number who aren't Absolut employees: 3. ▢ Average number of words in an Absolut ad: 2. Number of words in Absolut Index: 351. ▢ Percentage of people who read all the words in an Absolut ad: 99.7. Number of people who have read all of this ad: You're the first.

WILDFLOWERS
ABSOLUT MIXTURE
MIXED COLORS & KINDS
.05 G NET WT.

ABSOLUT SPRING.

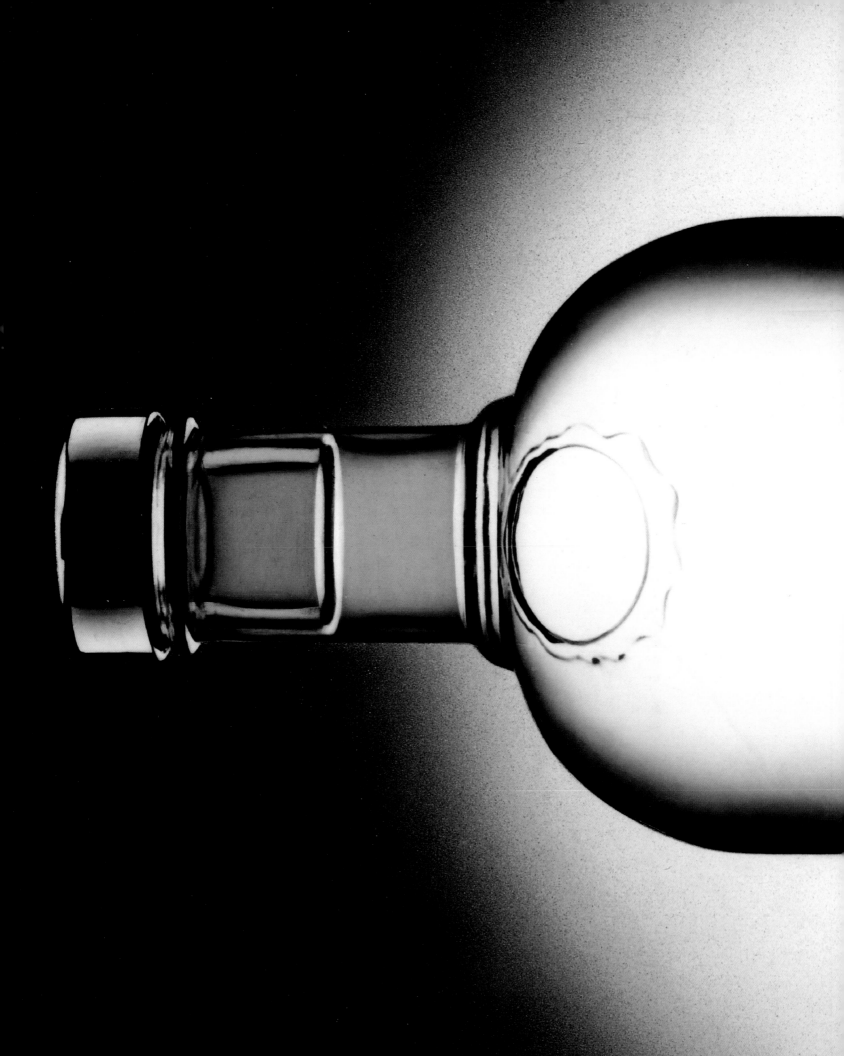

ABSOLUT DATA SHEET

NAME: *Absolut Vodka*

BUST: 11¼" WAIST: 11¼" HIPS: 11¼"

HEIGHT: 11" WEIGHT: 1 Liter

BIRTH DATE: 1879 BIRTHPLACE: *the fields of southern Sweden*

AMBITIONS: *To always be cool, with or without ice*

TURN-ONS: *Swedish massages, ice, olives, tonic, Tomato juice, a twist of lemon, a wedge of lime, orange juice, mixers*

TURN-OFFS: *drinking and driving*

FAVORITE BOOKS OR PLAYS: *The Iceman Cometh, The Glass Menagerie, The Spy Who Came in from the Cold, Soul on Ice*

THE PERFECT NIGHT: *At home with my closest friends, Sven, Bjorn, Ingmar; while jumping back and forth between the sauna and the ice baths, we exchange our favorite Gravlax recipes.*

ABSOLUT RUSCHA.

When guys first started noticing me!

ABSOLUT INTELLIGENCE.

When people started respecting my mind!

ABSOLUT L.A.

My first visit to the coast!

ABSOLUT CENTERFOLD.

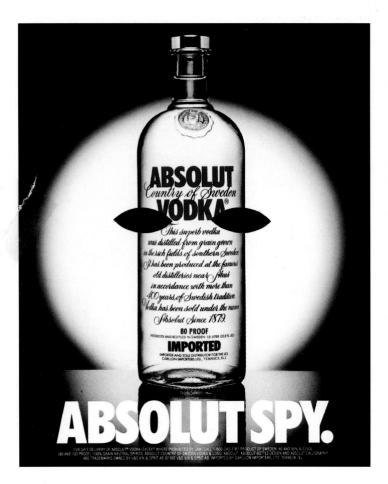

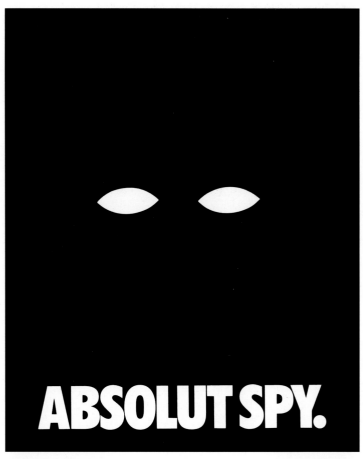

(gatefold) ABSOLUT CENTERFOLD. While this is one of the campaign's more famous ads, and anybody can guess which magazine it was designed for, it almost didn't happen at all. Tom McManus and Dave Warren created it, with a big assist from Geoff Hayes. Geoff suggested the CENTERFOLD headline and advised Tom not to show any bottle type at all. (Tom had wanted to include the type on the floor, as if it were dropped clothing.) Knowing that Michel Roux was hesitant about approving such an expensive one-shot ad, Geoff suggested bringing *Playboy* salesman Foster Tennant into the agency to see if they could get the price down. The strategy worked because *Playboy* was hungry for Absolut business. It was Foster who suggested the "data sheet" that Dave Warren then fleshed out.

ABSOLUT SPY. We punched eyeholes through a bottle that appeared on the third cover (that is, the inside back cover) of the November '92 issue of *Spy*. Using our ad, we reasoned, readers on a train, for example, could keep an eye on their fellow commuters without themselves being noticed. Any further comment here would be gratuitous.

ABSOLUT MERGER. Taking a cue from *MAD* magazine, Steve Feldman created an ad that required the readers of *Business Week* to fold together a bisected Absolut bottle. When this was accomplished correctly, the headline read ABSOLUT MERGER.

ABSOLUT FAX. It may be difficult to remember that just a few years ago, fax machines were something of a novelty, not the daily communications weapons they are today. This ad is a typical example of Absolut's ability to get behind a trend before it takes off. In the summer of 1990, Absolut sent an "actual" fax to the readers of *Forbes* magazine—or at least it *looked* like an actual fax, bound in and printed on a thin, glossy, curling stock, in washed-out fax gray.

ABSOLUT

ABSOLUT

ABSOLUT

ABSOLUT

ABSOLUT

ABSOLUT
EUROCITIES

ABSOLUT GENEVA.

ABSOLUT EUROCITIES.

I n 1992 Absolut, now entering its thirteenth year in America, continued to enjoy great fortune. That the brand had survived the 1980s intact came as something of a surprise to a few muckrakers, who saw it as an eighties icon likely to take a fall. Even the ballyhooed changes of the nineties—people seeking a less extroverted lifestyle (remember "cocooning"?) and drinking less (a trend that actually began a decade earlier)—failed to slow down the brand. To be sure, consumers did dispense with some well-known, brand-name indulgences they'd been introduced to in the eighties, but Absolut wasn't one of them, perhaps because unlike $50,000 cars, $5,000 watches, and $500 shoes, Absolut is an *affordable* luxury. For under $20 one can still purchase the very best in its category, along with a certain cachet.

Then, too, while Absolut the brand continued to evolve, it had already become a classic; people understood that behind the smart marketing was a product of the highest quality.

Speaking of marketing, the New York chapter of the American Marketing Association had bestowed its Grand Effie prize on Absolut the previous year. "Effie" is short for "effectiveness," which is another term for sales. Effies are awarded across two dozen different product categories annually, with the Grand Effie given to a single marketer, regardless of category.

Meanwhile, back in Europe, Absolut was basically just getting started; outside of Sweden, the brand's sales were tiny, though select. The Absolut people at Vin & Sprit, Curt Nycander and now Claes Fick, decided the time was right to really launch Absolut on the Continent.

TBWA recommended using the American experience as a recipe for Europe. For advertising, that meant running the early Absolut product ads for a couple of years to establish awareness of the brand and its values. Only after consumers became acquainted with the real Absolut bottle would we take it away.

This strategy required a certain amount of self-control because many Europeans were already familiar with the ads through travel and exposure to American magazines, and we knew they would want the "Warhols" right away.

ABSOLUT ATHENS.

TBWA's Paris office is the hub of Absolut advertising in Europe, and Daniel Gaujac the smart, witty, and very French Frenchman who runs it. Although a newcomer to the brand, he understands it as well as anyone. After a couple of years of product ads (and considerable growth for the brand throughout Europe), Gaujac initiated an idea for a new ad series, inspired by the Absolut Cities campaign.

The Absolut Cities of Europe ads are a salute to twenty cities, utilizing landmarks, products, or attitudes for which each city is known. Each ad captures a "universal truth" about its city that will be recognized by people everywhere. While the campaign broke exclusively in *Newsweek International* over two years, 1993–94, these ads also appear regularly in the United States, where they are among our most popular.

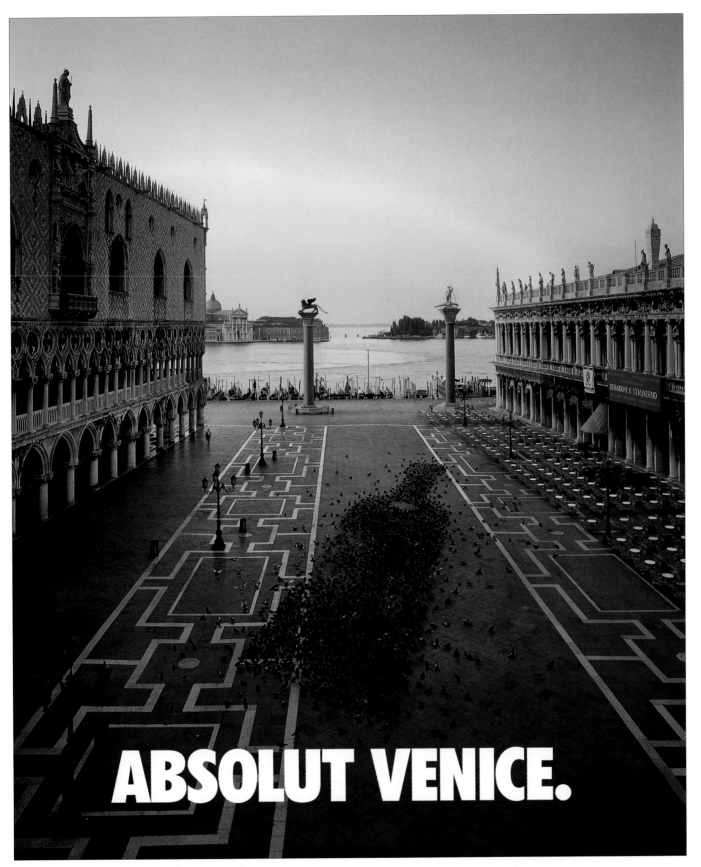

ABSOLUT VENICE.

ABSOLUT VENICE. In Venice, you can enjoy being serenaded by a singing gondolier; if he has a good voice, you may want to ask him to take you to Harry's Bar for an Absolut cocktail. From there, it's on to a palazzo and then off to the Piazza San Marco to see the pigeons. It took an entire harvest of wheat from the rich fields of southern Sweden to attract enough pigeons for this shoot.

ABSOLUT BERLIN.

ABSOLUT BERLIN. Berlin, the city where East and West were divided for twenty-eight years, has now become the European city of peace. When the Wall fell, citizens helped dismantle it and took home fragments as souvenirs. This is the piece that Absolut removed.

ABSOLUT NAPLES.

ABSOLUT NAPLES. Naples is a city of warmhearted and emotional yet united people. Its streets are narrow and packed with very small Italian cars, food stalls, and flowering plants. The Neapolitans share everything with one another, including the task of drying their laundry.

ABSOLUT COPENHAGEN. Tivoli (read backward, "I lov it"), the father of all Disneylands, was created in 1844 as a theme park devoted to Hans Christian Andersen's fairy tales. In the heart of Copenhagen, its beautiful old entrance opens onto the magic gardens where screams of fear and delight can be heard.

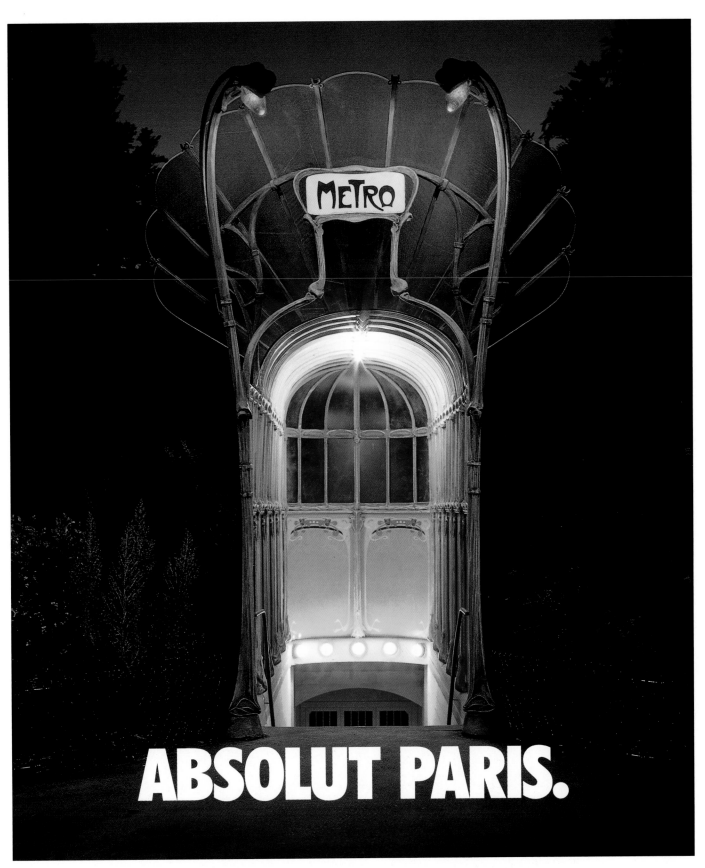

ABSOLUT PARIS.

ABSOLUT PARIS. Paris is the city of beauty, and beauty is everywhere; it's treasured and appreciated daily in the form of monuments, museums, houses, parks, bridges, and streets. Still, even the Metro entrances, painstakingly designed during the art nouveau era at the turn of the century, assume new shapes to keep up with the latest underground trends.

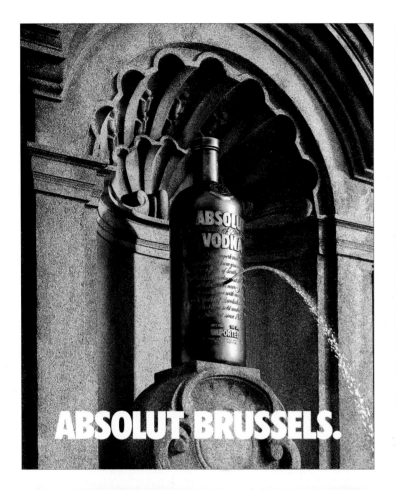

ABSOLUT BRUSSELS.

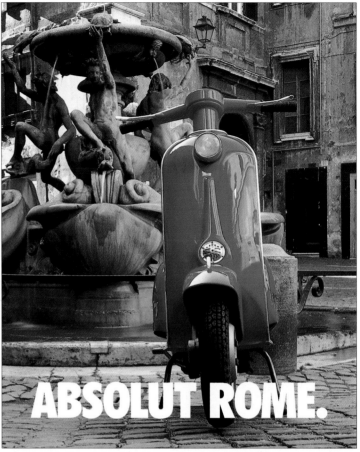

ABSOLUT ROME.

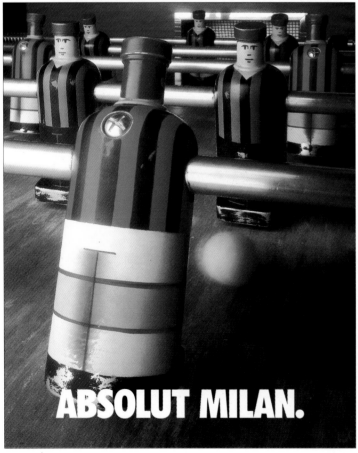

ABSOLUT MILAN.

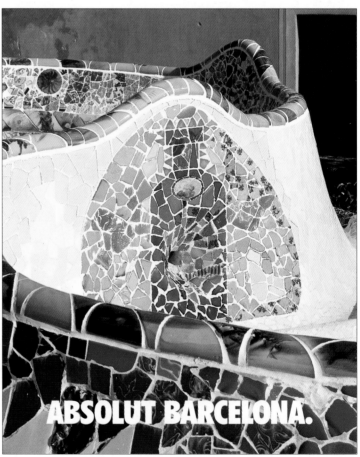

ABSOLUT BARCELONA.

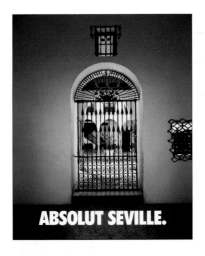

ABSOLUT SEVILLE.

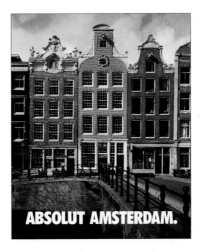

ABSOLUT AMSTERDAM.

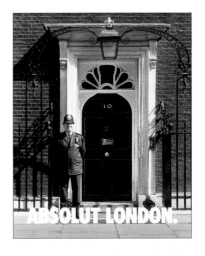

ABSOLUT LONDON.

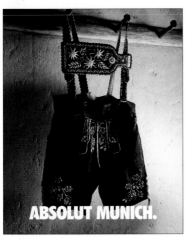

ABSOLUT MUNICH.

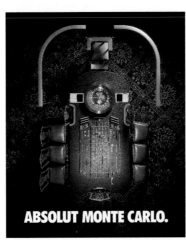

ABSOLUT MONTE CARLO.

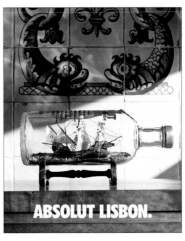

ABSOLUT LISBON.

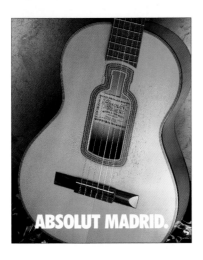

ABSOLUT MADRID.

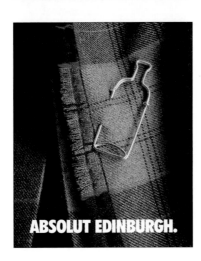

ABSOLUT EDINBURGH.

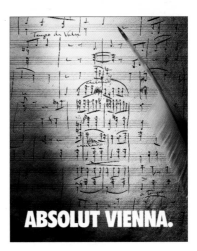

ABSOLUT VIENNA.

ABSOLUT BRUSSELS. Throughout Europe, Belgians are known for appreciating a good laugh. *Mannekin Pis* is a famous bronze statue of a watering cherub who, legend has it, saved Brussels from burning. Here Absolut poses as the national hero, offering a fountain of vodka.

ABSOLUT MILAN. Milan is home to Italian haute couture, museums, landmarks, elegant shops, top galleries, stylish restaurants, and refined people. There is, however, one occasion on which the Milanese surrender the high life and assemble: the semiannual soccer game between Inter Milan and A.C. Milan, always a highlight of the season.

ABSOLUT ROME. Rome is the world's richest living museum. Tourists cannot escape without spending days visiting the ancient monuments, landmarks, and galleries; drivers cannot get anywhere without spending hours and hours in city traffic, unless a motor scooter manages to slalom through the gridlock.

ABSOLUT BARCELONA. In Barcelona, the Spanish spirit of fiesta is expressed even in the architecture. The work of Antonio Gaudí is extraordinary—richly colored, with surprising shapes and beautiful swirls of mosaic tiles. A close look at the tiles reveals a certain familiar form.

ABSOLUT
FILM & LITERATURE

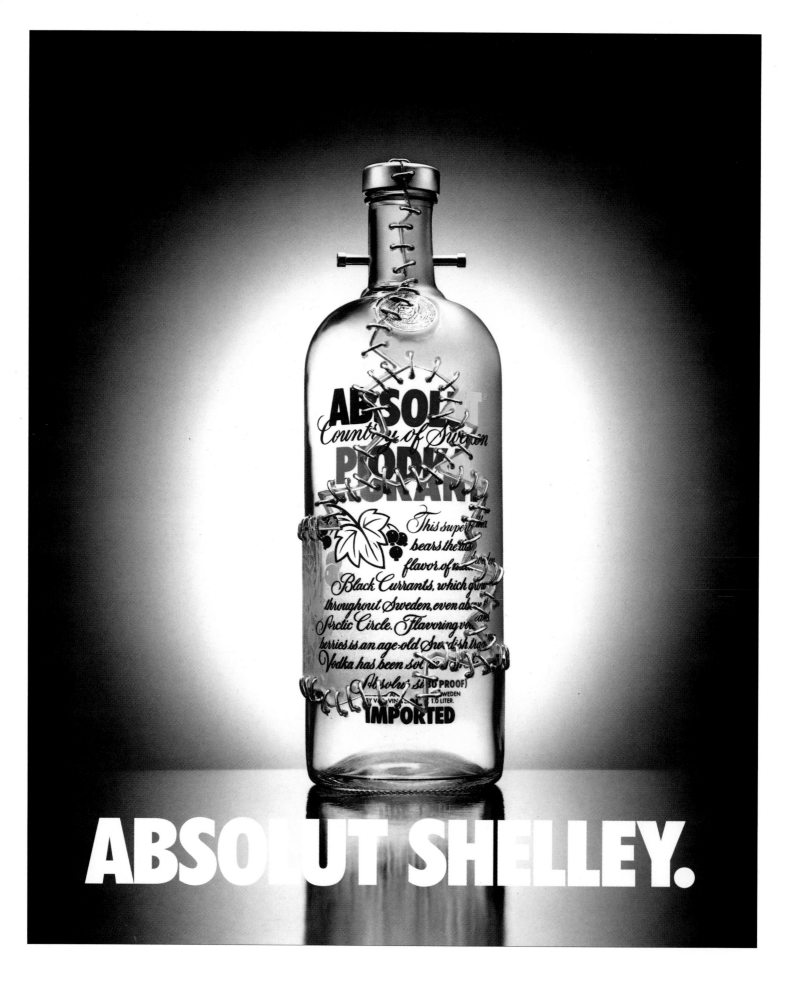

ABSOLUT SHELLEY.

ABSOLUT FILM & LITERATURE.

Some time prior to doing this book, I came up with a useful way to explain the history and breadth of the Absolut campaign: I invented categories for the hundreds of different ads. Sometimes these categories are easy to identify, and sometimes it can get a bit sticky. In either case, the classifications are pretty arbitrary. Because I have a unique perspective on the advertising—mine—I've created a system of putting certain ads in certain boxes. But these categories (and the chapters in this book) not only reflect how I see the body of work today, they also actually determine how we initiate additional Absolut advertising branches.

Sometimes we've been too quick to declare a trend and have identified a branch of the campaign that simply never blossomed. For instance, I was sure that ABSOLUT EVIDENCE (the bottle-in-the-thumbprint ad) was going to spawn a law-and-order series a few years back. And I also thought we were on the verge of an optometry series with ABSOLUT VISION, an ad that was yanked at the last moment (see Chapter 15, "Absolut Rejects").

But I wasn't wrong in 1994 when Dan Braun and Bart Slomkowski opened the portals of history—literary history, at least—with a trilogy of ads. ABSOLUT WELLS, ABSOLUT SHELLEY, and ABSOLUT STOKER pay homage to the writers H. G. Wells *(The Invisible Man)*, Mary Shelley *(Frankenstein)*, and Bram Stoker *(Dracula)*, respectively.

These three ads were but the first in a select group comprising what I think of as our film and literature series. It's a special set of ads that are obviously not for everyone. We run them only in literary-minded publications such as the *New Yorker* and the *New York Times Book Review*, or occasionally in film and entertainment magazines. Understanding them takes a few seconds—maybe many seconds—even when the reader is on the appropriate wavelength and reading a magazine whose emphasis is on literature. But we hear time and again that people appreciate the challenge, particularly when they conquer it.

These ads signify yet again how incredibly flexible this campaign and its glass bottle must be and are—so much so that they are able to, well, *transform* into an unlimited number of personalities.

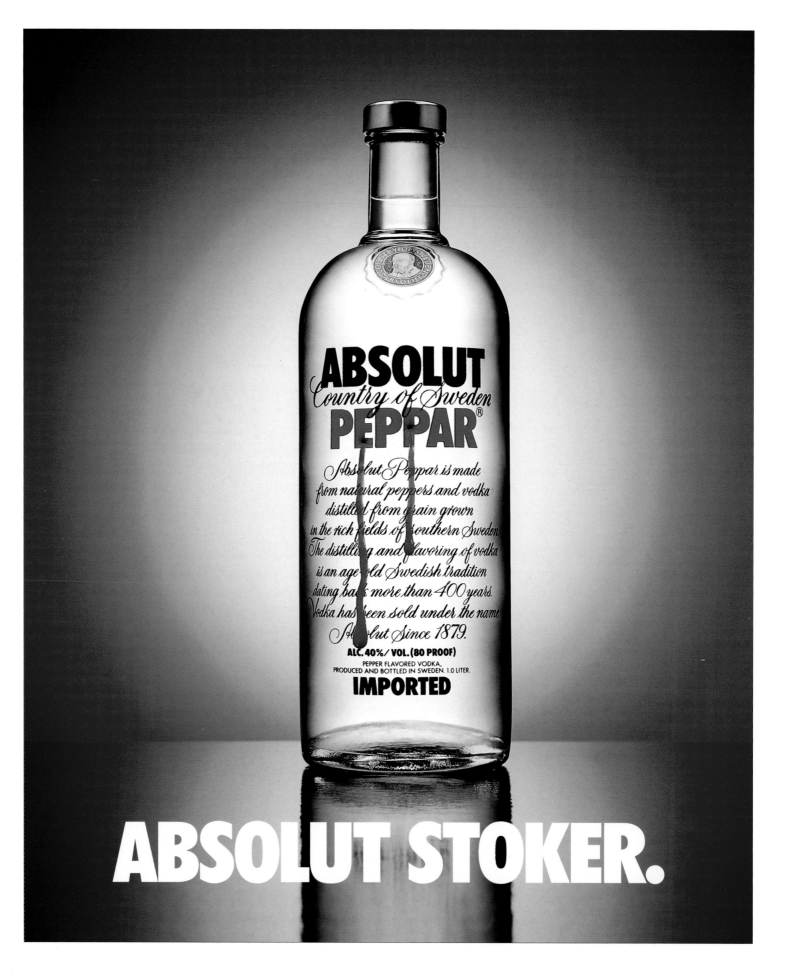

ABSOLUT WELLS.

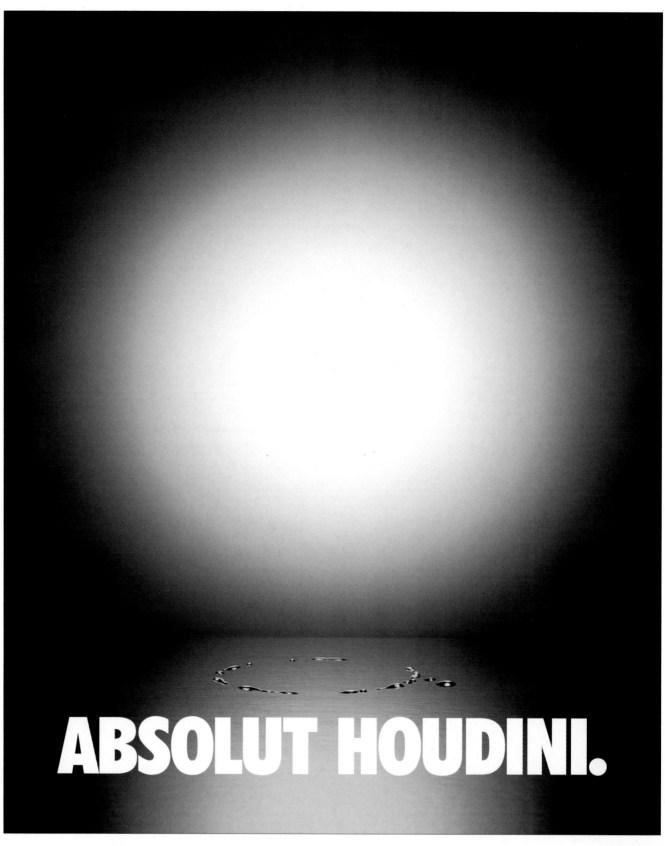

ABSOLUT HOUDINI.

ABSOLUT HOUDINI. OK, maybe it's a stretch to slip Houdini into film and literature, but I don't see a dead magicians' category opening up anytime, and anyway, he really was an entertainer. This wasn't a particularly easy ad to sell, though TBWA's new Creative Director, Tony DeGregorio, came up with a helpful approach: "We already have 498 ads with bottles," he said, "but we only have one other ad—ABSOLUT LARCENY—without the bottle." Good point.

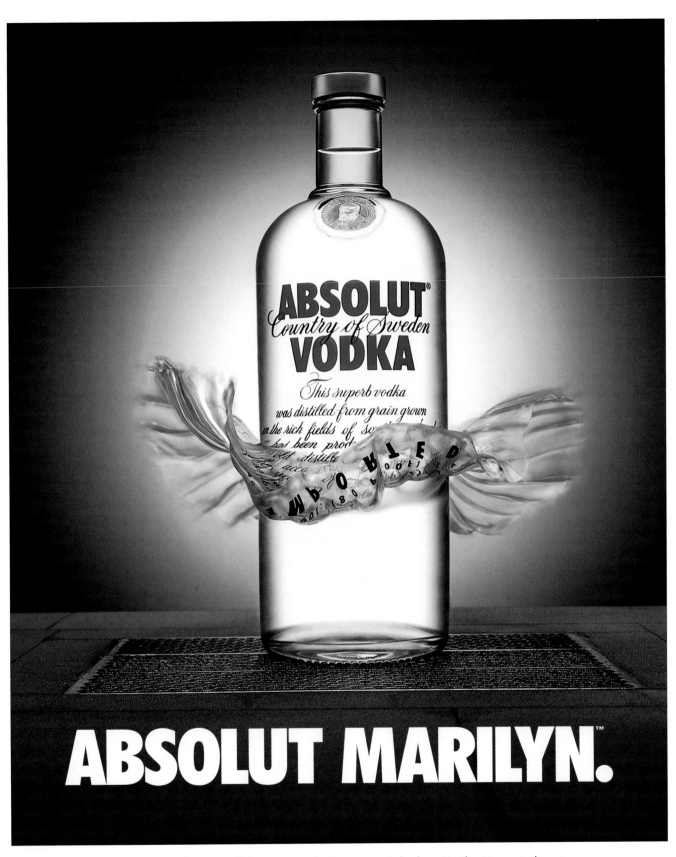

ABSOLUT MARILYN. Every film buff can recall the scene in *The Seven Year Itch* where Marilyn Monroe's dress is raised by the whoosh of a subway passing underneath a grate. Alix Botwin and Lisa Kay captured that moment for this ad. And the Estate of Marilyn Monroe agreed to allow it. As Steve Bronstein wouldn't have been able to control a bottle wearing a cotton dress, the one featured here is made of a very solid, very stiff acrylic. The effect of a breeze was added in the retouching.

absolut cummings. As in e. e. cummings—a great poet who is perhaps better remembered for spending his life in lowercase type than for any individual poem he wrote.

ABSOLUT ROSEBUD. Dan and Bart created this ad to honor the mystery of what many consider to be the greatest film of all time, *Citizen Kane*.

ABSOLUT

ABSOLUT

ABSOLUT

ABSOLUT

ABSOLUT

ABSOLUT
TAILOR-MADE

CHAPTER THIRTEEN

ABSOLUT TAILOR-MADE.

The Absolut advertising war chest increased significantly from under $1 million upon the campaign's debut in 1981, to a figure many times that by the end of the decade. (Client confidentiality prevents me from revealing the precise figures.)

Yet it remains a relatively small advertising budget compared to the tens of millions or hundreds of millions spent to advertise national brands such as Advil, Pepsi, and Nike. But these companies' campaigns, of course, include television advertising, which is largely off-limits to distilled spirits and can eat up money in a hurry. However, Absolut spends nearly its entire budget in print media, so it makes the brand an important advertiser for the magazines it chooses to do business with.

From the beginning, the planning and negotiating of media placement for Absolut were conducted differently from other spirits' and brands' campaigns. In Europe, the pricing of all media, especially print, has long been subject to negotiation. In 1980s America, in contrast, newspaper and magazine advertising was typically planned and then ordered without any dickering over prices. TBWA's understanding of the process was derived from its European perspective, and the agency became a pioneer in this country in insisting on negotiating over print space.

While a few larger-circulation magazines were used early on, including *Playboy* and *Sports Illustrated,* TBWA preferred to seek out for Absolut newer, smaller niche publications such as *Spy, Details,* and *Paper* magazines. More conservative advertisers generally wait for magazines to develop a track record in the market, and eventually demonstrate, through audience research, that their readers are already Absolut-type customers based on their demographics—age, education, income, etc. We were simply more daring. If we liked the editorial focus and quality of a magazine, we would bet on its potential to succeed and would become an early advertiser. Getting in on the ground floor enabled us to secure desirable positions in the magazine, often the back cover, at very favorable costs. Other advertisers, particularly spirits

YOUR AD HERE.
It could be. Just
turn the page,
choose from among
the watercolors we've provided and,
brandishing a cotton swab and your native
brilliance, create a beautiful ad for
Absolut. Then we'll launch your career
(or at least your ad in SPY).

ABSOLUT PARTICIPATION

ABSOLUT PARTICIPATION. *Spy* magazine invited its readers to create their own Absolut ads. (Talk about passing the buck.) Readers were provided with a palette of Absolut-shaped paints and encouraged to "brandish a cotton swab and your native brilliance." Two thousand entries were submitted, not bad for a magazine whose total circulation was about thirty-five thousand. The winning entry, published in the magazine, consisted of an all-black page under the heading ABSOLUT SARTRE.

companies, would soon follow us in. This led to our earning even more favorable rates as we would negotiate what someone termed a "Pied Piper rate." The publications were sometimes referred to as "downtown" because, at least in New York, that was precisely where many of their readers lived or worked. These readers were either already Absolut customers or soon likely to be: probably only recently out of college, starting a career, or on their first or second job, they were experiencing the nightlife, the arts, the museums that the Big City offered.

TBWA was also a very early supporter of media directed toward the gay and lesbian communities. We introduced this market to Carillon in the early eighties as a segment predisposed to purchasing premium products. Since Michel Roux was neither prejudiced

nor inclined to corporate squeamishness, he thought it was a fine idea.

Claude Fromm has been TBWA's Media Director since 1978. He's the thinker, the swami, and a very tough negotiator. Working for him are Reatha Braxton and Melissa Pordy. Reatha began her career as Claude's secretary back at Geers Gross and is recognized for her commitment to Absolut. Well known in the ad industry, she was in 1995 named a "Media Maven" by *Advertising Age*. As the Associate Media Director, she has a reputation for being a great negotiator, for concealing under her exterior toughness a warm heart, and for receiving up to two hundred phone calls a day, some of which she even returns. Melissa is ably following in Reatha's big footsteps.

Michel Roux also personally enjoyed selecting the magazines that would carry his brands' advertising, and he liked to negotiate the best rates and meet the sales reps and pick their brains for ideas to further Carillon's business. With Michel urging us on, we organized this entire process in 1988.

That year, in what would become an annual rite of spring, we invited about two hundred magazines out to Carillon headquarters in Teaneck, New Jersey, each for a thirty-minute meeting. Michel held court in Carillon's conference room as each magazine pitched for Absolut's business. We'd schedule up to fourteen meetings a day, back-to-back-to-back, so that by day's end, the room, strewn with the magazines' promotional materials (which had surely felled a dozen trees), half-eaten cakes and half-drunk cocktails, and enough garbage to fill a dumpster, inevitably resembled a party that had gone on too long.

But these meetings, dubbed the Media Marathon, also yielded something very useful for the brand. With Absolut's media plan now embracing scores of magazines, and with a vast pool of ads to choose from, we saw a new opportunity: where possible, we wanted to match the ads that appeared in a particular magazine to the mindset of that magazine's readers. So we asked for their help in creating Absolut ads tailor-made for many of their publications. Absolut had a history of pursuing ideas from unexpected sources, so this was nothing new for us; for the magazines, however, it was a radical departure. We had drafted them into our creative army.

ABSOLUT HOFMEKLER.
HOMAGE TO JAN VERMEER

ABSOLUT HOFMEKLER.
HOMAGE TO PETER PAUL RUBENS

Because these magazine sales and promotion people weren't trained to create ads, they needed a good deal of guidance and supervision from the agency. While the vast majority of the ideas submitted were never used, some of those that were used are very good.

One ad that certainly possessed campaign quality was ABSOLUT STORY. The readers of *Esquire* were asked to write an original story that had to include the words "Absolut Vodka." (I can only guess how many would-be writers went back and added those two words to existing efforts.) Cartons and cartons of stories filled the Carillon conference room. The winner was Leonore Hershey, who penned a scandalous tale set on Capitol Hill.

ABSOLUT HOFMEKLER. *Penthouse* art? It's not what you'd think. Ori Hofmekler is an Israeli-born artist on the magazine's staff whose specialty is repainting the work of the old masters. His task was to insert Absolut bottles into these paintings and make it look as if they'd been there from the beginning. I think he did a great job, though I still suspect that *Penthouse* isn't the most appropriate venue for this art.

ABSOLUT HOFMEKLER.
HOMAGE TO AMEDEO MODIGLIANI

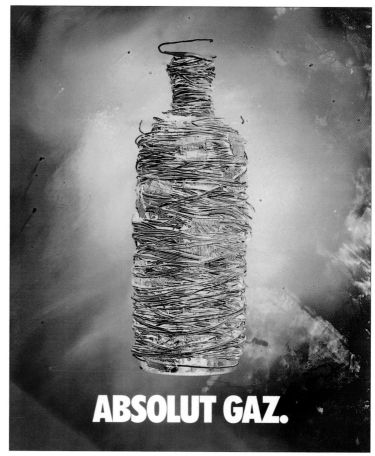

ABSOLUT PORTO.

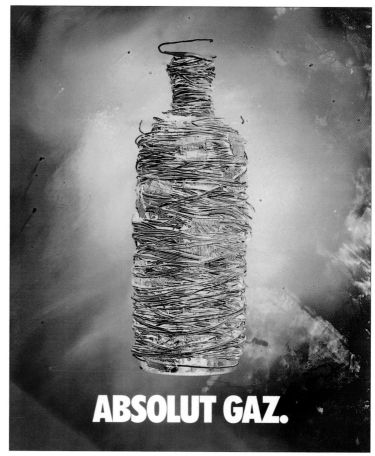

ABSOLUT GAZ.

ABSOLUT SPEER.

ABSOLUT KAI.

ABSOLUT GRAUPE-PILLARD.

ABSOLUT SALZMAN.

ABSOLUT PORTO, ABSOLUT GAZ, ABSOLUT SPEER, ABSOLUT KAI. Each of these digital artists creates his art on a computer. The ads appear regularly on the back cover of *Wired* magazine, the Bible of the digerati.

ABSOLUT GRAUPE-PILLARD, ABSOLUT SALZMAN, and ABSOLUT PINK were all created exclusively for BOMB magazine, a small-circulation, quality magazine devoted to the arts and culture.

ABSOLUT PINK.

ABSOLUT SCUDERA.

ABSOLUT BOLAÉ.

ABSOLUT SCUDERA, ABSOLUT BOLAÉ, ABSOLUT HENRIQUEZ. Simon Scudera, Bolaé, and Luis Henriquez are Florida artists/designers who have been profiled in *Haut Decor*, a design magazine for the southern part of that state. Naturally, the ads appear on the back covers of the same issues that carry the stories.

ABSOLUT HENRIQUEZ.

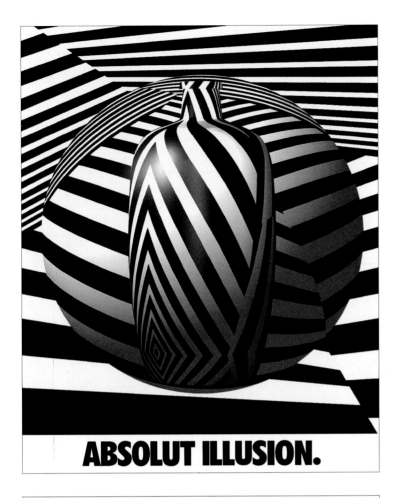

ABSOLUT ILLUSION.

ABSOLUT ILLUSION, ABSOLUT PARADOX, ABSOLUT CREATION. These ads are from a series that appears in *I.D.* magazine, a tiny (circulation twenty thousand) publication devoted to international design. They are the work of a Chicago design group called Thirst.

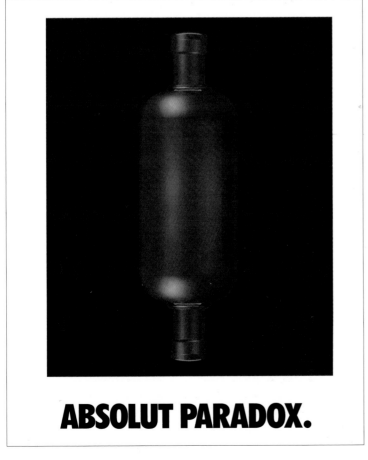

ABSOLUT PARADOX.

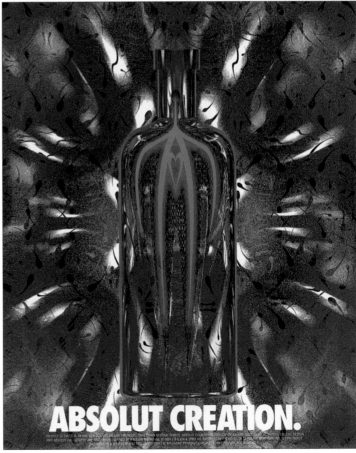

ABSOLUT CREATION.

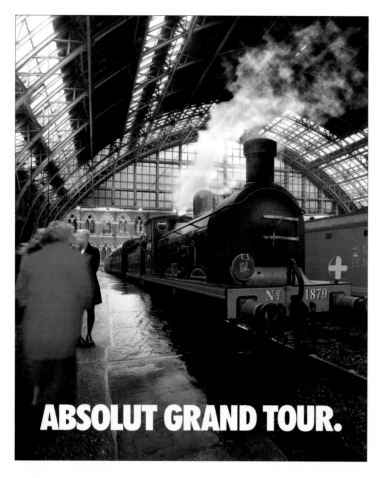

ABSOLUT GRAND TOUR.

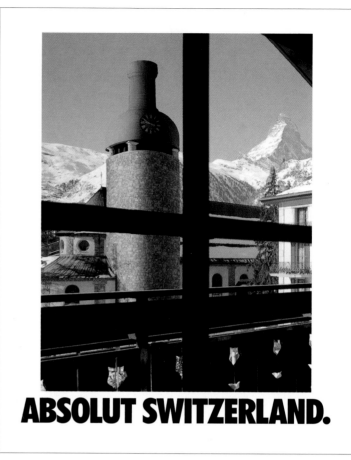

ABSOLUT SWITZERLAND.

ABSOLUT POLYNESIA.

ABSOLUT BOLOGNA.

ABSOLUT CADIZ.

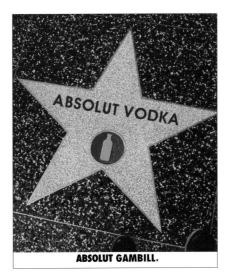

ABSOLUT GAMBILL.

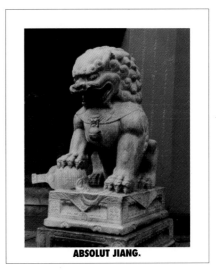

ABSOLUT JIANG.

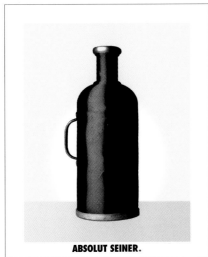

ABSOLUT SEINER.

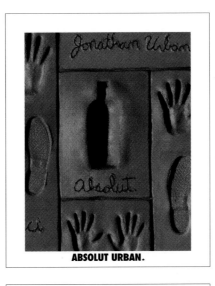

ABSOLUT URBAN.

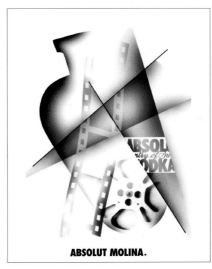

ABSOLUT MOLINA.

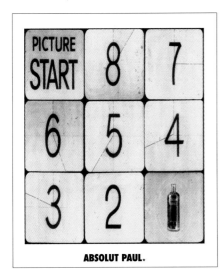

ABSOLUT PAUL.

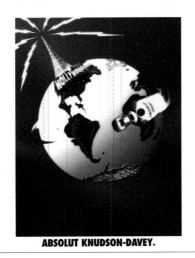

ABSOLUT KNUDSON-DAVEY.

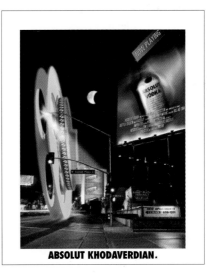

ABSOLUT KHODAVERDIAN.

ABSOLUT GRAND TOUR, ABSOLUT SWITZERLAND, ABSOLUT POLY-NESIA, ABSOLUT BOLOGNA. Dennis Marsico is a photographer for *Travel Holiday* magazine. Whenever he's on assignment, typically shooting a cover story of some vacation spot, he takes additional photos that will later be transformed into Absolut ads, to run in the same issue as the corresponding editorial.

ABSOLUT PHOTOS. Absolut has showcased the work of aspiring and professional photographers in the pages of *American Photo* magazine for five years. This particular series, on a Hollywood theme, was created by students at the Art Center College in Pasadena, California.

ABSOLUT

ABSOLUT

ABSOLUT

ABSOLUT

ABSOLUT

ABSOLUT
ABSOLUT TOPICALITY

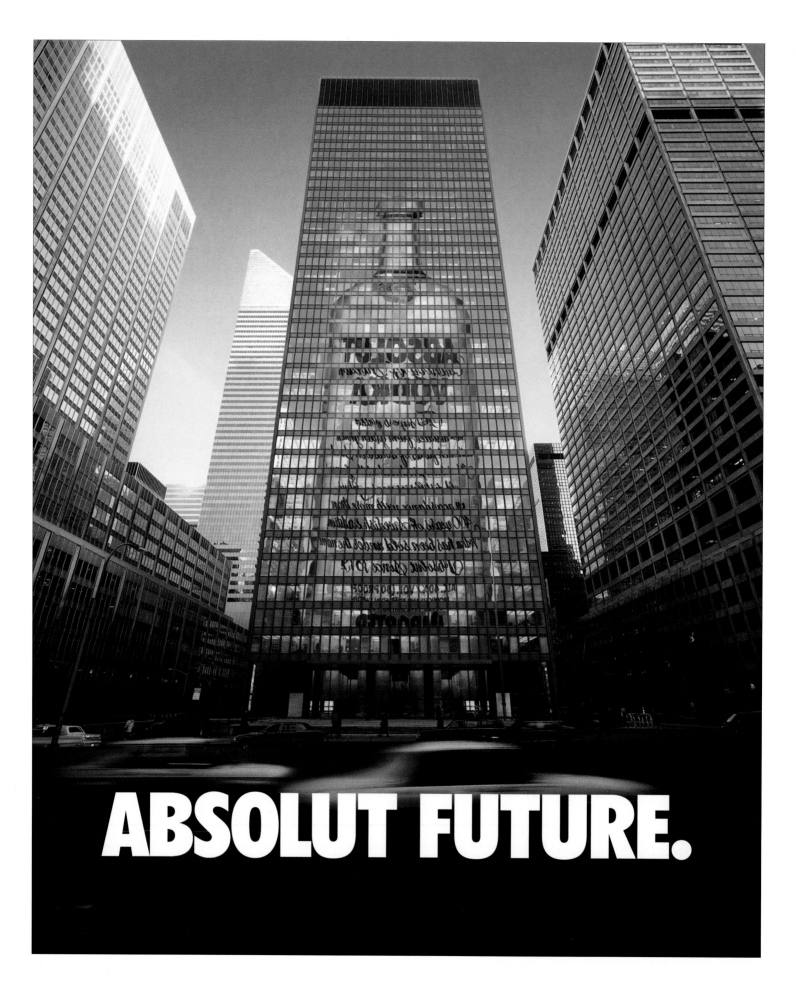

ABSOLUT FUTURE.

252

ABSOLUT TOPICALITY.

Part of the campaign's charm, we feel, is Absolut's ability to show up unexpectedly. I'm referring here not to party-crashing but to surprise appearances.

It's as though Absolut had a sixth sense that kept it a step ahead of world news, holidays, critical sports victories, worthwhile charitable events, or salutes to people or things that deserve an acknowledgment.

We call this group topical ads, and all feature Absolut's unique spin on something newsy. The events covered typically fall into one of three categories. We know what will happen and when (e.g., a holiday). We know the what but not the when (the end of a strike). We know the when but not the what (a sports championship).

More often than not, we place these ads in newspapers instead of magazines simply because we can create and produce a newspaper ad much faster than a magazine ad, and we can supply it to the newspaper as little as a day before it actually runs. (Some magazines require the submission of advertising material two months before a particular issue goes on sale.)

Because of the time crunch, newspaper ads aren't always the prettiest, but what they lack in beauty, they can compensate for with a good idea. Or late-breaking news.

We even created an ad to announce some momentous news concerning Absolut itself. In 1994, Vin & Sprit entered a worldwide distribution agreement with Seagram, the global wine, spirits, beverage, and now film and entertainment company. The Swedes needed a powerful partner to help grow the brand's sales worldwide; up to now, Absolut had had different importers in each country, each with a different understanding of the brand and each experiencing a varying degree of success. After a lengthy review that included the four major international spirits companies (including Carillon's parent company, International Distillers & Vintners), Seagram was selected. To kick off the Seagram relationship, the ad ABSOLUT FUTURE ran in the *Wall Street Journal.* The bottle is reflected in New York's landmark

Seagram Building, designed by Mies van der Rohe and Philip Johnson.

Unfortunately for Carillon, its contract to market Absolut in the United States was terminated; on a happier note, the Absolut advertising campaign and TBWA's relationship with the brandowner, Vin & Sprit, would continue.

Carillon was shocked at losing Absolut, but on a business level, the company recovered very quickly. Dick McEvoy and Michel Roux engineered a coup: on February 1, 1994, the first official day of Seagram's relationship with Absolut (and the day we published ABSOLUT FUTURE), Carillon began importing Stolichnaya Vodka. The trade press declared an impending "vodka war," which never materialized, partly because the brands were—and always had been—respectful competitors. Later that spring, however, Creative Director Arnie Arlow left TBWA and was reunited with Michel Roux by joining Stolichnaya's new agency, Margeottes Fertitta & Partners. On *that* occasion, we chose not to do a topical ad.

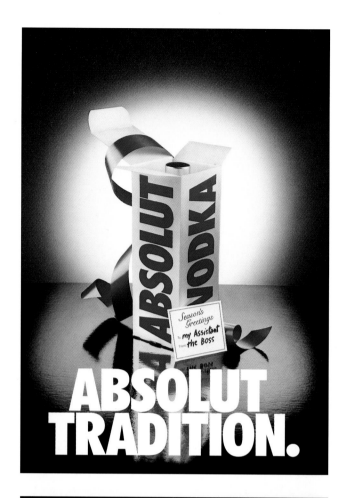

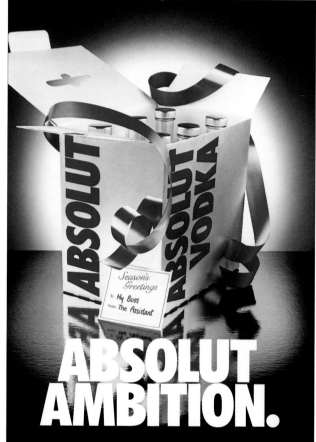

ABSOLUT TRADITION/ABSOLUT AMBITION. Very occasionally we're also mercenary, and we hold out the hope that readers will actually go out and purchase Absolut right after seeing the advertising. This two-page newspaper ad encouraged rising young junior executives to buy their bosses an entire case.

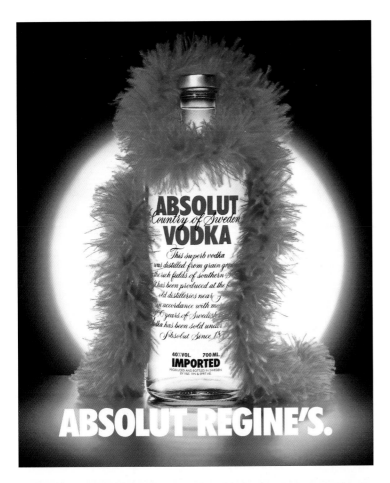

ABSOLUT REGINE'S.

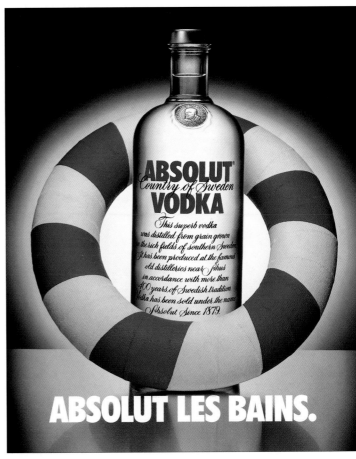

ABSOLUT LES BAINS.

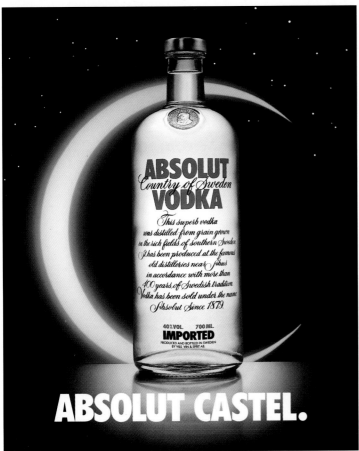

ABSOLUT CASTEL.

ABSOLUT REGINE'S, ABSOLUT LES BAINS, ABSOLUT CASTEL. Somewhat surprisingly, liquor advertising in France is tightly restricted by French law: the only permissible elements in an ad are the product's ingredients, its place of manufacture, and its place of sale. We found a delightful method of staying within the spirit of the French law by showing pivotal, symbolic aspects of some of the nightclubs where Absolut is available.

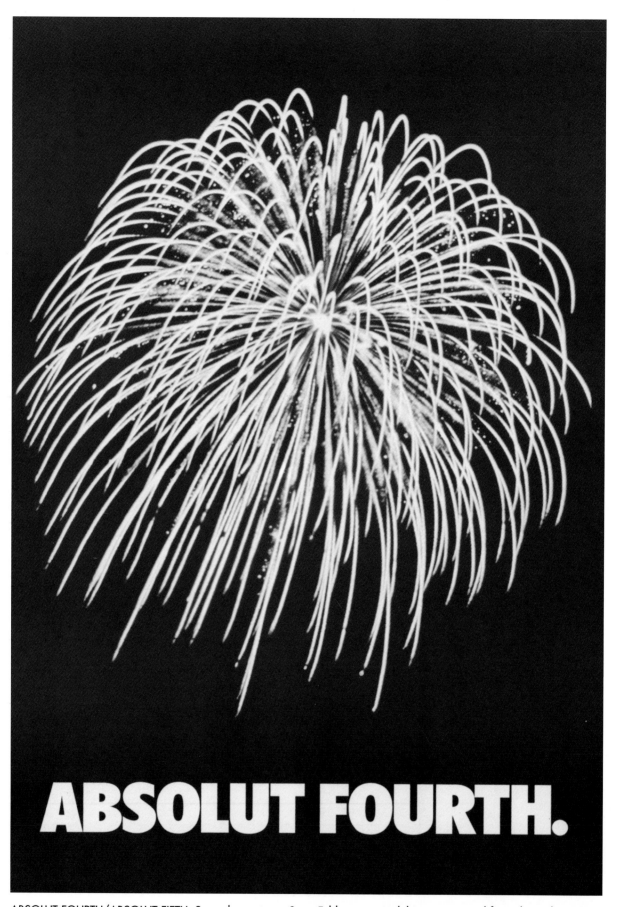

ABSOLUT FOURTH/ABSOLUT FIFTH. Several years ago, Steve Feldman created this two-page ad for Independence Day.

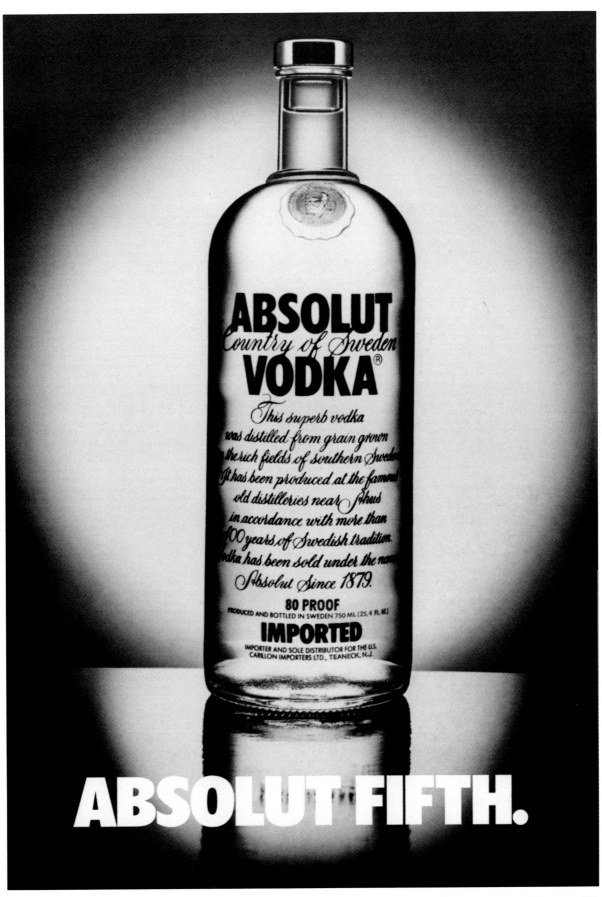

Even though wine and spirits have gone metric, we counted on readers to remember the former measure: *fifth* as in "fifth of a gallon."

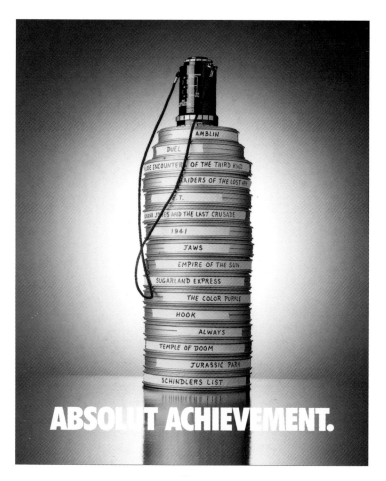

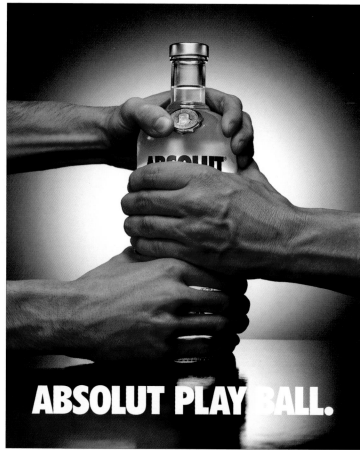

ABSOLUT ACHIEVEMENT. When Steven Spielberg was honored with the American Film Institute's Lifetime Achievement Award, Absolut saluted the director with a bottle composed of film cans of all his movies.

ABSOLUT PLAY BALL. We figured that eventually the 1994 Major League Baseball strike would have to end. So we had plenty of time to prepare this color ad for *Sports Illustrated* to run on Opening Day 1995.

ABSOLUT SAN FRANCISCO. This ad ran on Super Bowl Monday in 1995, after the NFC reprised its annual maul of the AFC. When Arthur Shapiro, Seagram's U.S. marketing chief, told me that we wouldn't need to provide the newspapers with an ABSOLUT SAN DIEGO headline (to be used in the event that San Diego won), I knew we'd have to, since Arthur doesn't have the best prediction record in these matters. This may have been the last time he was correct.

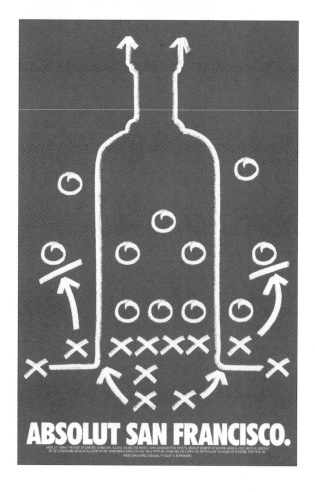

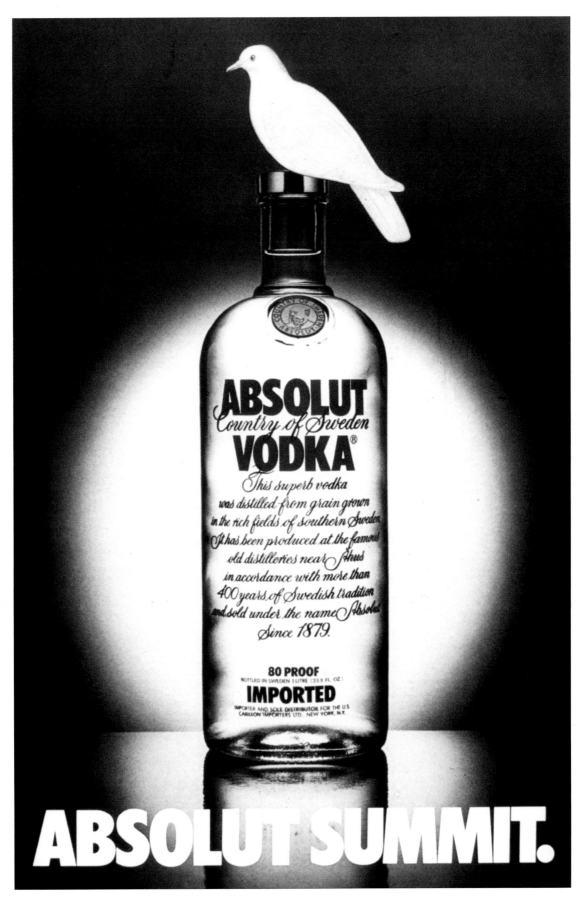

ABSOLUT SUMMIT. Whenever Presidents Reagan and Gorbachev got together in Iceland, or Italy, or New Jersey, we would run this ad as Absolut's vote for peace.

ABSOLUT

ABSOLUT

ABSOLUT

ABSOLUT

ABSOLUT

ABSOLUT
REJECTS

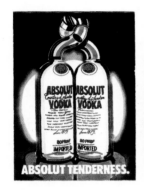

ABSOLUT TENDERNESS.

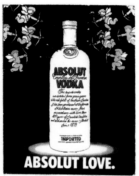

ABSOLUT LOVE.

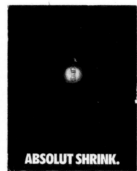

ABSOLUT SHRINK.

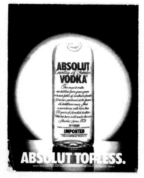

ABSOLUT TOPLESS.

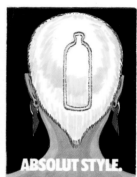

ABSOLUT STYLE.

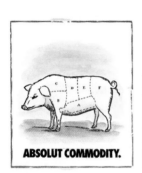

ABSOLUT COMMODITY.

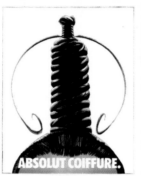

ABSOLUT COIFFURE.

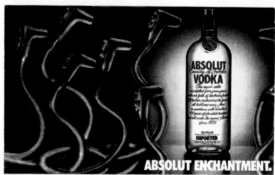

ABSOLUT ENCHANTMENT.

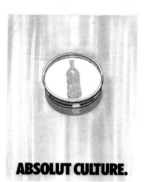

ABSOLUT CULTURE.

ABSOLUT REJECTS.

ABSOLUT REJECTS.

A few years ago—in 1992, I believe—Art Director Alix Botwin had what sounded like a wonderful idea for an ad. It was to be a two-page spread featuring about ten Absolut ideas that TBWA had at some time or other presented to Carillon . . . all of which had been rejected.

The ad, called ABSOLUT REJECTS, contained miniatures of some of our never-to-happen favorites: ABSOLUT ENCHANTMENT, in which the soda guns found in bars rise up like snakes, as if charmed by the Absolut bottle; ABSOLUT STYLE, one of two hairdo ads, this one showing the razor-cut perimeter of the bottle on a punk-style blonde; and ABSOLUT CULTURE, starring the bottle in a petri dish. All real, and all rejects.

This seemed like a very appropriate ad to run in *Advertising Age*, among other publications. But while we saw it as an amusing look inside the campaign, Michel Roux was less than thrilled by the idea. He hadn't liked any of the ads individually, and he liked them even less collectively. He also didn't care for the word "rejects," which hardly connoted a positive aspect of Absolut.

We brought this ad back to the altar several times, only to be rejected on each occasion. I'll always have a warm spot for it in my heart, though, and it occurred to me when I was putting this book together that there's a veritable army of other rejects, some very good, some laughably bad, that just didn't make it for one reason or another. For every Absolut ad that did make it, perhaps another half dozen were left on the drawing board. Here's a choice selection of the latter.

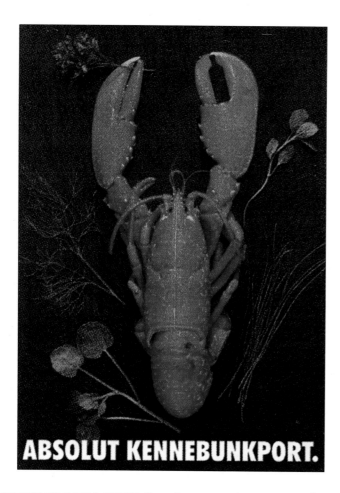

ABSOLUT KENNEBUNKPORT.

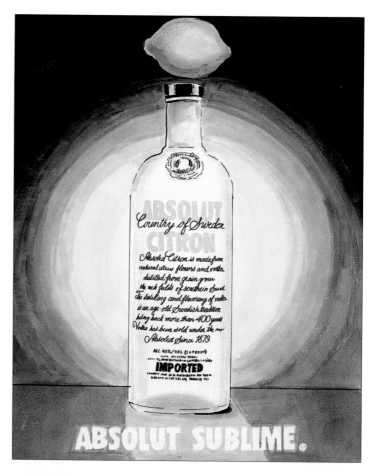

ABSOLUT SUBLIME.

ABSOLUT KENNEBUNKPORT. If you have a good memory, you'll recall that this Maine town was often in the news during President Bush's term in office—it was his summer residence.

ABSOLUT SUBLIME. This ad did not have a big fan club. I liked it because there are so few citrus puns out there that it's hard to give one up.

ABSOLUT BOISE. I think this was a love-at-first-sight idea; all too soon, though, we ran into a "no meat, no vegetables" brick wall. But I bet it would be a hit in Idaho.

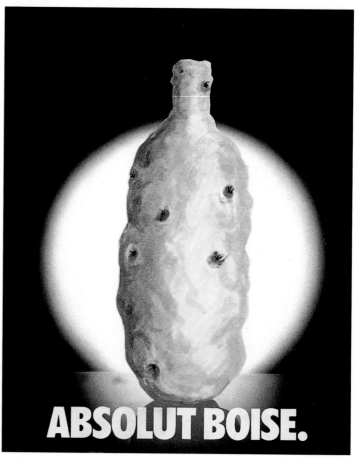

ABSOLUT BOISE.

ABSOLUT VEGAS. Over the past few years, we've shown this idea to anybody who was willing to look at it. Nobody liked it. (I can't understand why; we think it captures the romantic side of Las Vegas.) When I last showed ABSOLUT VEGAS to Curt Nycander, our nonviolent Swedish client, he informed me that if I ever presented it again, he would smack me.

ABSOLUT REINDEER. This idea is living proof that there are limits to what can be done to create the bottle shape.

ABSOLUT PHILADELPHIA. If this ad had a weakness, we thought, it was its obviousness. Michel Roux, quaintly, just wasn't comfortable with the idea of appropriating a national monument.

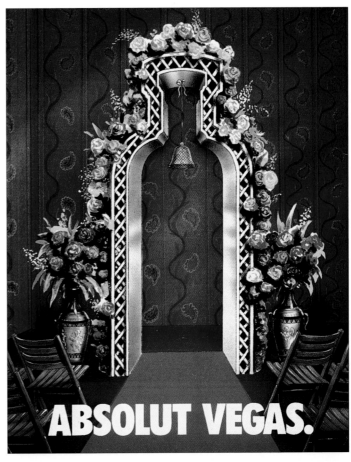

ABSOLUT VEGAS.

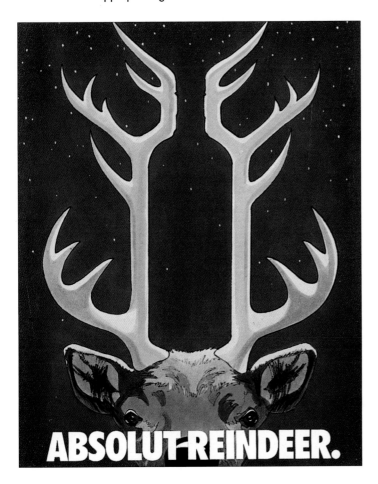

ABSOLUT REINDEER.

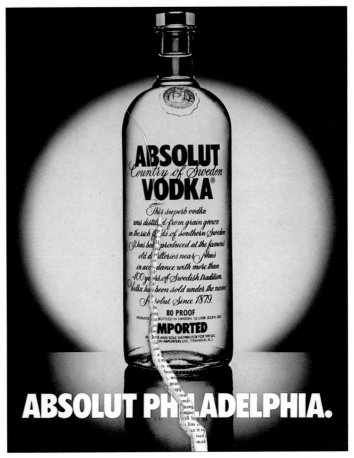

ABSOLUT PHILADELPHIA.

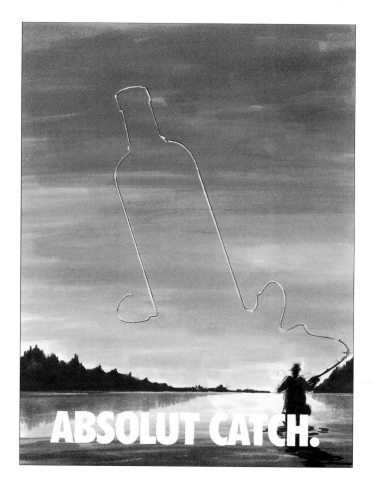

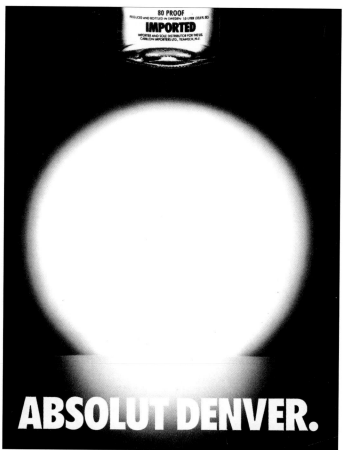

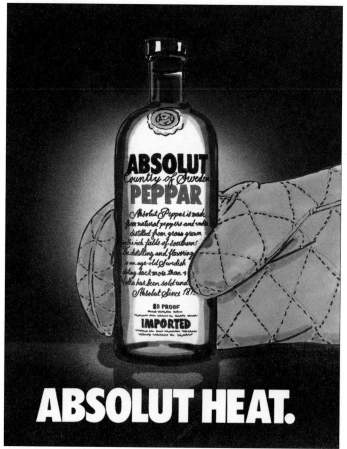

ABSOLUT CATCH. Following the popularity of the film *A River Runs Through It*, based on the novel by Norman Maclean, we were smitten with fly fishing. We might have been able to sell the ad if we had taken the client to the movie first.

ABSOLUT DENVER. It's difficult to keep even Absolut on the ground in the Mile High City.

ABSOLUT HEAT. An early attempt to convey Peppar's fiery personality.

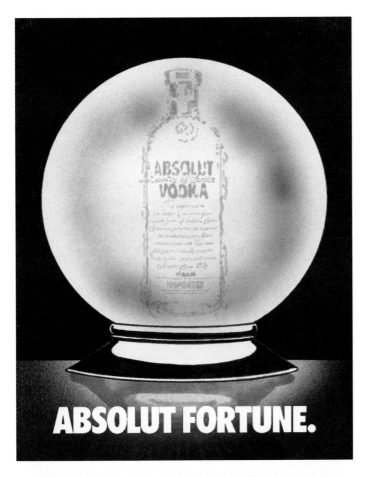

ABSOLUT FORTUNE.

ABSOLUT MEMPHIS.

ABSOLUT FORTUNE. With the possible exception of the Statue of Liberty clutching an Absolut bottle, this is the most frequently submitted unsolicited idea received by the agency, which helps to explain why we never did it.

ABSOLUT MEMPHIS. Yet another unsuccessful hair ad.

ABSOLUT RIPLEY'S. Believe it or not, this ad was rejected without a lot of discussion.

ABSOLUT RIPLEY'S.

ABSOLUT SQUIRT.

ABSOLUT VISION.

ABSOLUT SQUIRT. It isn't easy returning to the lemon-lime well, time after time, to convey Citron's reason for being. But ABSOLUT SQUIRT, we thought, was kind of charming.

ABSOLUT VISION. This ad was actually finished when we pulled the plug on it. It was really just a case of bad timing: two other advertisers came out with similar treatments right before ABSOLUT VISION was to debut. We preferred to kill it rather than risk being embarrassed. These things happen, even innocently.

ABSOLUT NIGHTCAP. This Christmas spectacular was to include a give-away wool cap for the reader. When Arnie Arlow pitched it to Michel Roux a few years ago, Michel actually became angry at us for showing it to him (the first and only time I can remember his doing that). "You people don't understand the brand!" he spat. Coming from Michel, this was major criticism. On reflection, I realize it may just have been a bad day for new ideas.

ABSOLUT NIGHTCAP.

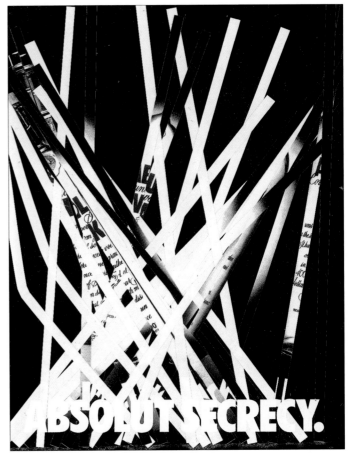

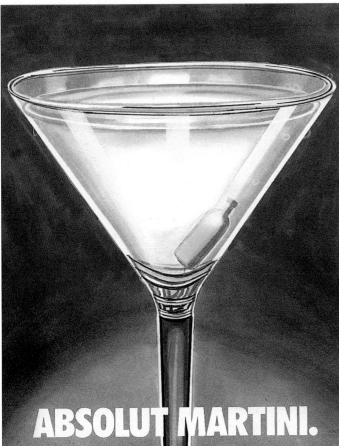

ABSOLUT BREAK. We couldn't convince the client that pool had become a very upscale sport in the past few years.

ABSOLUT SECRECY. Around the time of the Iran-Contra hearings in Congress, we proposed doing an actual shredded ad encased in a plastic pouch. I think it fell through because it would've cost a fortune, although Oliver North offered to fund it.

ABSOLUT MARTINI. We almost produced this ad; in fact, we still might. In a few years, someone will comb through the agency's reject closet, find this, and ask, "Why didn't the client buy the olive ad?"

ABSOLUT CREDITS AND PERMISSIONS.

Chapter 1
page 6. Photograph of Curt Nycander supplied by Impact International.

Chapter 4
page 54. Susan E. Davis, ABSOLUT SOLUTION: Behind the scenes for production of Absolut Miami, *Step-by-Step Graphics*, September/October 1991.

Chapter 5
page 64. ABSOLUT WARHOL. © 1996 Andy Warhol Foundation for the Visual Arts/ARS New York.
page 69. ABSOLUT HARING. © The Estate of Keith Haring.

Chapter 8
page 164. Drawing by Weber © 1988 The New Yorker Magazine, Inc. All rights reserved.
page 171. ABSOLUT INDIANA. © 1991 James Wille Faust.

Chapter 10
page 207. *Absolut Lee* by Antonio Carlos Jobim © 1987 Corcovado Music produced by Pat Philips and Ettore Stratta.

Chapter 11
Graham Ford was the photographer for Athens, Berlin, Brussels, Edinburgh, Geneva, Lisbon, Madrid, Milan, Monte Carlo, Munich, Paris, Rome, and Vienna.
Vincent Dixon was the photographer for Amsterdam, Barcelona, Copenhagen, Naples, Seville, and Venice.

Chapter 13
page 247. ABSOLUT ILLUSION, ABSOLUT CREATION, and ABSOLUT PARADOX were created by Rick Valicenti/THIRST. Tony Klassen and Mark Rattin did the digital imaging; Todd Lief wrote the copy.

Chapter 15
page 267. Ripley's is a Registered Trademark of Ripley Entertainment Inc.

INDEX

A

ABSOLUT 19TH 34
ABSOLUT ACHIEVEMENT 258
ABSOLUT ADAMS 159
ABSOLUT AIDAN 184
ABSOLUT ALABAMA 171
ABSOLUT ALAÏA 132
ABSOLUT ALASKA 171
ABSOLUT ALBERT 184
ABSOLUT ALFARO 132
ABSOLUT ALLEN 162
ABSOLUT AMERICANA 136
ABSOLUT AMSTERDAM 227
ABSOLUT ANTICIPATION 27
ABSOLUT APPEAL (1) 195
ABSOLUT APPEAL (2) 195
ABSOLUT ARIZONA 171
ABSOLUT ARKANSAS 171
ABSOLUT ARMAN 70
ABSOLUT ARNOLD 177
ABSOLUT ARTISTS OF THE NINETIES 150
ABSOLUT ATHENS 220
ABSOLUT ATLANTA 59
ABSOLUT ATTRACTION 17
ABSOLUT AULD 79
ABSOLUT AVITAL 157
ABSOLUT BAE & CASTRO 129
ABSOLUT BALL 88, 90–91
ABSOLUT BARCELONA 226
ABSOLUT BARRY/WALKER 120
ABSOLUT BARSOTTI 166
ABSOLUT BASA 157
ABSOLUT BAYOU 124
ABSOLUT BEASLEY 161

ABSOLUT BECKER 154
ABSOLUT BEENE 125
ABSOLUT BENNIS EDWARDS 116
ABSOLUT BERLIN 222
ABSOLUT BILLOPS 160
ABSOLUT BLAHNIK 133
ABSOLUT BLUM 151
ABSOLUT BOISE 264
ABSOLUT BOLAÉ 246
ABSOLUT BOLOGNA 248
ABSOLUT BONILLA 127
ABSOLUT BOSTON 58
ABSOLUT BRAVO viii, 18
ABSOLUT BREAK 269
ABSOLUT BRENDEN 144
ABSOLUT BRITTO 74
ABSOLUT BROOKER 161
ABSOLUT BROOKLYN 56
ABSOLUT BRUSSELS 226
ABSOLUT BUATTA 148
ABSOLUT BUBB 116
ABSOLUT BURKE 145
ABSOLUT CALIFORNIA 169
ABSOLUT CAMERON 104
ABSOLUT CARAEFF 154
ABSOLUT CARPENTER 154
ABSOLUT CASEY 112
ABSOLUT CASTEL 255
ABSOLUT CATCH 266
ABSOLUT CENTERFOLD 210–213
ABSOLUT CHAST 167
ABSOLUT CHAVEZ 145
ABSOLUT CHELSEY MCLAREN 113
ABSOLUT CHICAGO 50
ABSOLUT CHRISTOPHER 156
ABSOLUT CITRON 198
ABSOLUT CLARITY 15
ABSOLUT CLODAGH 148
ABSOLUT COLORADO 171

ABSOLUT CONNECTICUT 171
ABSOLUT COPENHAGEN 224
ABSOLUT COULTER 141
ABSOLUT CREATION 247
ABSOLUT CROSS 138
absolut cummings 236
ABSOLUT D.C. 53
ABSOLUT D.C. 171
ABSOLUT DAHL 145
ABSOLUT DEAN 143
ABSOLUT DEEN 157
ABSOLUT DEFINITION 22
ABSOLUT DÉJÀ VU 27
ABSOLUT DEL GRECO 109
ABSOLUT DELAWARE 171
ABSOLUT DENNIS 125
ABSOLUT DENVER 266
ABSOLUT DESIGN 146
ABSOLUT DESPERT 157
ABSOLUT DIXON 144
ABSOLUT DOODLE 83
ABSOLUT DORR 176
ABSOLUT DOW SIMPSON 84
ABSOLUT DREAM 16
ABSOLUT DUARDO 154
ABSOLUT DUKE 121
ABSOLUT ECHO 152
ABSOLUT EDELMANN 85
ABSOLUT EDERER 157
ABSOLUT EDINBURGH 227
ABSOLUT EISEN 129
ABSOLUT EISENMAN 177
ABSOLUT ELECTRIC 78
ABSOLUT ELEGANCE 27
ABSOLUT EMERSON 129
ABSOLUT ENGLISH 154
ABSOLUT ENVIRONMENT 96
ABSOLUT ESSENCE 207
ABSOLUT ESTRADA 107

ABSOLUT EVIDENCE	37	ABSOLUT HARVEST	198	ABSOLUT KHODAVERDIAN	249		
ABSOLUT FALCONER	177	ABSOLUT HAWAII	171	ABSOLUT KLEIN	157		
ABSOLUT FASHION	110	ABSOLUT HEAT	266	ABSOLUT KNUDSEN-DAVEY	249		
ABSOLUT FASHION	122	ABSOLUT HEAVEN	14	ABSOLUT KOREN	167		
ABSOLUT FAX	215	ABSOLUT HEISEL	129	ABSOLUT KOSHER	18		
ABSOLUT FEITH	129	ABSOLUT HENRIQUEZ	246	ABSOLUT KOSOLAPOV	180		
ABSOLUT FERNANDEZ	142	ABSOLUT HERITAGE	158	ABSOLUT KOZLOV	184		
ABSOLUT FERRARA	109	ABSOLUT HIRSCHFELD	76	ABSOLUT KRASNY	184		
ABSOLUT FEZZA	115	ABSOLUT HOBAN	126	ABSOLUT KURANT	194		
ABSOLUT FIFTH	257	ABSOLUT HOFMEKLER	243	ABSOLUT KURANT	199		
ABSOLUT FIRST CLASS	206	ABSOLUT HOLLYWOOD	57	ABSOLUT L'CHAIM	80		
ABSOLUT FLORIDA	171	ABSOLUT HOOKER	142	ABSOLUT L.A.	46		
ABSOLUT FORSYTHE	116	ABSOLUT HOT SOX	129	ABSOLUT LAMM	179		
ABSOLUT FORTUNE	267	ABSOLUT HOUDINI	234	ABSOLUT LANDMARK	39		
ABSOLUT FOURTH	256	ABSOLUT HUMPHREY	161	ABSOLUT LANG	131		
ABSOLUT FRABEL	73	ABSOLUT HUTTON	147	ABSOLUT LANGAN	138		
ABSOLUT FREDA	119	ABSOLUT IDAHO	171	ABSOLUT LARS	129		
ABSOLUT FULTON-ROSS	163	ABSOLUT ILLINOIS	171	ABSOLUT LARSON	143		
ABSOLUT FUTURE	252	ABSOLUT ILLUSION	247	ABSOLUT LATYSHEV	180		
ABSOLUT GALLEGOS	144	ABSOLUT IMAGINATION	162	ABSOLUT LE COCQ	79		
ABSOLUT GALLIANO	132	ABSOLUT IMPIGLIA	78	ABSOLUT LE FEVRE	154		
ABSOLUT GARCIA (Fernando)	129	ABSOLUT IMPRESSION	204	ABSOLUT LEBEDEV	184		
ABSOLUT GARCIA (Rick)	157	ABSOLUT INDEX	208	ABSOLUT LEE	157		
ABSOLUT GARTEL	83	ABSOLUT INDIANA	171	ABSOLUT LES BAINS	255		
ABSOLUT GAMBILL	249	ABSOLUT INTELLIGENCE	35	ABSOLUT LEVA	120		
ABSOLUT GASKINS	123	ABSOLUT IOWA	171	ABSOLUT LEVINTHAL	72		
ABSOLUT GAZ	244	ABSOLUT JACKSON	149	ABSOLUT LIMELIGHT	195		
ABSOLUT GEM	16	ABSOLUT JACOBS	108	ABSOLUT LISBON	227		
ABSOLUT GENEROSITY	27	ABSOLUT JAKOBSEN	139	ABSOLUT LOCADIA	148		
ABSOLUT GENEVA	218	ABSOLUT JEANETTE	121	ABSOLUT LOCKE	162		
ABSOLUT GEORGIA	170	ABSOLUT JENSON	157	ABSOLUT LONDON	227		
ABSOLUT GIFT	97	ABSOLUT JIANG	249	ABSOLUT LORENZ	166		
ABSOLUT GLASNOST	178	ABSOLUT JOBIM	207	ABSOLUT LORENZO	82		
ABSOLUT GRAHAM	114	ABSOLUT JOESAM	163	ABSOLUT LOUISIANA	168		
ABSOLUT GRAND TOUR	248	ABSOLUT JOY	26	ABSOLUT LOUISVILLE	58		
ABSOLUT GRAUPE-PILLARD	245	ABSOLUT JOY...TO THE WORLD	94–95	ABSOLUT LYNN	73		
ABSOLUT GUZMAN	84	ABSOLUT KAI	244	ABSOLUT MADRID	227		
ABSOLUT HALL	119	ABSOLUT KANSAS	171	ABSOLUT MAGIC	22		
ABSOLUT HAMILTON	165	ABSOLUT KEELER	157	ABSOLUT MAGNETISM	24–25		
ABSOLUT HARING	69	ABSOLUT KEIKO	124	ABSOLUT MAHON	156		
ABSOLUT HARMONY	41	ABSOLUT KENNEBUNKPORT	264	ABSOLUT MAINE	172		
ABSOLUT HART	163	ABSOLUT KENTUCKY	171	ABSOLUT MAJOLI	177		

ABSOLUT MANHATTAN	49	ABSOLUT NATORI	121	ABSOLUT PHENOMENON	22–23
ABSOLUT MARILYN	235	ABSOLUT NEBRASKA	172	ABSOLUT PHILADELPHIA	265
ABSOLUT MARINÉ	81	ABSOLUT NEIMAN	79	ABSOLUT PHILPOT	160
ABSOLUT MARTINEZ	125	ABSOLUT NEIZVESTNY	184	ABSOLUT PICCONE	118
ABSOLUT MARTINI	269	ABSOLUT NEREYDA	175	ABSOLUT PINK	245
ABSOLUT MARY	193	ABSOLUT NEVADA	172	ABSOLUT PITTSBURGH	59
ABSOLUT MARYLAND	172	ABSOLUT NEW HAMPSHIRE	172	ABSOLUT PLANAS	154
ABSOLUT MASSACHUSETTS	172	ABSOLUT NEW JERSEY	172	ABSOLUT PLATT	107
ABSOLUT MASTERPIECE	23	ABSOLUT NEW MEXICO	172	ABSOLUT PLAY BALL	258
ABSOLUT MASTROIANNI	123	ABSOLUT NEW ORLEANS	52	ABSOLUT POLENGHI	154
ABSOLUT MATROSOV	182	ABSOLUT NEW YORK	172	ABSOLUT POLYNESIA	248
ABSOLUT MAY	113	ABSOLUT NEWTON	130	ABSOLUT POMODORO	109
ABSOLUT MAX	113	ABSOLUT NIGHTCAP	268	ABSOLUT PORTO	244
ABSOLUT MEMPHIS	267	ABSOLUT NORBERG	139	ABSOLUT POSTCARDS	208
ABSOLUT MERGER	214	ABSOLUT NORTH CAROLINA	172	ABSOLUT PROFILE	27
ABSOLUT MEYERS	177	ABSOLUT NORTH DAKOTA	172	ABSOLUT PURYGIN	184
ABSOLUT MIAMI	55	ABSOLUT NYESTE	138	ABSOLUT PUZZLE	202
ABSOLUT MICHEL	121	ABSOLUT ODETTE	177	ABSOLUT RARITY	23
ABSOLUT MICHEL AND CULLEN	117	ABSOLUT OGANESIAN	184	ABSOLUT RECYCLED	73
ABSOLUT MICHELSON	157	ABSOLUT OHIO	173	ABSOLUT REGINE'S	255
ABSOLUT MICHIGAN	172	ABSOLUT OKLAHOMA	173	ABSOLUT REINDEER	265
ABSOLUT MILAN	226	ABSOLUT OKSHTEYN	184	ABSOLUT REJECTS	262
ABSOLUT MILLER	111	ABSOLUT OLDHAM	120	ABSOLUT REOLON	112
ABSOLUT MINNESOTA	172	ABSOLUT OPTIMIST/PESSIMIST	27	ABSOLUT RHODE ISLAND	173
ABSOLUT MIRIPOLSKY	156	ABSOLUT OREGON	173	ABSOLUT RHODES	127
ABSOLUT MIRONENKO	184	ABSOLUT ORIGINAL	32	ABSOLUT RICHTER	167
ABSOLUT MISSISSIPPI	172	ABSOLUT OVERSTREET	160	ABSOLUT RIDDLE	163
ABSOLUT MISSOURI	172	ABSOLUT PACOVSKY	154	ABSOLUT RIGGS	142
ABSOLUT MITTA	182	ABSOLUT PARADOX	247	ABSOLUT RIPLEY'S	267
ABSOLUT MOLINA	249	ABSOLUT PARIS	225	ABSOLUT ROBERTS	167
ABSOLUT MOLINARI	133	ABSOLUT PARK	154	ABSOLUT RODRIGUE	75
ABSOLUT MONTANA	172	ABSOLUT PARSONS	145	ABSOLUT ROLO	113
ABSOLUT MONTE CARLO	227	ABSOLUT PARTICIPATION	242	ABSOLUT ROME	226
ABSOLUT MOODY	125	ABSOLUT PASSION	37	ABSOLUT ROSEBUD	237
ABSOLUT MORPH	196	ABSOLUT PAUL	249	ABSOLUT ROSSER	157
ABSOLUT MOSSIMO	129	ABSOLUT PEAK	33	ABSOLUT ROTH	112
ABSOLUT MOTHERSBAUGH	154	ABSOLUT PENNSYLVANIA	173	ABSOLUT RUFFNER	72
ABSOLUT MUNICH	227	ABSOLUT PEPPAR	188	ABSOLUT RUIZ	129
ABSOLUT MURPHY	157	ABSOLUT PEPPAR	190–91	ABSOLUT RUSCHA	71
ABSOLUT NAKHOVA	183	ABSOLUT PERFECTION, I	13	ABSOLUT SALADINO	149
ABSOLUT NANTUCKET	61	ABSOLUT PERFECTION, II	10	ABSOLUT SALZMAN	245
ABSOLUT NAPLES	223	ABSOLUT PETACQUE	78	ABSOLUT SAN FRANCISCO	51

ABSOLUT SAN FRANCISCO	258	ABSOLUT SUAREZ	153	ABSOLUT WASZAK	143
ABSOLUT SCHARF	68	ABSOLUT SUBLIME	264	ABSOLUT WEBER	164
ABSOLUT SCHENCK	160	ABSOLUT SUBLIMINAL	36	ABSOLUT WELLS	233
ABSOLUT SCUDERA	246	ABSOLUT SUMMIT	259	ABSOLUT WEST VIRGINIA	173
ABSOLUT SEASON	40	ABSOLUT SU•ZEN	129	ABSOLUT WHITE	156
ABSOLUT SEATTLE	60	ABSOLUT SWITZERLAND	248	ABSOLUT WILKE•RODRIGUEZ	115
ABSOLUT SECRECY	269	ABSOLUT TARANTINO	112	ABSOLUT WILLIAMS	177
ABSOLUT SECURITY/LARCENY	20	ABSOLUT TEJADA	119	ABSOLUT WINKELMAN	80
ABSOLUT SEINER	249	ABSOLUT TENNESON	72	ABSOLUT WISCONSIN	173
ABSOLUT SEREBRIAKOVA	184	ABSOLUT TENNESSEE	173	ABSOLUT WISHES	99
ABSOLUT SEVILLE	227	ABSOLUT TEXAS	173	ABSOLUT WOLF	149
ABSOLUT SHAMASK	116	ABSOLUT THULIN	124	ABSOLUT WONDERLAND	93
ABSOLUT SHANAHAN	166	ABSOLUT TIHANY	148	ABSOLUT WYOMING	173
ABSOLUT SHARP	120	ABSOLUT TOI	129	ABSOLUT X-RAY	207
ABSOLUT SHELLEY	139	ABSOLUT TOMPKINS	157	ABSOLUT YAKHNIN	180
ABSOLUT SHELLEY	230	ABSOLUT TRADITION	43	ABSOLUT YAKUT	182
ABSOLUT SHIRE	157	ABSOLUT TRADITION/AMBITION	254	ABSOLUT YANKILEVSKY	182
ABSOLUT SITBON	133	ABSOLUT TREASURE	19	ABSOLUT YERMAN	154
ABSOLUT SLICE	198	ABSOLUT TRICK OR TREAT	204	ABSOLUT ZAKHAROV	184
ABSOLUT SOFTWARE	205	ABSOLUT TRIGÈRE	129	ABSOLUT ZELDIS	138
ABSOLUT SOKOV	184	ABSOLUT TRUTH	37	ABSOLUT ZHURAVLEV	184
ABSOLUT SOUTH CAROLINA	173	ABSOLUT TULOSBA	37	ABSOLUT ZIEGLER	166
ABSOLUT SOUTH DAKOTA	173	ABSOLUT TURK	177	ABSOLUT ZLOTNIK	184
ABSOLUT SOUTHWEST	140	ABSOLUT TWIST	192	ABSOLUT ZOX	157
ABSOLUT SPADA	174	ABSOLUT TYLER	124	ABSOLUT ZVEZDOCHETOV	181
ABSOLUT SPEER	244	ABSOLUT URBAN	249	ABSOLUT ZVEZDOCHETOVA	184
ABSOLUT SPINAZZOLA	78	ABSOLUT UTAH	173	ABSOLUTLY	16
ABSOLUT SPRING	209	ABSOLUT VALLIEN	84		
ABSOLUT SPROUSE	109	ABSOLUT VAN HAMERSVELD	155		
ABSOLUT SPY	214	ABSOLUT VEGAS	265		
ABSOLUT SQUEEZE	197	ABSOLUT VENICE	221		
ABSOLUT SQUIRT	268	ABSOLUT VERMONT	173		
ABSOLUT ST. LOUIS	59	ABSOLUT VIENNA	227		
ABSOLUT STANDARD	38	ABSOLUT VIGIL	144		
ABSOLUT STARDOM	30	ABSOLUT VIRGINIA	173		
ABSOLUT STEFFE	126	ABSOLUT VISION	268		
ABSOLUT STENDERU	129	ABSOLUT VONNEGUT	77		
ABSOLUT STIRRING	42	ABSOLUT WACHTEL	83		
ABSOLUT STOCKINGS	98	ABSOLUT WARHOL	64		
ABSOLUT STOKER	232	ABSOLUT WARHOLA	72		
ABSOLUT STORY	240	ABSOLUT WARMTH	100		
ABSOLUT STYLE	106	ABSOLUT WASHINGTON	173		